Getting Started with 3D
A Designer's Guide
to 3D Graphics and Illustration

by
Janet Ashford and John Odam

PEACHPIT PRESS

Getting Started with 3D:
A Designer's Guide to
3D Graphics and Illustration

Janet Ashford and John Odam

Peachpit Press
1249 Eighth Street
Berkeley, CA 94710
(800) 283-9444, (510) 524-2178
(510) 524-2221 (fax)

Find us on the World Wide Web at:
http://www.peachpit.com

Peachpit Press is a division of Addison Wesley
Longman.

ISBN 0-201-69676-2

0 9 8 7 6 5 4 3 2 1

Printed and bound in the United States of
America.

DEDICATION

To the memory of J. William Bulay, a fine Jungian analyst and a good friend.
—Janet Ashford

To Caleb, Seth and Alison, my loving and supportive children.
—John Odam

ACKNOWLEDGMENTS

We would like to acknowledge Adobe Systems, Meta-Creations and Strata for providing helpful answers to our technical questions. Special thanks to Mark Harvey at Strata.

Thanks to the following publishers for permission to reproduce book covers and page designs: Addison Wesley Longman; Energy and Resources Group, University of California, Berkeley; and Pfeiffer. Thanks also to the Metropolitan Museum of Art for permission to reproduce a photograph in their collection that appears on page 17.

Special thanks to Jim Lennon for inspiring us with his amazing 3D graphics. Thank you to Florence Ashford for the use of one of her childhood paintings. Thanks also to Jackie Estrada for her careful indexing and to publisher Nancy Aldrich-Ruenzel and editor Victor Gavenda of Peachpit Press for their enthusiastic support of our project. Kate Reber of Peachpit Press, Doug Isaacs of Adage Graphics, Tim Holt of Shepard Poorman, and Jonathan Parker, all gave us invaluable production advice. Jack Davis reviewed our manuscript and provided helpful comments.

Contents

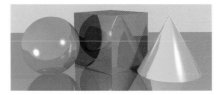

1 | Getting Started

Introduction

HOW WE CAME TO WRITE THIS BOOK

In the late 1970s I heard a young graphic designer give a presentation on his involvement with computer animation. He delighted us with images of wireframe objects, texture maps and renderings, all accomplished with the aid of a roomful of refrigerator-sized computers with whirring tape reels—lovingly attended, no doubt, by earnest, bespectacled experts in white coats.

It was not until the next decade, after desktop publishing was well established, that 3D graphics could be done on a personal computer. The first programs I used were mostly limited to creating cubes and geodesic spheres. Although I was thus able to generate a few images for geometry book covers, I seemed always to be lagging behind my geekier colleagues with their revolving multimedia logos.

Then came the second wave of 3D programs with more features, color and—best of all—ray tracing. With reflections and shadows, the shapes seemed to have an uncanny presence. As images slowly began to emerge on my computer screen, rendering from a coarse mosaic to a finished picture, I was reminded of the art of Paul Klee. And as the picture gradually came into focus I sensed the deadpan surrealism of René Magritte.

Today, computer-generated 3D images have entered into the mainstream of editorial and advertising design. Hatched by the mathematics community and incubated by the military, engineering and computer game industries, 3D computer imaging continues to develop in the hands of art directors, illustrators and designers.

With *Getting Started with 3D*, as with *Start with a Scan*, our goal is to share our adventures and experiments with you and to pass along some tips we have acquired along the way.

—*John Odam*

These early efforts at 3D imaging, made during the early 1990s, were mainly confined to geometric shapes.

For the past several years I've watched John Odam create delightful illustrations using desktop 3D software. Unlike the overwrought spaceships that often characterize 3D art, John's designs are subtle, clever and always well-suited to the project at hand, whether it's a book cover or a technical illustration. So after finishing our first book collaboration, *Start with a Scan*, we decided to do a book on 3D, drawing on John's years of experience and my ability to test our instructions as a relative novice. We figured that if someone like me (with a solid background in 2D computer graphics but relatively little 3D experience) could quickly learn to create 3D illustrations, so could our readers. And guess what?— I passed the test and so will you! After working through the tutorials for the programs we use in this book most often, I was quickly able to create good-looking 3D images. (In fact, I produced over a third of the illustrations in the book.)

I must admit that I was skeptical and a bit intimidated when 3D software first appeared on the market and I hesitated to get involved. It seemed too difficult and too technical. But in the course of creating this book, I've come to view 3D software as a very intuitive, powerful and *enjoyable* tool for creating images. I now think of desktop 3D as an aid to image-making which is sophisticated but similar to the grids and lenses used by artists during the Renaissance, or the photo references we keep on hand, all of which help us to solve the age-old artist's problem of depicting the three-dimensional world on a flat, two-dimensional surface. But what makes computer 3D different is that the same model, once constructed, can be used to generate any number of images simply by moving the camera or by changing the lighting or surface texturing of the objects. This makes 3D an especially powerful medium and provides many rewards for the time you put into learning it.

—*Janet Ashford*

Paul Cézanne believed that all forms in nature are based on the cone, the sphere and the cylinder. His goal in painting was to "uncover the permanent qualities beneath the accidents of appearances."

WHAT THIS BOOK IS ABOUT

Getting Started With 3D is first of all a pictorial overview of the current world of desktop 3D. It lets you know, almost at a glance, the sorts of functions that are included in 3D programs and the kinds of images that can be produced. Rather than focus on a single program, we have worked in a generic way, distilling the functions of the most popular 3D softwares that are available now for both Macintosh and Windows platforms. You won't find program-specific, click-and-drag instructions here, but you will find a clear description of the features that most 3D programs have in common. We focus on the use of 3D to produce still images for print and for web design. (We do not cover animation in this book, although throughout the text we often mention functions that are useful for animation.)

Just as graphic design and illustration are part of the history of art and partake of its aesthetic values, imaging with computer 3D draws on the techniques and developments of hundreds of years of painting, photography, filmmaking and theater design, as well as illustration and design. In this book we attempt to place 3D in its art historical context and to stimulate readers to remember and apply the broader values of art to this new field.

IS THIS BOOK FOR YOU?

We think that 3D graphics can be a useful part of the repertoire of any graphic designer or illustrator because it expands your range and is sometimes the easiest medium for getting the 2D image you want.

Throughout our writing we've had three groups of readers in mind:

• First, experienced, computer-literate designers and illustrators who are curious about 3D and perhaps hesitant about taking on what appears to be a difficult subject.

• Second, design students and people who are new to the computer graphics field, who want to know how 3D works and what kinds of images can be created in this medium.

• And third, instructors who are teaching 3D graphics in high schools, colleges and trade schools, who need a good overview text for their students.

Readers can discover what sorts of images can be created with a 3D program, how such programs work and which program might best fit their needs. Once you've done the tutorial for your own 3D program, you should be able to go directly from our book to your computer to duplicate the effects you see on our pages. We hope you'll discover, as we did, that desktop 3D is easier than you think.

BACKGROUND AND SOFTWARE YOU WILL NEED

We assume that most of our readers are already familiar with the most popular desktop graphics programs (including Photoshop, Painter, FreeHand, Illustrator and Streamline, on either Macintosh or Windows platforms). You'll also need to have a full-featured 3D graphics program, in order to work along with us and try out the many techniques described in the book. We have not included specific instructions for every technique because we want our book to be applicable in a variety of different programs and computers. For the same reason, screen dumps and menus are rarely shown. But we do include enough detail so that you should be able to duplicate our techniques in whatever 3D program you are using.

This opening image for a discarded chapter was created with 3D clip art and built-in environmental effects.
Human figures from Acuris

How to Use This Book

LEARNING BY LOOKING

Getting Started with 3D, like its predecessor *Start with a Scan*, is first and foremost a visual treat. You'll be able to learn a lot about how 3D works—and gain inspiration for your design projects—simply by looking at the many images in the book. So first of all, look at it! 3D images are often used to create virtual worlds for computer games and often have the hard-edged look of science fiction illustration. But we've found that other styles can be generated from 3D models, resulting in images that belie their origins in 3D. You may be surprised to find that such a variety of images is possible in this medium.

Computer 3D is a fairly technical art, however, so we've also provided a carefully written text that explains how 3D graphics software works, covers the features that are included in most popular 3D graphics programs, describes the functions that are common to most and also points out which programs have unique or specialized functions. The manuals that come with 3D software tend to be cursory, so we've provided as much information as possible on the theoretical underpinnings of computer 3D to help you link what you already know about computer graphics, art and aesthetics with the world of computer 3D graphics.

HOW THIS BOOK IS ORGANIZED

We start our exploration of the three-dimensional world in Chapter 2 by covering the fundamentals of 3D in traditional art, to help ground you in the workings of the human visual system and the concepts of linear perspective and representation that were developed during the Renaissance. The rest of the book is organized into chapters that describe the basic functions of computer 3D, essentially in the order that these would usually be performed when building a 3D model and rendering it. Chapter 3 provides an overview of the entire process

involved in producing a 3D image: creating 3D objects, manipulating and assembling objects into a model, applying surface maps for texture and color, lighting the scene, viewing the scene with cameras and rendering final images. This chapter can be used as a "tutorial" if you follow along with using your own 3D software. Each of the topics covered in Chapter 3 is then discussed in more detail in the five chapters that follow (4 through 8). Finally, Chapter 9 is devoted to showing how you can use 3D images in your illustration and design projects. In this chapter we cover some creative uses of 3D typography, ways to use 3D images as illustration references and ways to alter rendered 3D images using image-editing programs.

HOW THIS BOOK WAS PRODUCED

Most of the 3D images in this book were produced using Ray Dream Designer (MetaCreations), Vision 3D (Strata, Inc.) and Bryce 3D (MetaCreations). Some images were also produced using Infini-D (MetaCreations), StudioPro (Strata, Inc.) and Dimensions (Adobe). All image-editing was done in Photoshop; some special effects were created in Painter and autotracing was done with Streamline. The book's pages were laid out in Adobe PageMaker and printed using a direct-to-plate method. We used Macintosh PowerPC computers to create all the images shown in this book, but the techniques shown here can also be done using the same programs running on Windows.

SECTION TITLE | CAPTIONS DESCRIBING METHODS AND PROCEDURES | HOT TIPS ON 3D TECHNIQUES | SIDEBAR ON A SPECIAL TOPIC

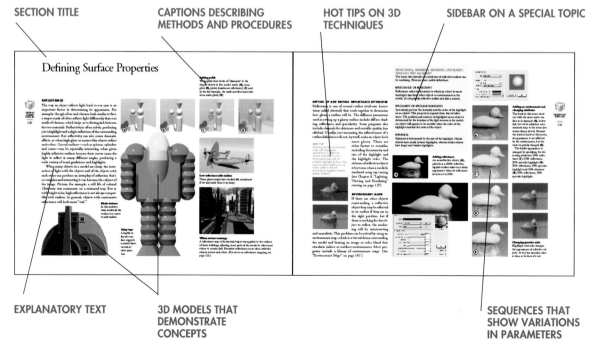

EXPLANATORY TEXT | 3D MODELS THAT DEMONSTRATE CONCEPTS | SEQUENCES THAT SHOW VARIATIONS IN PARAMETERS

2 | The World of Three Dimensions

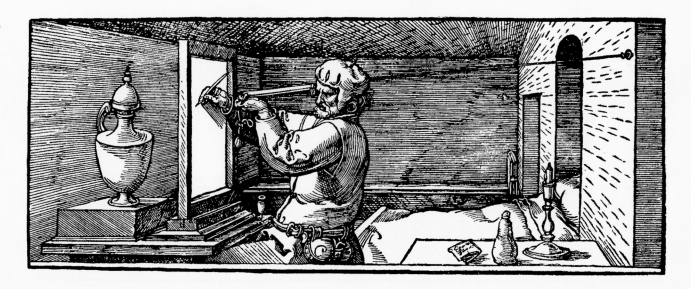

The Language of Three Dimensions

LIVING IN A 3D WORLD

In the real world we are surrounded by solid objects that are three-dimensional objects (rocks, trees, mountains, bears, people), which we must be able to recognize and locate in space. Our senses equip us to interpret and interact with the three-dimensional world we inhabit. With our sense of touch we experience the solidity and texture of everyday objects. Our hearing helps us to immediately recognize and locate the source of threatening or interesting sounds. And our highly developed visual system (our eyes working together with our brain) helps us to identify objects and determine whether they are close to us or far away.

Our senses are vital to our survival in the world, but they also provide us with profound aesthetic experiences. "Beauty before me, beauty behind me, beauty all around me" goes a Native American poem, expressing the especially great pleasure we take in the visual perception of nature. This pleasure was one factor that led human beings to begin making graphic art: both sculptural and two-dimensional. And though hunting rituals may have inspired our ancestors' cave paintings of animals, those elegant and realistic images also show a keen appreciation of the beauty of natural forms. In the thousands of years since these early artists first depicted three-dimensional objects on a flat surface, people have developed and honed their "drawing" skills in order to imitate in pictures the way things look in real life.

This striving to represent the real world (as well as to create new worlds) is a driving force behind the systems of perspective and modeling that were developed during the Renaissance and lead directly to the creation of 3D models and images using computers. Today's computer programs for 3D modeling and rendering are simply the latest tools in a long line of mechanical aids to drawing. All of these methods, old and new, have as their aim the depiction of solid objects on a flat surface in a way that mimics the eye's view of the real world.

THE HUMAN VISUAL SYSTEM

In order to create two-dimensional images that look similar to real scenes, artists take advantage of the way our visual system works, imitating with paint the various depth cues we use to interpret what we see around us.

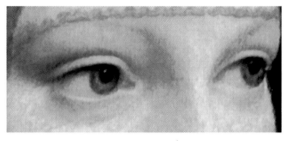

Two Eyes = Two Images = Depth
Because we have two eyes spaced slightly apart and facing forward, our brain receives two slightly different views and merges them to create a perception of depth. The sense of depth provided by our binocular vision cannot be duplicated on a two-dimensional surface, such as a painting or a computer screen, but various monocular (one-eye) depth cues can be imitated. Techniques for rendering depth were developed during the Renaissance by many architects and painters, including Leonardo da Vinci. The eyes shown above are a detail from his painting *Lady with the Ermine*, painted around 1485. It is in the collection of the Czartoryski Museum, Cracow.

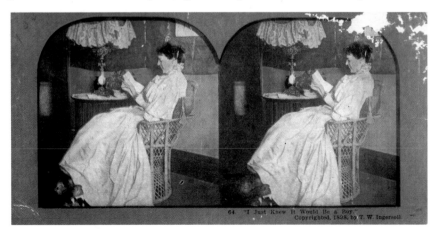

Stereoscopic images
Sir Charles Wheatstone (1802–1875) was the first to develop a process for producing two offset views of a scene, to simulate the differing views seen by each eye. When presented to each eye separately in a device called a *stereoscope*, these two views create a perception of depth. Wheatstone's device was introduced in 1838, shortly before the invention of photography. During the 1850s several inventors created stereoscopic cameras, with lenses placed about 2.5 inches apart to imitate the spacing of the eyes. Stereoscopic photography became very popular around the turn of the century. The image at left, entitled "I Just Knew It Would Be a Boy," was produced by T. W. Ingersoll in 1898. Although the pictures appear identical at first glance, notice how the objects in the right-hand image are slightly to the right in the frame, compared with the objects in the left-hand picture.

To view the images without a stereoscope is tricky, but try placing a piece of paper upright between them and touch your nose to the paper's edge so that each eye sees only one image. Your brain may (or may not) merge the two flat images into one image with depth.

*Learning to draw is really a matter of
learning to see…*
—Kimon Nicolaïdes, *The Natural Way to Draw*

Creating three dimensions with two
Leonardo da Vinci (1452–1519) painted this *Annunciation* when
he was only 21 years old. The painting employs all the monocular
depth cues we will describe in this chapter, including occlusion,
size differences, linear perspective, shading, texture gradients and
aerial perspective. Can you find examples of each of these in the
painting? For an analysis of the perspective in this painting, see
page 10.

The same techniques used by traditional artists are also
incorporated in the programming of desktop 3D soft-
ware, in order to create computer graphics that look
strikingly similar to real objects.

BINOCULAR VISION

How do we perceive depth? The most important aspect
of our visual system is the fact that we have two eyes
rather than one (*binocular vision*). And in human beings,
along with other predators, these eyes are located a small
distance apart on the front of our heads (as opposed to
prey animals, which have their eyes located on the sides
of their heads). This provides us with a large binocular
visual field, in which each eye gets a slightly different
view (*retinal disparity*). These two views are combined
by the brain in a way that gives us the perception of
depth. The disparity is sometimes called *parallax* and the
combining of the two images is called *stereopsis* ("solid
sight"), or *stereo vision*.

Stereo vision helps predators find and track their
prey, especially over long distances. But it doesn't do
much to help artists depict solid-looking shapes, since
two-dimensional art is, by definition, *flat*. So to create a
sense of depth, artists must use their paint or pixels to
imitate the depth cues that can be perceived with only
one eye.

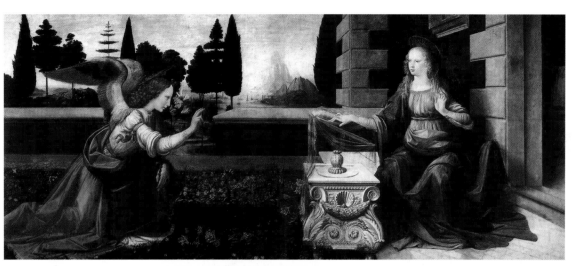

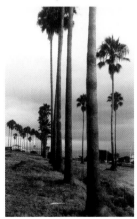

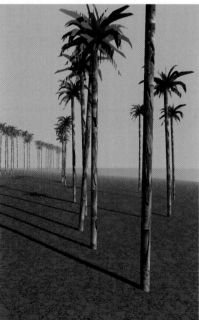

Art imitates life
This photograph of coastal palm trees receding
into the distance includes all of the monocular
depth cues used in the painting above. In the 3D
rendering next to it, created in Strata StudioPro,
we've tried to imitate these depth cues in an in-
vented landscape based on the photo. Images in
any medium that include all six monocular
depth cues look the most convincing in terms of
the imitation of reality.

We will continue to use examples from paint-
ing, photography and 3D imaging to illustrate
each of the monocular depth cues on the follow-
ing pages. (Photo by Janet Ashford)

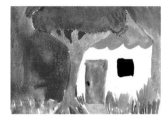

MONOCULAR DEPTH CUES

In addition to the depth cues provided by binocular vision, there are many cues that function with only one eye, or viewpoint. These are called *monocular depth cues* and include the following:

OCCLUSION

Objects that are close to us partly block our view of objects that are "behind" them or further away.

SIZE DIFFERENCES

An object that is closer to us looks larger than a similar-sized object that is further away.

LINEAR PERSPECTIVE

Lines that are parallel with our line of sight (such as railroad rails when we're standing in the middle of the track) appear to converge together in the distance.

TEXTURE GRADIENTS

Uniform textures (such as a checkered table cloth) look denser when they are farther away.

SHADING

Light shining on an object wraps around it in a way that creates gradations of light and dark. Parts of an object that are further away from the light look darker.

ATMOSPHERIC PERSPECTIVE

Objects that are further away look fuzzier, less detailed and often bluer than near objects because particles of dust in the atmosphere cause light to be scattered and also because different temperatures of air masses between object and viewer cause refraction of light.

While both binocular and monocular depth cues help us avoid bumping into tables, only monocular depth cues can help us interpret an image on a flat surface—such as a painting, a photograph or a 3D rendering. Over the years, artists have learned how to imitate these monocular depth cues in order to create images that look real.

Keeping in mind that the final product of a 3D graphics model is a flat image, programmers have designed their software to render 3D models in a way that imitates the conventions already used by painters. These techniques include occlusion through the creation of objects with opaque surfaces; size differences based on relative positions in 3D "space"; the use of linear perspective to show the convergence of parallel lines on a vanishing point; the use of light and dark areas to show modeling of forms; and the use of *aerial perspective* or atmospheric effects to create a sense of distance. These traditional techniques all have analogs within computer 3D programs.

OCCLUSION

This depth cue is one of the most apparent and easiest to understand. Objects which are close to us partially block our view of objects that are further away or "behind." In addition, when we view a single opaque object, the surfaces that are facing us hide the surfaces that are in back. For example, when looking at a cube, we can see only three of its six surfaces at a time. This effect of occlusion is readily apparent in a photograph or in a painting done by an artist with conventional training. However, occlusion presented a problem in early computer 3D programming.

HIDDEN LINE REMOVAL

Early 3D graphics programs were able to draw only the contours or edges of objects. This was done by a plotting of points very similar to the techniques used by Renaissance artists (see "The Science of Drawing" on page 13). A line image like this is called a wireframe and is the simplest way to display a 3D object. However, a wireframe drawing is often visually confusing because the computer traces and presents to the viewer every edge,

Blocking the view
Solid objects that are close to us partially block our view of objects that are behind them, providing immediate information about their relative positions in space. This is called *occlusion*. In the child's painting above, occlusion (the tree blocks our view of the house) is the only depth cue that has been provided. The painting is expressive and decorative, but without further depth cues it looks quite flat. In the photo and 3D image below, the trunks of the close palm trees block our view of the trees behind them. These two images also include size differences and some shading, cues which enhance our perception of depth. But with only three monocular depth cues provided in these detail views, the images look almost as flat as the child's drawing.

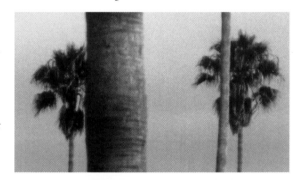

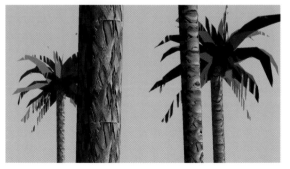

including those that should be hidden behind surfaces. There is no illusion of depth to help the viewer interpret the image. So beginning around 1963, algorithms that enable "hidden-line removal" and "hidden-surface removal" were developed to solve this problem. These processes are also sometimes called *occultation*, not because they involve magic, but because they remove *occulted* or hidden lines. (For information on wireframe views and shading see "Rendering" on page 34.)

SIZE DIFFERENCES

Objects that are the same size look larger when they are close to us and smaller when they are farther away. This occurs because the image made on the retina of the eye by a distant object is smaller than the image made by a similar-size object that is close.

In naive art, the relative size of objects in a picture often has more to do with their emotional importance or status. For example, a child may draw herself as the largest figure in a family group, towering over her mother and father. Obviously, the artistic purpose of the child is not to imitate reality but to express ideas and feelings, so accurate size relationships are not important.

But as systems of linear perspective developed (see next page), it became possible to accurately determine what size distant objects should be in order to produce images that look natural.

TEXTURE GRADIENTS

Regular patterns, either human made (such as a tiled floor or cobbled street) or natural (such as wildflowers in a field or waves on the ocean), appear denser as they recede into the distance. This effect is related, of course, to the fact that objects of the same size look smaller when they are farther away. So each paving brick in the street looks a little smaller than the one in front of it.

Artists often take advantage of this depth cue by using a tiled floor in their interior compositions. The diminishing size of the tiles as they move away from the viewer is reinforced by the receding parallel lines as they move toward the vanishing point.

When a regular pattern, such as a checkerboard, is applied to a 3D object as a surface texture, the program will calculate the rendering so that the pattern appears smaller and denser on those parts of the object that are further from the "camera."

Hiding the "hidden lines"
This demonstration of "hidden line removal" was created by Melvin L. Prueitt for his book, *Computer Graphics*, published by Dover Publications in 1975. The 3D objects are visually confusing when all the edges calculated by the computer are visible (top). But when the "occult" or hidden lines are removed (bottom), the objects are easier to interpret and take on the appearance of depth. Algorithms that remove hidden lines and surfaces make it possible to create opaque-looking objects on the computer and duplicate the monocular depth cue of occlusion.

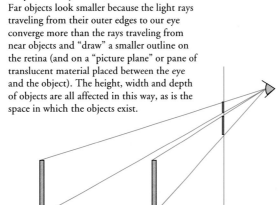

Why do far objects look smaller?
Far objects look smaller because the light rays traveling from their outer edges to our eye converge more than the rays traveling from near objects and "draw" a smaller outline on the retina (and on a "picture plane" or pane of translucent material placed between the eye and the object). The height, width and depth of objects are all affected in this way, as is the space in which the objects exist.

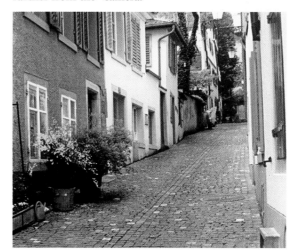

Textures are denser at a distance
The cobblestones paving this street in Zurich, Switzerland look smaller as they move further from the viewer. This decrease in the size of a regular pattern is called a texture gradient and adds to the sense of depth in an image. (Photo by Janet Ashford)

The Art of Illusion

LINEAR PERSPECTIVE

In Western art before the Renaissance, in most Oriental art and also in naive folk and children's art from around the world, accurate linear perspective is absent. The relation of objects in space is shown in a formal or stylized way, following conventions that are not mathematical; for example, objects which are further away are sometimes shown as being above objects which are closer, even though they may not be drawn smaller.

This type of nonscientific representation works well when accurate depiction is not the goal. For example, in Medieval Europe, artists were more concerned with depicting religious ideas than with duplicating reality. Paintings tended to be flat, decorative surfaces, with little sense of depth. No one expected a painting to look like a real scene. The same aesthetic still prevails in much Eastern art. But during the Renaissance, European artists, as well as philosophers and scientists, turned more toward nature and humanistic values and developed systems both for understanding and celebrating natural phenomena. One result of this change in emphasis was the development of systems of *linear perspective* to aid artists in depicting reality. Many Renaissance artists, including Leonardo Da Vinci and Albrecht Dürer, developed systems and wrote treatises on the relations between geometry and painting and worked out methods of translating 3D forms into 2D images.

THE BASIC CONCEPTS OF PERSPECTIVE

Perspective is defined in the *Oxford English Dictionary* (*OED*) as "the art of delineating solid objects upon a plane surface so that the drawing produces the same impression of apparent relative positions and magnitudes, or of distance, as do the actual objects when viewed from a particular point." The *art* of perspective is based on two related facts about the way we perceive visually: (1) that parallel lines appear to converge at a vanishing point located on the horizon and (2) that objects which are further away look smaller than those which are closer. Desktop 3D programs are all based on classical systems of perspective and employ the same key words and concepts.

HORIZON LINE

The *horizon* (from a Greek word for "the bounding circle") is the place where the sky meets the earth. If we were on the masthead of a ship far at sea, we could turn in a complete circle and view the entire horizon, which would describe a circle around us. But on land, our view of the horizon is usually obscured by trees, buildings or other objects. Even though the horizon is round, in graphic images it is usually drawn as a straight, horizontal line, since in a landscape view we usually see only a short segment of the horizon. In an image, this is called the *horizon line*.

Note that in real life, the horizon line is always at your own eye level. The place where sky meets earth will be at the level of your eyes whether you are standing, lying down, or at the top of a tall building. In a graphic image, the horizon line may be placed high, low or near the middle depending upon the height of the "eyes" of the viewer whose view is being presented by the artist.

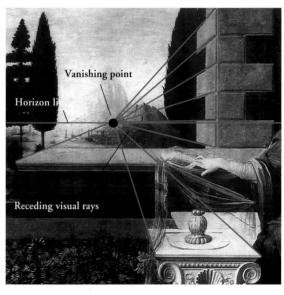

From theory to art
In a detail of Leonardo's *Annunciation* we can see that the parallel lines of the architectural elements on the right recede almost perfectly to a single vanishing point located on the distant horizon. The invisible lines that converge on the vanishing point (they're shown in red above) are called perspective lines, visual rays, or orthogonal lines. This way of drawing in perspective lets us know that the parallel lines of the building blocks and table are parallel with our line of sight. This is an example of 1-point perspective, in which all the lines that are parallel to the viewer's line of sight converge on a single vanishing point.

VANISHING POINT

The *vanishing point* (or *principal vanishing point*) is a point on the horizon toward which we are looking and toward which all the parallel lines in the scene that are parallel to our line of sight will appear to converge. Other receding lines in a scene that are not parallel to the line of sight will appear to converge on other vanishing points. These points may be to the left or the right of the principal vanishing point and may also be above or below the horizon line. These other vanishing points may actually lie outside the boundaries of the image. (See the section on 1-, 2- and 3-point perspective on pages 14–15.)

VIEWPOINT

The *viewpoint* or *station* point is the point at which the viewer of a scene stands. In a 3D model, this point is often called the "camera."

LINE OF SIGHT

The *line of sight* is the line between the viewpoint and the principal vanishing point.

PICTURE PLANE (OR PROJECTION PLANE)

The picture plane is an imaginary plane that is perpendicular to the line of sight and that stands between the viewer or viewpoint and the scene being viewed.

Viewing the horizon

The horizon line is always at the viewer's eye level, no matter how high or low the viewer may be. When you are standing, the horizon line falls toward the middle of the view. When you are lying down, the horizon line is also low and more of the sky is seen. When you are elevated, the horizon line is raised and more of the ground plane is seen. To illustrate this we constructed a model in Ray Dream Designer using clip art of a city block and various creatures. The top image shows a high horizon (flying duck's-eye view), the center image shows a more centered horizon (standing velociraptor's-eye view) and the bottom image shows a low horizon (ladybug's-eye view).

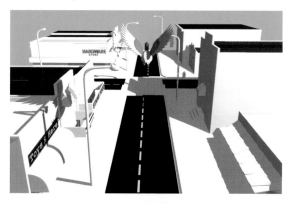

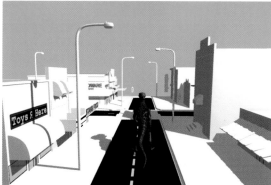

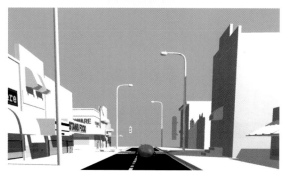

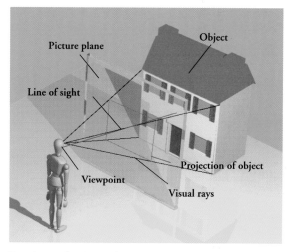

Drawing on the picture plane

The "picture plane" is a hypothetical plane placed in between the observer (viewpoint) and the object (in this case a house) and oriented perpendicular to the line of sight. The situation is similar to that of viewing an object through a window. In theory, the object's image could be drawn by tracing its outlines on the glass of the window. To illustrate this, we constructed a model in Ray Dream Designer using clip art. The picture plane is modeled by a flat rectangle with a clear glass texture map. The visual rays marked above are drawn from the viewpoint to the four corners of the front of the house. As they pass through the picture plane they

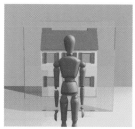

describe a rectangle (shown in red lines) that represents the viewer's view of the house front. A rendering made from the same model but with the camera placed in back of the viewer, gives us a view similar to what the viewer sees on or "through" the picture plane.

VISUAL RAYS

Perspective depends upon the concept that when we look at an object, every point on its surface sends a visual ray in a straight line to our eyes. These rays converge on us, so to speak, in the same way that lines drawn along parallel edges of objects converge on a vanishing point. There are an infinite number of such hypothetical visual rays, but important ones can be traced by simply drawing lines from the viewpoint to the object (as in the figure at the right) or by drawing lines from objects to the vanishing point (as in the illustration on page 10).

Visual rays are important in computer 3D because the rendering of 3D models into images uses a process called "ray tracing," based on the existence of these hypothetical rays. In theory, the "ray" traveling from the model to each pixel in the computer image (which is analogous to the picture plane) determines what the color and intensity of that pixel will be. To assign the correct values, the ray tracing algorithm works backward, tracing the path of the ray from the pixel back to the model, taking into account whether it came directly from a light source, or was reflected by a surface, or was refracted (bent) through a material like glass.

FORESHORTENING

Foreshortening is a distortion that occurs when we look at an object that recedes away from us, because the closer parts of it look larger than the parts that are further away. For example, when we view a person standing up, most of their body is equally distant from us, so their hands look about as large as their feet. However, when we view a person who is lying down, with their feet toward us, their feet will look larger than their hands because the feet are closer. Foreshortening is a challenge to traditional artists, since it requires that we really look at the outlines of an object rather than draw what we expect to see. However, foreshortening is done automatically in a computer 3D program, whenever we move the camera to view an object across its longest dimension.

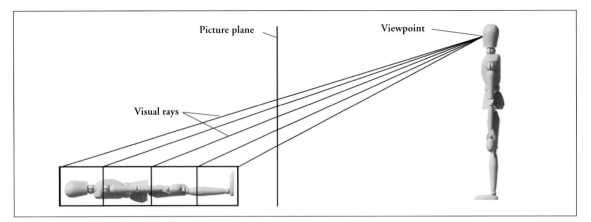

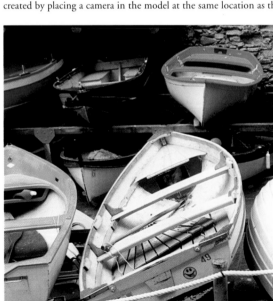

Foreshortening

When we view a long (or tall) object from a viewpoint in which our line of sight runs perpendicular to the long axis of the object, its length is not distorted. For example, in the diagram above we can see exactly how tall (or long) both mannequins are, because we are looking at them from the side. But when we view the lying down figure from the front (as the mannequin's friend is doing) so that the line of sight is running parallel to the figure's long axis, the mannequin's length is shortened and its shape is distorted. This occurs because the parts of the mannequin that are closer to us (such as the feet) look larger than similar-sized parts (such as the hands) that are further away. If we draw a box grid around the supine mannequin and draw visual rays from five equidistant points on the grid to the viewpoint (the other mannequin's head), we can see that the distance between the rays becomes unequal as they pass through the picture plane, which is the hypothetical surface that makes up the image we see. The foreshortened image seen by the standing mannequin is shown at left. It was created by placing a camera in the model at the same location as the standing mannequin's head.

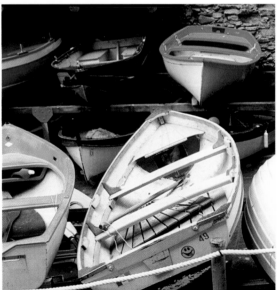

Variations

A photograph of Italian fishing boats illustrates the principle of foreshortening. The length of the boats is condensed into shorter, squatter shapes, creating an interesting image of theme and variations. (Photo by Janet Ashford)

The Science of Drawing

GRIDS AND RAY TRACING IN THE 1500S

Can't draw a straight line, much less a curved one? Try the methods of Albrecht Dürer (1471–1528), a German engraver, painter and draftsman who was one of the greatest artists of his time and a lover of linear perspective. His concern with proper proportion and the application of mathematical systems to art made him the northern counterpart of da Vinci, who also expounded on systems of perspective. Several of Dürer's woodcuts (two are shown here; one is on this chapter's opening page) illustrate his methods for drawing objects accurately, so that the foreshortening of the image on paper is similar to what we see when looking at the object itself.

Dürer's method follows closely the definition given by the *Oxford English Dictionary* for linear perspective: "… an application of projective geometry, in which the drawing is such as would be made upon a transparent vertical plane (*plane of delineation*) interposed in the proper position between the eye and the object, by drawing straight lines from the position of the eye (*point of sight*) to the several points of the object, their intersections with the plane of delineation forming the corresponding points of the drawing."

All of Dürer's woodcuts are reproduced in *The Complete Woodcuts of Albrecht Dürer*, edited by Willi Kurth (Dover Publications, 1963).

From *Underweisung der Messung*, 1525, Albrecht Dürer.
In this woodcut from Dürer's treatise on geometry, two men demonstrate an early form of "ray tracing," the method used today in computer 3D to determine how 3D objects should be rendered on a flat, 2D surface.
Here's how this laborious process worked:

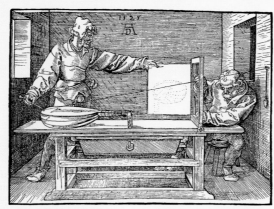

Cross-hairs in vertical frame

Plotting of lute

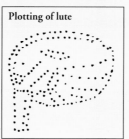

Creating a visual ray
A spot on the wall to the right of the table is marked by a small hook which represents the "viewpoint." A string attached to the hook passes through an open wooden frame which is perpendicular to the table. The plane defined by this frame is the "picture plane" and it is also perpendicular to the "line of sight." (The line of sight is defined as a straight line between the view point and the center of the object being viewed, in this case a lute. It can also be called a visual "ray").

Viewing the object
The other end of the string is tied to a pointer, held by the man on the left. This man (let's call him the pointer) touches various points along the contours (edges) of the lute. This is analogous to looking at or viewing the various parts of the lute.

Marking the visual rays
As the pointer touches each point, the other man (we'll call him the plotter) moves two cross-hairs (probably threads made of silk) which are attached to the wooden frame so that they slide. One cross-hair is vertical and slides from left to right, while the other is horizontal and slides from top to bottom. The plotter slides each cross-hair until together they mark the position at which the line-of-sight string or "ray" passes through the frame.

Plotting the points
The string is untied for a moment and the plotter swings shut a hinged drawing surface, attached to the frame, on which he has tacked a piece of paper. Using the cross-hairs as a guide, the plotter marks the spot where the visual ray passed through. Then he swings open the drawing surface, the pointer moves his pointer to another spot on the lute and they continue the plotting process until they have produced a foreshortened drawing of the lute delineated by dots.

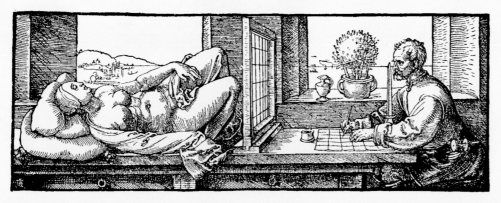

From *De Symmetria Partium Humanorum Corporum*, 1532, Albrecht Dürer.
In this illustration, Dürer demonstrates a grid method of drawing in which the artist places a grid in a vertical frame between himself and his subject, views the subject through the grid and draws what he sees in each grid "square" on a corresponding grid on paper on the table in front of him. To make sure that his eye view remains constant, the artist always aligns his nose with a vertical guide.

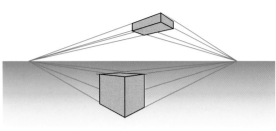

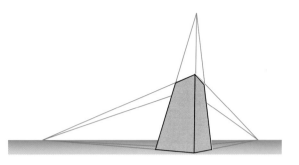

1-point perspective

In a 1-point perspective view, objects (such as the cubes shown above, for example) are orthogonal or aligned at right angles to the viewer; that is, the horizontal and vertical lines of the cubes' front and back sides all lie in planes that are perpendicular to our line of sight, while the receding parallel lines of the cubes's sides are parallel with line of sight. All of the receding parallel lines converge on a single vanishing point.

In this type of perspective or "projection," objects that straddle the horizon line show only a front and a side surface, but objects above the horizon line also show a bottom surface and objects below the horizon line show a top surface.

The photo below of a symmetrical hallway in Balboa Park, San Diego, provides a perfect example of 1-point perspective in real life. Because the viewer's line of sight passes through the center of the hallway, all the lines of the building which are parallel with the line of sight converge on a single vanishing point at the end of the hall. (Photo by Janet Ashford)

2-point perspective

When the objects in a scene (such as the cubes above) turn an edge or corner towards the viewer (instead of being "orthogonal" as in the 1-point perspective view at left) then 2-point perspective comes into play. In this situation, some of the receding parallel lines extending from the objects converge on a vanishing point to the left, while others converge on a vanishing point to the right.

Two-point perspective is often encountered in life, as in the photo below of the Point Loma lighthouse in San Diego. Here the line of sight runs from the viewer to a corner of the lighthouse, with the two side walls oriented almost perfectly at 45 degree angles from the line of sight. We can find the two vanishing points by drawing the horizon and then extending receding lines from the walls of the building to the horizon, following the angles of the building. Often in a 2-point perspective view, the vanishing points lie outside the boundaries of the scene. Two-point perspective is a popular view in 3D graphics programs. (Photo by Janet Ashford)

3-point perspective

When objects are viewed from a position that is extremely low (worm's eye view) or extremely high (bird's eye view), then a third vanishing point is created. For example, when looking up at a very tall building, not only do the horizontal rays along the sides of the building recede to two vanishing points on the horizon, as in a 2-point projection, but the parallel vertical rays running up and down the building converge on a third vanishing point in the sky. A photo looking up at a tall bell tower at Balboa Park in San Diego shows this effect clearly. Lines drawn along the main vertical edges of the tower converge on a vanishing point somewhere just off the top of this page. (Photo by Janet Ashford)

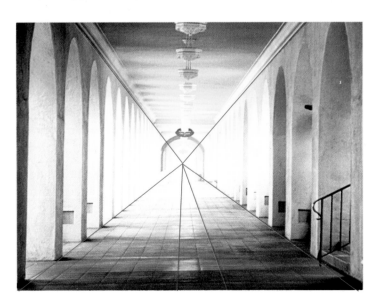

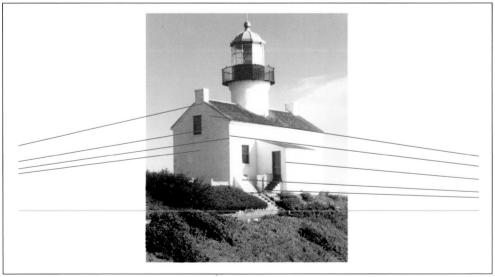

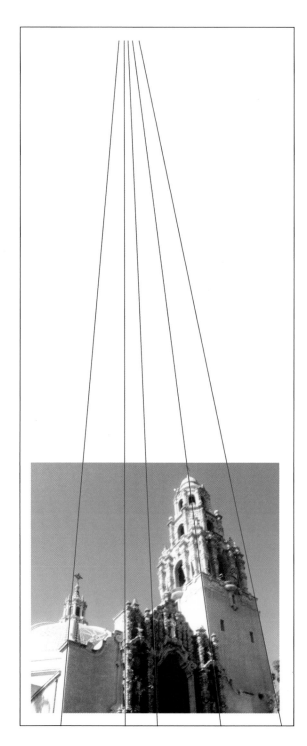

DIFFERENT TYPES OF PERSPECTIVE

Different types of perspective occur when objects are viewed from different viewpoints and angles. Schemes of 1-, 2- and 3-point perspective have been devised to accommodate these differences and are used extensively in drawing and painting, as well as in computer 3D. In real life, however, since our eyes are constantly roaming over the scenes around us, several types of perspective may occur simultaneously.

1-POINT PERSPECTIVE

In a 1-point perspective view there is only one vanishing point and all lines that are parallel to the line of sight converge on this point.

2-POINT PERSPECTIVE

In this view, sometimes called an "off-axis" view, the primary receding lines of the objects are not parallel with the line of sight and they recede to two different vanishing points, located at the left and right of the picture.

3-POINT PERSPECTIVE

When objects are viewed from below or above, sometimes a third vanishing point appears, towards which the vertical lines of the objects recede.

ORTHOGRAPHIC VIEWS

In addition to views with linear perspective, most 3D programs also include *orthographic* views. *Ortho* means "straight" or "at right angles to" something else; so an orthographic view is one in which the direction of the projection is perpendicular (at right angles) to the picture plane. In 3D modeling these include the views called front, back, left, right, top and bottom. In an orthographic view, the parallel lines in the model do not converge on a vanishing point but remain parallel; also, objects that are the same size look the same size even when they are further away. Many 3D program manuals recommend the use of an orthographic view during the initial phase of modeling, since it easier to measure and align objects.

ISOMETRIC VIEW

In some 3D programs, there is also an *isometric* view, which is a type of orthographic view in which the principal axes (x, y, z) of the object are equally foreshortened so that the same measure scale can be applied to each axis. An isometric projection looks similar to a projection using linear perspective, so it gives a sense of depth, but it is easier to measure and manipulate. This type of projection is often used in mechanical drawing.

For more information on orthographic and isometric views see the section on "Viewing the 3D World" on pages 26–29.

Following the converging lines
A perspective drawing from a 19th-century engraving shows a carefully drawn grid of converging lines receding toward a vanishing point on the horizon. The building was drawn in perspective by aligning its structures to the grid. We used Strata StudioPro to construct a model similar to the one in the engraving. Viewing it in a 1-point perspective projection, we can see that the computer's view differs a little from the hand engraving, but the parallel beams of the 3D structure do appear to converge on a vanishing point. However, viewing the same model in an isometric projection, there is no converging of parallel elements.

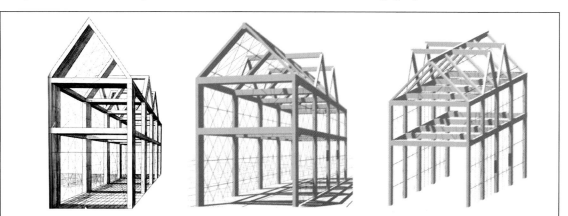

The first objective of the painter is to make a flat plane appear as a body in relief and projecting from that plane.
—Leonardo da Vinci

LIGHT AND DARK

In addition to perspective, another essential technique for creating the illusion of depth in a two-dimensional image is *chiaroscuro,* or the modeling of forms with areas of light and dark. This method of shading was devised during the Renaissance and again, Leonardo da Vinci was one of its greatest exemplars.

With the technique of chiaroscuro, objects do not have clear outlines (as in a coloring book) but appear to emerge from darkness, as though being revealed by the light hitting them. Often a highlight appears where the light strikes an object and reflects brightly. In a black-and-white drawing the highlight may be pure white, or a pale shade of gray, depending upon the reflectiveness of the object being drawn. Darker shades of gray blend gradually across the object as the light decreases, until they reach the edge where the lighted part of the object meets the unlit part. Here there is a more rapid transition to dark shades of gray, though the unlit side of an object rarely becomes completely black because of the presence of reflected or ambient light in most scenes.

The shadows cast by lighted objects are also rendered in varying shades of gray. The part of the shadow that is closest to the object is usually the darkest. It becomes lighter as it recedes away from the object, as it is affected by ambient light.

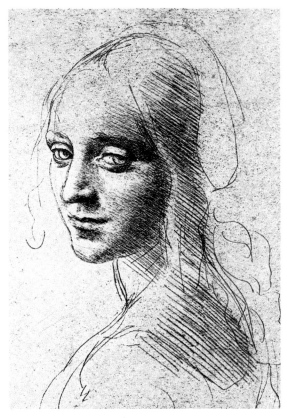

Leonardo and chiaroscuro
Writing in his *History of Art* (Prentice-Hall and Harry N. Abrams, 1962), H. W. Janson observes the technique of da Vinci: "Leonardo … thinks not of outlines, but of three-dimensional bodies made visible, in varying degrees, by the incidence of light. In the shadows, these shapes remain incomplete, their contours are merely implied. In this method of modeling (called *chiaroscuro,* "light-and-dark") the forms no longer stand abruptly side by side but partake of a new pictorial unity, the barriers between them having been partially broken down."

In this drawing from his notebooks, we can see the process of chiaroscuro at work, as Leonardo uses a light pencil sketch to rough in the outlines of the woman's face, head and shoulders and then works into the face with shadow to model the forms of mouth, eyes and nose so that they appear to almost rise from the surface of the paper.

THE SYMBOLISM OF LIGHT AND DARK

Chiaroscuro shading of this type can be very subtle and expressive of emotional states. In fact, light and shadow are seen as symbols for more elevated dualities by one critic speaking of Rembrandt's work:

The richness and variety of Rembrandt's achievements are inexhaustible, but close to their centre is a curious duality of light and shadow, manifestation and concealment, matter and spirit.

The light and shade of his mature art is most striking; it fluctuates unaccountably, it hides what it might reveal. As light and shade alternate across the form of the painting, it is hard at first glance to perceive whether the shifts are caused by changing planes, varying textures, or some unregarded object casting its shadow. Yet the light and shade are expressions of a more profound duality.
—(J. M. Nash, *The Age of Rembrandt and Vermeer* Phaidon Press, 1972)

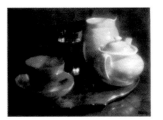

CHIAROSCURO ON THE COMPUTER

Shading with values of light and dark is also done in computer 3D, using algorithms that calculate the effects of lights placed in a 3D "scene," taking into account the color, intensity and direction of the lights as well as the surface properties and reflectiveness of the objects in the scene. In the same way as traditional chiaroscuro, the calculations made by the computer "reveal" the objects in a model by shading them.

GOING BEYOND ACCURACY

The moodiness of a chiaroscuro treatment can sometimes be captured in photography, particularly when a subject is lit by a single light. Around the turn of the century, in fact, the members of the Photo Secessionist movement sought to lessen the "wealth of trivial detail" that photographs could capture and instead used different printing techniques to produce photographs that looked more like paintings than photos.

In the new art of computer 3D imaging, the limits of memory and programming capability mean that light and shadow and the modeling they create are less sophisticated than in painting or photography, with tones and the transitions between them sometimes appearing more harsh. However, the crisp, hard-edged look that often results in computer 3D shares in the aesthetic of the Super Realist school of painting that developed during the 1960s. This way of painting exaggerates trivial detail to produce images that are even more "realistic" than the real world. (For an example of a 3D rendering in super realist style see the motorcycle on page 98.)

At the same time, various techniques can be used to soften the effects of light and dark in a 3D image—both

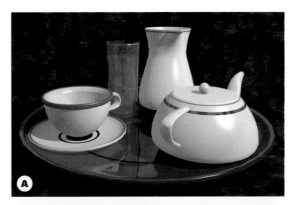

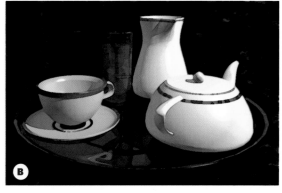

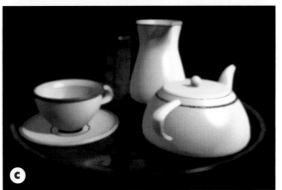

before and after rendering—so that it looks less like a digital image and more like a painting of the old school. One can use atmospheric effects in the model or edit the rendered image afterward with filters. (We describe more techniques for achieving a "painterly" look with 3D in "Applying filter Effects" on page 158.) In either case, the world of feeling and style in 3D imagery is just beginning to be explored.

From plain to fancy
To explore the use of chiaroscuro in computer 3D we used clip art in Ray Dream Designer to assemble a still life similar to the photo above. Using a single point light source, we made a rendering that clearly delineates the forms but lacks charm or emotional content (**A**). 3D renderings often tend to be rather utilitarian (similar to product photos in a catalog, for example) rather than aesthetically pleasing. However, renderings can be modified in an image editing to add a more artistic touch. To create a more dramatic "photo realist" treatment we increased the contrast and saturation and applied Photoshop's Watercolor filter (**B**). To create a softer, more glowing version, similar to the Kuehn photograph above, we increased the contrast, applied a Gaussian blur and applied the Paint Daubs filter (**C**). Some 3D programs, including Designer, also make it possible to add filtered effects during the rendering process.

Looking Through a Black Box

THE CAMERA OBSCURA AND THE CAMERA LUCIDA AS EARLY DRAWING AIDS

The camera is one of the greatest aids to drawing ever invented. The camera does such an excellent job of translating real world objects into flat images on paper, that after the invention of film-based cameras in the 19th century, artists largely abandoned the task of representational art to develop the more subjective styles of Impressionism and Expressionism.

But early cameras, without film, had been used by artists since the Renaissance as mechanical aids to drawing. One of the early precursors of the modern camera is the *camera obscura*, from the Latin words for "dark chamber." This devise is a darkened box or sometimes a darkened room with a small opening in one wall containing a double convex lens. Images outside the box are projected onto the interior wall opposite the lens.

A related device, called a *camera lucida* ("light chamber") is an instrument in which the rays of light from an object or scene pass through a special prism and are reflected downward onto a piece of paper placed under the devise. In this way, an artist can trace the contours of the objects being reflected. Many historians believe that the Dutch artist Jan Vermeer (1632–1675) used a *camera obscura* or *lucida* to project scenes in his house onto a canvas for tracing. Vermeer's paintings display not only very accurate perspective, but also include highlights or blobs of light and also unfocused areas, both of which appear to be artifacts of the lenses he used.

Computer 3D images can be used in the same way, not only as images in themselves, but as guides for painting or drawing. For more information see "Using 3D Images as References" on page 156.

20th Century Vermeer

Vermeer excelled at realistic scenes of everyday life, especially interiors in which everyday people and things were transformed by light into extraordinary objects. *The Music Lesson* (or *Lady and Gentleman at the Virginals*) shows a room in Vermeer's own house and is one of several paintings made in that room that have fascinated art historians, who have speculated that Vermeer used a *camera lucida* to aid his rendering of perspective. Certainly his paintings have a modern, photographic quality

Researchers at Cornell University's Program of Computer Graphics created a 3D graphics model of Vermeer's room to illustrate a scientific paper ("A Two Pass Solution to the Rendering Equation: a Synthesis of Ray Tracing and Radiosity Methods" by John R. Wallace, Michael F. Cohen and Donald P. Greenberg, 1987).

In addition, Professor Phillip Steadman of The Open University in England built a physical model of the room and furnished it with paintings, objects and mannequins in period dress to produce a photograph that closely resembles Vermeer's painting. An article by Steadman describing his work ("In the Studio of Vermeer") appears in *The Artful Eye* (Gregory, Harris, Heard and Rose, editors) published by Oxford University Press in 1995. All the images shown on this page were taken from World Wide Web sites maintained by Cornell University, Professor Steadman and aficionados of Vermeer.

Physical model of *The Music Lesson* constructed by Phillip Steadman of the Open University, England

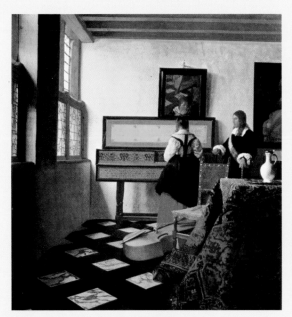

The Music Lesson by Vermeer, 1662–65 (in the collection of Buckingham Palace, London)

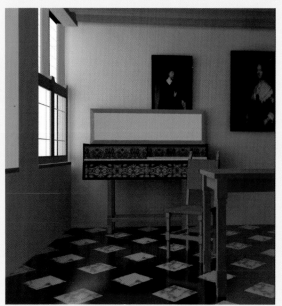

Computer rendering of *The Music Lesson* made at Cornell University

ATMOSPHERIC PERSPECTIVE

Another key to depicting three-dimensional reality is the fact that our eyes perceive distant objects as less clear and distinct than those in the foreground. Near objects look sharper and more focused than those that are far away. Also, objects in the distance look bluer and more monochromatic than foreground objects, which have brighter, richer colors. This blueness is often seen in landscapes, both real and painted, in which distant hills, for example, are rendered in soft blues, in contrast with the brighter greens and browns of foreground features. Atmospheric perspective was first described and named by Leonardo da Vinci, who called it *aerial perspective.*

WHY DISTANT OBJECTS ARE BLUE

Distant objects look blue for the same reason the sky looks blue—because blue light is scattered by the atmosphere more easily than light of redder colors. The white light that comes to us from the sun contains a whole rainbow of colors, which we can see when light is passed through a prism. But the light from the blue end of this rainbow spectrum has shorter wavelengths than does light from the red end. So blue light is more likely to be scattered or deflected by the particles of oxygen, water and dust in the atmosphere. In a way, the whole atmosphere acts like a prism, but because of the match between the short wavelengths of blue light and the small size of the atmospheric particles, the blue light gets deflected the most. This scattering of blue light occurs throughout the atmosphere, so that when we look up at the sky we see blue light coming to us from all directions.

In addition, when we look at distant objects we are looking through more atmosphere than when we look at near objects. So we are receiving more blue light (from

Getting bluer and bluer
This photo of the coastline of northern Italy shows five hillsides jutting out into the Mediterranean. The hill closest to us is full of rich color, with sharp focus and detail. But though the plants and rocks on each hillside are essentially the same, each distant one appears less saturated, less focused, less detailed and bluer as the hills recede away from the viewer. (Photo by Janet Ashford)

the atmosphere), along with the reflected light showing the color of the objects themselves. So distant objects tend to look bluer. The further away they are the bluer they look.

WHY DISTANT OBJECTS LOOK FUZZY

In addition to creating a blue tone, the scattering of the blue light rays coming to us from distant objects means that they look less focused than near objects, whose light rays travel through less atmosphere on their way to our eyes.

Most computer 3D programs include atmospheric controls (sometimes called fog) that mimic the effects of aerial perspective. A blue haze may be applied to the more distant objects in a model (controls allow the user to specify the starting and ending position of the fog) or may also be applied to the foreground as well, to imitate the technique of *sfumato.*

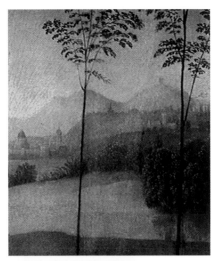

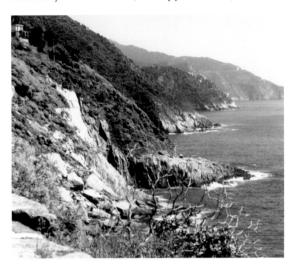

Creating a poetic vision
In addition to acting as an important depth cue, mist and soft focus can also be used by artists to create emotional effects. Writing of Leonardo da Vinci in his *History of Art* (Prentice-Hall and Harry N. Abrams, 1962), H. W. Janson describes his use of these techniques in the painting *The Virgin of the Rocks*: "Here the figures emerge from the semidarkness of the grotto, enveloped in a moisture-laden atmosphere that delicately veils their forms. This fine haze (called *sfumato*) ... lends a peculiar warmth and intimacy to the scene. It also creates a remote, dreamlike quality and makes the picture seem a poetic vision rather than an image of reality pure and simple." In this case, the artist has applied a haze even to objects that are closer to the viewer.

A similar effect can be seen in another painting of the Virgin by da Vinci, shown above. In a detail of the landscape, we can see clearly the artist's use of blue paint and soft focus to indicate the distance of the far mountains.

"FICTIVE SPACE"

Through the use of rational systems of perspective along with the emotional values created by the depiction of light and atmosphere, Renaissance artists were able to create a *fictive space* in their landscapes and backgrounds that not only provides a convincing imitation of reality, but that evokes feelings of awe, wonder and pleasure in the viewer. Desktop 3D programs employ all three traditional techniques (perspective, chiaroscuro and atmospheric depth cues) as well as other monocular depth cues (occlusion, size differences and texture gradients) to create renderings that imitate reality, and in skilled hands 3D graphics can also be used to create images that touch the emotions.

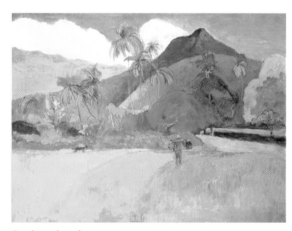

Breaking the rules
One of Gaughin's paintings of Tahiti manages to create a convincing fictive space while violating many of the usual cues. For example, while he does make use of naturalistic size differences and occlusion, Gaughin painted both foreground and background objects with equal detail and saturation, choosing to dispense with the visual cues of atmospheric perspective. As a result, the painting is both a realistic landscape and a flat, decorative surface. 3D graphics images can be modified with filters to achieve similar effects.

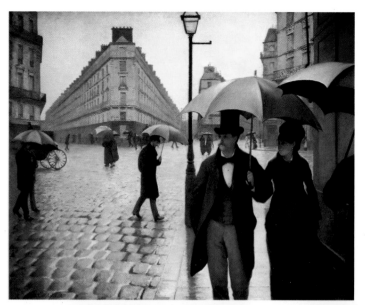

Creating a sense of place
The Impressionists painted over 300 years after the height of the Renaissance, yet they employed the representational techniques developed by the earlier masters (or else played off tradition by breaking the rules). *Paris Street* (left) was painted by Caillebotte in the late 1800s and provides a beautiful example of depth and a sense of place using all the monocular depth cues described in this chapter. The artist's use of a texture gradient on the street is especially striking, as is the dramatic use of size differences (among the pedestrians with umbrellas) and atmospheric perspective.

The eerie towers in our 3D rendering (below) show occlusion, size differences and atmospheric perspective, even though the model itself is quite simple. The techniques of representing depth that artists have used over the centuries, including the logic of perspective, are built into today's 3D programs. But we can still learn from the masters how to apply those techniques imaginatively to create a unique sense of place in computer generated images.

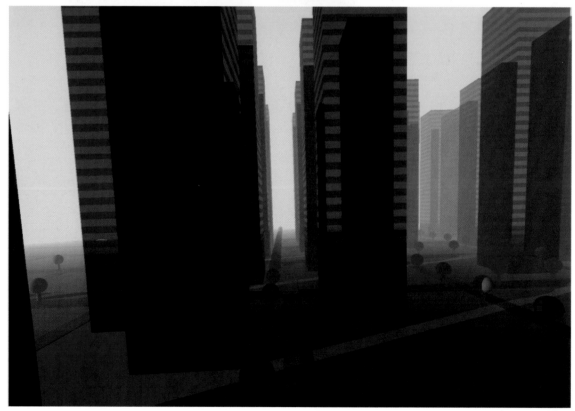

3 | The Basics of Desktop 3D

The 3D Modeling Process

MODELING STEP BY STEP

Now that you've seen how desktop 3D is related to the rest of the art world—and discovered what beautiful effects can be achieved—you may be eager to get your hands on some 3D software. But here's a mild word of caution: go slowly, don't take on too much at once, be prepared to use patience and perseverance to learn this new skill. If you're already proficient in creating 2D art with computer graphics programs, then you are a large step ahead. But in creating three-dimensional art on a computer, you will be dealing with virtual objects and scenes which are created and manipulated in a virtual 3D "space," which can take some getting used to.

In this chapter we will describe the basic components of the desktop 3D process, in the order they would usually be performed. These include: creating and arranging 3D objects; operating in 3D space; applying color and texture; lighting the scene; viewing the scene with cameras; and rendering the image. By explaining each component we will be providing an overview of the whole process of computer 3D as well as providing a step-by-step guide for approaching a particular 3D project. In addition, we'll be providing you with a tutorial that can be used with any software.

Almost starting from scratch
This image looks sophisticated but it was created easily and fairly quickly by assembling a cast of 3D "clip art" objects along with shapes made with primitives tools. In the course of this chapter we'll demonstrate how scenes like this one can be assembled and how they can be varied with different textures, lighting and camera views.

CREATING A DEMONSTRATION MODEL

To demonstrate each step of the 3D process, we will be working with a model constructed of a combination of 3D clip art and primitive shapes. We'll arrange the objects into a kind of still life, create background textures, apply ready-made surface textures, light the scene, capture views of it with various cameras and render the model into images. All of these processes are described in more detail in later chapters, but for now we'll work with the simple, preset features that most programs include.

You may want to join us by using your own software and some 3D clip art to create a demonstration model. You'll need a full-featured 3D program such as Ray Dream Designer, Strata StudioPro, Infini-D or form•Z. You'll also need some 3D "clip art." Most 3D programs come with at least a small collection of ready-made objects, while some include hundreds. 3D clip art is also available on CD-ROM from many sources. (See Resources on page 166.)

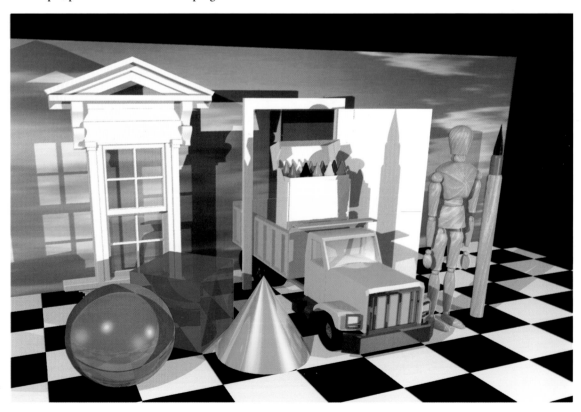

Genius is nothing but a great aptitude for patience.
—Georges Louis Leclerc de Buffon (1707–1788)

LEARNING YOUR PROGRAM

The basic components of 3D modeling and rendering are included in all full-featured desktop 3D programs, although each program provides a slightly different interface, with its own tools, methods and terms. For example, different programs give different names to the 3D "space" in which models are constructed: it might be called the "scene," the "universe," or the "world." If you are new to desktop 3D, you might want to start by going through the tutorial that came with your program. This will give you an idea of how your particular software handles modeling, surface mapping, lighting and so on and the terminology it uses. You could then try creating a still life like the one in this chapter and follow along as we develop it through each step. As you work along with us, you'll be creating your own illustrations to match each of the ones in this chapter.

It may seem intimidating at first, but the best way to become comfortable with desktop 3D is simply to plunge in. Don't try to meet an illustration deadline with your first project. But do set aside time to explore, play around and learn. Don't be discouraged if your first attempts are frustrating. Learning desktop 3D is a little like learning to ride a bike or drive with a stick shift. There will be lots of starts and stops at first, but eventually you'll get the hang of it.

CREATING 3D MODELS

The first step in computer 3D imaging is to create a *model.* Typically, a model is a collection of 3D objects, either geometrical or freeform, which are arranged together in a scene of some kind. It is these objects to which texture maps and surface properties will be applied and these objects which will, depending upon their shape and properties, absorb or reflect the light that is directed towards them. When a camera is positioned in the scene, its view of the model's objects will be used to create the final rendered image.

CREATING OBJECTS

The objects in a model can be of several types: geometric primitives, such as cones, cubes and spheres; extruded shapes, such as 3D type or molding; lathed shapes, such as goblets or lamp shapes; or freeform shapes, such as leaves or fish.

PRIMITIVES AND MACHINED OBJECTS

In general, the manufactured objects in our environments, especially those made of rigid materials, tend to be composed of primitives and extruded or lathed shapes. That's because manufactured items are produced using machines that use real world processes of extrusion and lathing.

FREEFORM OBJECTS

Objects in the natural world (and some human-made objects manufactured with plastic materials) tend to be composed of freeform shapes. In Chapter 4, Creating 3D Objects, we'll explain the creation of all these types of objects. But for now, we'll be using only primitive shapes and ready-made objects that contain more complex shapes.

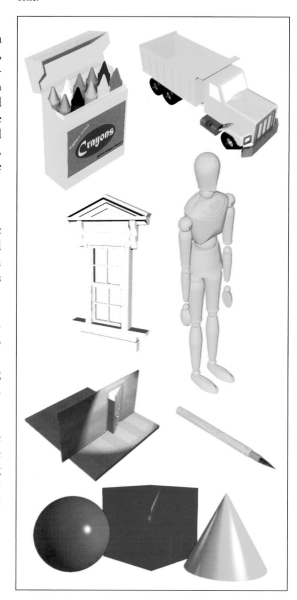

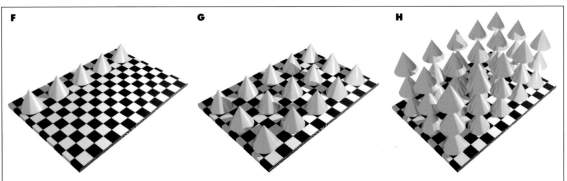

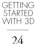

Scaling

A 3D object, such as the cube at the far left (**A**), can be scaled proportionately (made smaller or larger equally in all three dimensions) (**B**) or can be scaled in one or two dimensions only. We made our cube 200% bigger than the original in the x (width) dimension (**C**), 200% bigger in the y (height) dimension (**D**) and 200% bigger in the z (depth) dimension (**E**).

MANIPULATING OBJECTS

Objects that have been created in a 3D program can be manipulated in ways that are very similar to the transformations used in two-dimensional graphics programs such as Illustrator or FreeHand. For example, 3D objects can be positioned, scaled and rotated. The main difference between 2D and 3D transformations is that in the 3D environment these operations include the third dimension of depth, as well as in the familiar two dimensions of height and width. (For more information on the 3D environment see "Where Am I" on page 29.)

As in many 2D drawing programs, most 3D programs make it possible to duplicate 3D objects, some programs enable duplication with symmetry (so that you need model only one half of a symmetrical object) and most programs allow you to duplicate along with other transformations to create a step-and-repeat sequence.

ROTATION OF OBJECTS IN 3D SPACE

With all three dimensions in play, 3D objects can be rotated through space in an infinite number of directions, just as a stick thrown to a dog can twist and turn as it flies along its path. Most 3D programs allow users to specify rotation around the x, y and z axes separately, either by entering values for degrees into a dialog box or palette, or by clicking on arrow keys. Some programs also include a "joystick" type of tool which allows rotation of objects in all three dimensions at once. (For more detailed information on transformations see "Transforming Objects" starting on page 66.)

Ray Dream Designer employs the terminology used for the orientation of airplanes in flight to describe and control the rotation of 3D objects: yaw, pitch and roll.

Duplicating

We created a yellow cone using a primitive tool, then duplicated it and moved the duplicate to the right. With the duplicate still selected, we duplicated again and this time a second duplicate was created and automatically moved to the right in the same way we had moved the first duplicate. By duplicating two more times we created a row of five cones (**F**). (Many 3D programs feature this type of "memory" which makes it possible to duplicate an object along with transformations such as rotation or positioning.) We grouped the row of cones and duplicated the row twice to create a two-dimensional grid of cones (**G**). To create a three-dimensional grid (**H**), we grouped the three rows of cones and then duplicated the group twice.

Rotating

Rotation can occur around any of the three major axes (x, y and z) separately or in combination. Try using the movement of your own head to get a feel for rotation in 3D space.
X-axis rotation
When you nod your head forward or back (as when saying "yes") you are rotating it around the horizontal x axis. This type of rotation is also call *pitch* in aeronautical terminology. Think of a pitcher pouring milk or the expression "pitch forward" (**I**).
Y-axis rotation
When you keep your head upright and turn it from side to side (as when saying "no") it's rotating around the vertical or y axis. This motion, like a door swinging on its hinges, is also called *yaw* (**J**).
Z-axis rotation
When you tilt your head from side to side (as when trying to touch your ear to your shoulder), it's rotating around the horizontal z axis. This is also called *roll* (**K**).

*Perseverance is more prevailing than violence; and
many things which cannot be overcome when they are
together, yield themselves up when taken little by little.*
—Plutarch (46–120)

COMBINING OBJECTS

Everyday objects, such as a coffee cup or a doorknob, often consist of a combination or group of shapes of different types.

GROUPING AND LINKING

Desktop 3D programs help us to model these objects by making it possible to group simpler 3D objects together to form a unit that can be moved and transformed as a whole. In addition, some programs make it possible to link elements together so that they can be transformed without affecting other parts of the model. Grouped or linked units, in turn, can be grouped and linked together to form complex items composed of many subgroups, such as a bicycle composed of frame, wheels, pedals and handles. For more information see "Organizing Objects Within a Model" on page 83.

ALIGNMENT

To help with the alignment of multiple objects, 3D programs usually include alignment functions similar to those in PostScript illustration programs. These make it possible to align objects along the x, y or z axes using their centers or other spots as reference points. Some programs also make it possible to distribute a group of objects so that they are evenly spaced along any of the three axes. For more information see "Measurement, Alignment and Grids" starting on page 76.

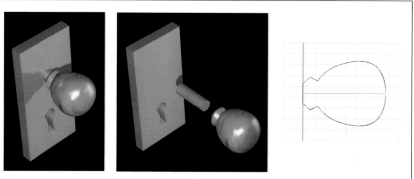

The sum of its parts
The sumi brush in our model is made of three simple objects. The handle is a cylinder with a wood texture, the grip piece is a tapered cylinder and the brush tip is a lathed object created by rotating a curved line around a center axis. A texture map makes the smooth brush object look like it is composed of hairs. In the same way, the door knob on the door in our model is composed of a faceplate made of an extruded shape containing a "hole," a cylinder and a lathed knob. The box of crayons is made up of several edited cubes plus crayons that are differently colored copies of a lathed shape. (Profiles of the lathed objects are shown in Ray Dream Designer modeling windows.)

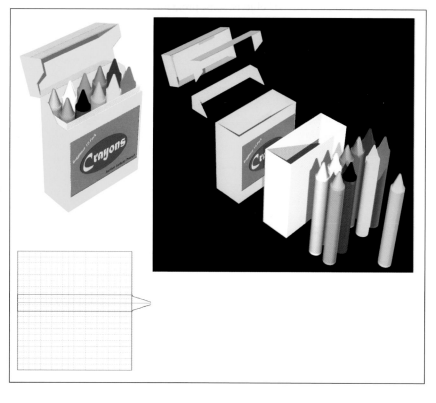

VIEWING THE 3D WORLD

Now that we have assembled some objects for a still life, seen how they can be transformed (scaled, rotated, positioned) and discovered how they were constructed, our next task is to assemble them into a well-composed and interesting tableau. To do this along with us, you'll need to become familiar with your program's way of presenting 3D models on the screen. But first, let's review some of what we learned about perspective in Chapter 2, "The World of Three Dimensions."

PERSPECTIVE IN COMPUTER 3D

For artists of the Renaissance and after, the creation of realistic paintings, especially those involving architectural elements, could involve a rather laborious process of sighting along perspective grids. But the problem of perspective is easily solved for the artist who works with computer 3D software, since correct perspective views of 3D objects are automatically calculated.

CONVENTIONAL PERSPECTIVE VIEWS

The on-screen view in many 3D programs imitates the grid systems devised by earlier artists, showing height, depth and width in a very graphic way. All objects in a 3D model are placed within this "space." When using a *perspective* view, objects in this area (sometimes called a *universe* or *world*) will appear to vary in size and position depending upon their distance from the viewer's eye, represented by the camera viewpoint.

ORTHOGRAPHIC VIEWS

But in addition to the so-called perspective view, 3D programs also offer *orthographic* views. These are the flat

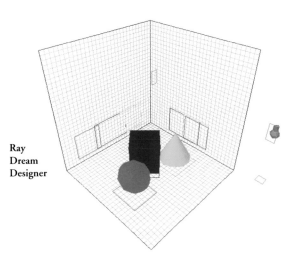

Ray
Dream
Designer

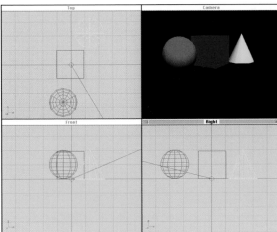

Infini-D

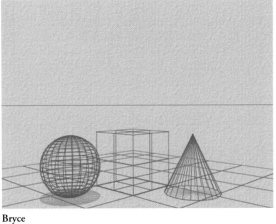

Bryce

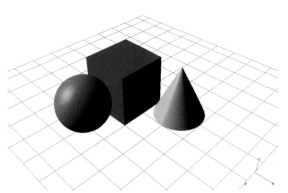

Strata StudioPro

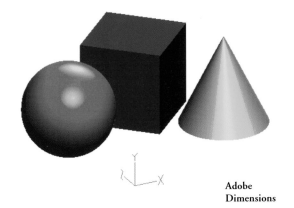

Adobe
Dimensions

Looking into space
Each 3D program presents 3D space in a slightly different way. The views here show the same model of three primitives as seen in the default perspective view in five different programs.

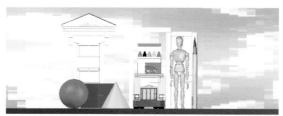
Front

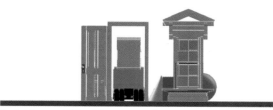
Back (shown with backdrop removed)

views of front, back, left, right, top and bottom that can be a great help in the alignment of objects.

The word "orthographic" combines the Latin words for "straight or right" and "writing" to indicate that in orthographic projections, objects are at right angles to the line of vision. Orthographic projections are commonly used in house elevations; for example, to show all sides of a house. In any orthographic view, there is no perspective, no receding of lines to a vanishing point. Parallel lines remain parallel, objects do not become smaller as they move away and the absolute dimensions of objects are preserved. As a result, these views are the best for aligning objects.

Many 3D software manuals recommend that you check the positioning of objects using at least two orthographic views during the construction of a model. Objects can appear to be lined up in a side view, for example (yes, all the animals are on top of each other in the totem pole) and still be out of alignment from a top view (uh-oh, each animal is hovering over a different area of the ground). So it's a good idea to keep more than one view window open while modeling (if your program and monitor screen size will allow this), or to shift back and forth between views often; for example, from *front*, to *side*, to *perspective*.

Right

Left

Orthographic views
Our tutorial model (see page 21 for a full rendering) is shown here in the six orthographic views commonly used in desktop 3D. All of the views were rendered in simple Gouraud shading, as they might be seen while working on-screen. By looking at all views we get a clear grasp of the position of all the objects in the model.

Top

Bottom (shown with floor removed)

There exists: first, the unchanging form, uncreated and indestructible, admitting no modification and entering no combination, ... second, that which bears the same name as the form and resembles it ... and third, space which is eternal and indestructible, which provides a position for everything that comes to be.
—Plato, *The Timeus*, 20

DIFFERENT KINDS OF GEOMETRY

GEOMETRY FOR ARTISTS

Projective geometry was developed during the Renaissance to help painters represent figures, buildings and landscapes in perspective. In projective geometry, solid forms are "projected" upon a picture plane with the aid of mechanical devices or grids (see "The Science of Drawing" on page 13) or by using a *camera obscura* (see "Looking Through a Black Box" on page 18).

GEOMETRY FOR DRAFTERS

Descriptive geometry, developed by Frenchman Gaspard Monge (1746–1818) aims to represent solid objects in order to understand their forms, dimension and position. This type of geometry is used in drafting and architecture and employs orthogonal projection (as opposed to linear projection involving a vanishing point) in which the parallel lines and planes are drawn so that they remain parallel rather than converging on a visible or invisible vanishing point.

GEOMETRY FOR MATHEMATICIANS AND PROGRAMMERS

Analytical geometry, developed by René Descartes (1596–1650) creates a synthesis between geometry and algebra so that points, lines, planes and solids can be described with algebraic equations. This makes it possible to represent 3D shapes as numbers in a computer.

GEOMETRY FOR COMPUTER 3D

The modern art of computer 3D graphics makes use of all three types of geometry in order to algebraically describe complex objects within a computer memory in way that makes it possible to create, assemble and render them to produce two-dimensional objects that employ the representational techniques of Renaissance painters.

ISOMETRIC PERSPECTIVE

An *isometric* perspective is a particular variety of orthographic projection. An object, such as a cube, is shown in a way that's similar to conventional perspective (with more than one of its sides visible, for example) but with a difference. All three of the principal axes (x, y and z) are at equal angles to the picture plane. So, all the edges and surfaces of the object which are parallel to the principal axes can be measured with the same scale, without distortion. This type of projection is commonly used in technical drawings (for example, the illustrations that accompany a manual for putting together a toy requiring assembly). In this case the goal is not to mimic natural perspective (to show how the object looks in the real world) but to clearly demonstrate its parts and how they fit together. Again, the positioning of objects in a 3D model may be easier in an isometric view.

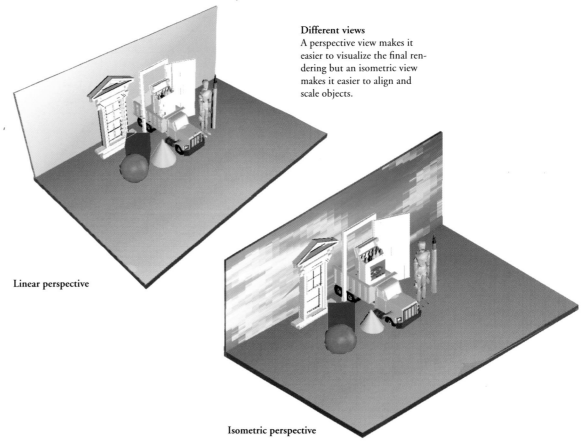

Different views
A perspective view makes it easier to visualize the final rendering but an isometric view makes it easier to align and scale objects.

Linear perspective

Isometric perspective

Where Am I?

DESCARTES AND X, Y AND Z

Computer programmers use the conventional mathematical method of describing points, lines and planes in space, which is called the *Cartesian coordinate system*, named for the French mathematician and philosopher René Descartes (1596–1650). In this system, points on a two-dimensional surface are located by using two perpendicular axes (or lines) called the *x* axis (horizontal) and the *y axis* (vertical) which cross each other at a point defined as zero. In geometry, the *x* axis typically represents width, while the *y* axis represents height. Each axis includes both positive and negative numbers, extending in both directions on either side of zero, with positive *x* numbers to the right of zero and positive *y* numbers above zero. The location of any point in two-dimensional space can be defined by two numbers, which are its *x, y* coordinates.

Points in three-dimensional space are located using a three-axis system in which a *z axis*, perpendicular to both the *x* and *y* axes, is added to represent depth. The resulting "space," which is used to contain and describe solid mathematical objects (such as cubes and spheres) is part of the Cartesian system, but it is also sometimes referred to as the *Euclidean geometry model* (named for Euclid, a mathematician from Alexandria who lived around the year 300 B.C.).

Euclidean space is defined by the *Oxford English Dictionary* as "the kind of space actually known to us,"

(as opposed to hypothetical spaces in which some of Euclid's axioms of geometry are rejected), so our intuitive knowledge of 3D space in the real world can usually be transferred to our interaction with the virtual space of computer 3D.

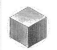

WHICH WAY IS UP?

In the traditional model for Euclidean space the *x axis* represents width, the *y axis* represent height and the *z axis* represents depth. However, not all 3D programs use this convention. Below are diagrams of some of the commonly used conventions. (In this book we employ the traditional Euclidean terms, except when describing a model built in a program which uses a different system.)

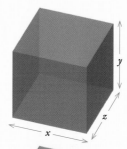

x axis = width
y axis = height
z axis = depth

This system is used by Adobe Dimensions Strata StudioPro Bryce

x axis = width
y axis = depth
z axis = height

This system is used by Infini-D

x axis = depth
y axis = width
z axis = height

This system is used by Ray Dream Designer

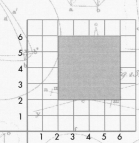

Plotting in 2D space
The size and location of a square can be described in two dimensions using the Cartesian coordinate system. The convention is to give the *x* coordinate first and the *y* second. Starting in the upper left and continuing clockwise, the location of the corner points of the square in the graph above can be given as (2, 6), (6, 6), (6, 2) and (2, 2).

Plotting in 3D space
By adding a *z axis* to the 2D grid, we can now describe the size and location of a cube in 3D space. The coordinates are given in *x, y, z* order. The corners points of the cube face on the right, starting with the closest upper corner and working clockwise, can be defined as (4, 4, 2), (4, 4, 4), (4, 0, 4) and (4, 0, 2).

Coloring, Lighting and Viewing

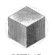
APPLYING SURFACE MAPS

Color and texture tell us whether a sphere is an orange, a tennis ball, or the moon. Desktop 3D programs make it possible to apply an infinite number of colors, textures and surface properties such as reflectance and transparency to all the geometrical objects in a model. All together, these attributes are called a *surface map*. Most programs come with built-in surface maps and these can be edited to produce custom surfaces. The computer calculates how every aspect of a surface map interacts with light to produce renderings that look very close to real world objects.

Surface maps are the 3D designer's first choice for modeling surface detail because they not only add realism, but they reduce the time spent in modeling and rendering. It's easier to apply a brick wall texture to a cube, for example, than to build a wall of many separate bricks.

ELEMENTS OF A SURFACE MAP

Surfaces maps are made up of several different elements. These are combined to duplicate the properties of natural surfaces. Surface map elements or *channels* include:

COLOR OR TEXTURE

This can be a solid color, a computer-calculated pattern such as stripes (also known as a *procedural texture*) or a scanned image of a real surface, such as grass or wood (also known as an image-based *texture map*).

BUMP MAP

A bump map is an image with light and dark areas that produces the effect of bumps on the object's surface, such as the pits in orange peel or the holes in Swiss cheese.

REFLECTION

Reflection channels can define how highlights behave and how shiny a surface is.

TRANSPARENCY AND REFRACTION

Transparency can be set between 0 and 100 to produce surfaces that are completely transparent, completely opaque, or any translucent value in between. An index of refraction can also be set so that a transparent object will appear to bend light in the same way that natural translucent objects do. All of these aspects of surface maps are explained in more detail in Chapter 7, "Designing Surfaces," beginning on page 101.

WAYS OF APPLYING SURFACE MAPS

Surface maps can be applied to objects in different ways, depending upon the shape of the objects. Mapping methods include, for example, straight or planar mapping in which the texture is applied so that it appears on all the outside and inside surfaces of an object, or spherical mapping, in which a surface map is wrapped around an object like paper around a balloon.

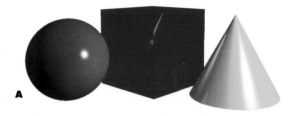

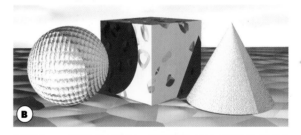

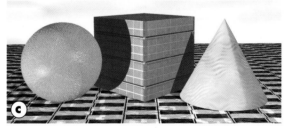

Shifting surfaces

Changing a surface map radically changes the appearance of an object. We started with the three primitive shapes in our basic model and applied simple glossy colors (**A**). Bump maps for wicker, Swiss cheese and shag carpet were applied to the sphere, cube and cone respectively, with a reptile skin bump applied to the ground plane. Combining a muted cream color with all four bump maps clearly shows the appearance of the raised and lowered surfaces (**B**). Texture maps that imitate real surfaces usually combine a bump map with an appropriate color map, often scanned from a real world surface. We used ready-made surface maps for orange peel, brick wall, wood and linoleum to transform our primitive shapes (**C**).

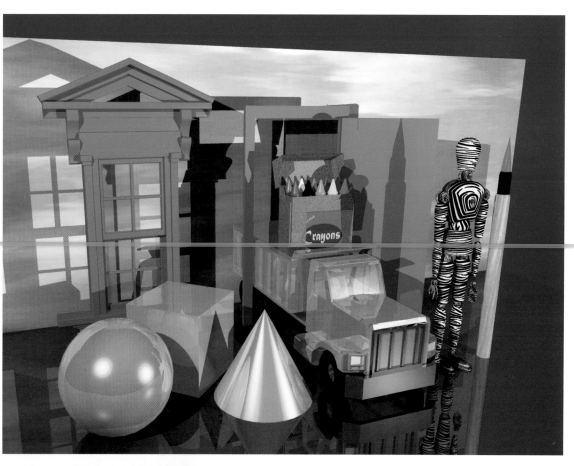

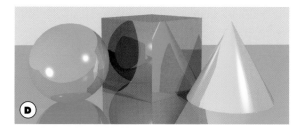

Changing properties

In addition to color and surface bumps, surfaces can be varied with regard to the way they interact with light. Using solid colors and no bump maps on our primitive shapes we created variations using high levels of reflection, shininess and highlight (**D**), high levels of transparency (with low reflection and highlight) (**E**) and high levels of glow (with low reflection and no transparency) (**F**).

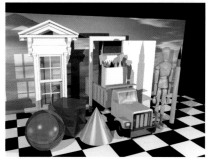

Alchemy at a touch

Starting with our original demonstration model (left), we changed the surface maps of all of the objects to create a new look. The mannequin was covered with zebra skin, the dump truck got a new, shiny paint job and chrome bumpers, the crayons were packaged in a cardboard box and the primitives, cast in solid gold, rest on a silver-plated ground.

LIGHTING THE SCENE

Lighting is essential to 3D graphics. Light sources must be present in order to create enough tonal value on objects to render the scene. Lighting also enhances the sense of depth in a scene and can be used to draw the viewer's attention to important parts of the model. Lighting can also be used to create a mood.

The light sources used in computer 3D are named for their real world counterparts and their use draws on the conventions already established in lighting for photography, filmmaking, television and theater. The virtual "light" cast by these sources is designed to behave like real light. It shines on objects, makes them look bright or dark, bounces off surfaces, or is absorbed or refracted.

TYPES OF LIGHTS

The four types of lights available in most 3D programs are ambient, directional, point and spot.

GLOBAL LIGHT SOURCES

Ambient and directional light spreads throughout a scene without emanating from a particular location. Ambient light is soft background light that does not cast shadows, imitating the reflected light that is usually present in a natural scene. Directional light (sometimes called global or distant light) imitates the type of light that comes from the sun. It is presumed to come from a source that is infinitely far away, so that all of its beams are parallel.

POSITIONED LIGHT SOURCES

Point and spot lights behave more like lamps, similar to the kind that are used in theater and film. They can be placed in a particular location and aimed to point in a one direction. A point light is similar to a bare light bulb. It emits light evenly in all directions. A spot light operates like its theater namesake. It can be aimed in one direction and its light spreads out in a cone-shaped area.

VARYING LIGHTS SOURCES

All light sources can be varied in intensity and color. Lights can also be varied in terms of fall-off, and positioned light sources can be varied as to location and direction. In addition, spots lights can be focused so as to have a large or small area of illumination, with hard or blurred edges.

Schemes of lighting

Starting with point lights to create a 3-point lighting setup, we positioned a bright key light to the left of the camera, a fill light (at half the strength of the key) to the right of the camera and a soft back light at the back of the model, in front of the backdrop (**A**). We then varied the lights to create several different effects. For a color variation, we colored the key light rich red, set it at 75% strength, colored the fill light deep blue, set it at 50% strength and deleted the back light (**B**). To create a dark, moody lighting setup we converted the key light from a point light source to a spot light, aimed it at the box of crayons and deleted the fill and back lights (**C**). To create a patterned light effect we set the key light to light blue, set the fill light to pale yellow and applied a gel with horizontal slats to the fill light (**D**).

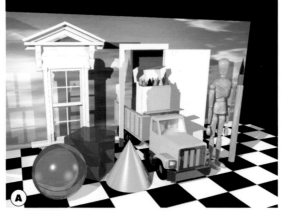

3-point lighting

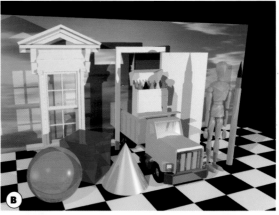

Colored light

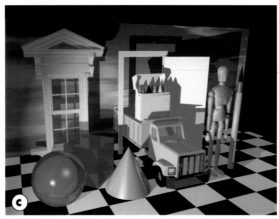

Moody lighting

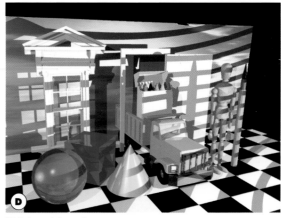

Lighting with a gel

LIGHTING THEORY

Photographers often use a system called 3-point lighting, using lights in three positions (the *key*, *fill* and *back lights*) to light an entire scene so that it is well illuminated, clear, but without distracting shadows. In computer 3D it's often a good idea to start with a 3-point lighting setup and then vary it to create special effects.

OTHER LIGHTING ELEMENTS

Most 3D programs provide gels, which are similar to the disks of patterned glass placed in front of theater lights. Gels can be used to cast patterned light onto a scene, such as the parallel stripes of blinds or the leafy pattern of foliage. For more detail on all methods of lighting see "Working With Lights" starting on page 128.

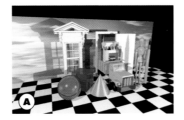

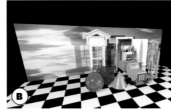

VIEWING WITH CAMERAS

Our view of a 3D scene is captured by a 3D "camera," which serves as the viewpoint. Most programs include a set of default views or cameras, for use during the modeling process (see "Viewing the 3D World" on pages 26–28). But it's also possible to view a scene through a custom camera, which can be located anywhere within the scene. In this way a single model can become the source of an unlimited number of images, as cameras can be moved and rotated into any position.

It's possible to set up several different cameras and toggle between views. It's also possible to move a camera along a path to create a series of shots that make up a "walk-through" of a model or an animation.

TYPES OF CAMERAS

The cameras used in computer 3D are designed to be similar to real world cameras and have similar names and properties. The three main types of cameras are named after their lens types: normal, wide-angle and telephoto. (Lens types are described in more detail in "Types of Camera Lenses" on page 140.)

MOVING AND CONTROLLING CAMERAS

In most 3D programs, cameras can be moved in the same way as other objects; for example, by dragging in a window, or by entering x, y, z coordinates in a dialog box. Cameras can also be rotated to point in a particular direction and some programs make it possible to link a camera with an object so that when the object is moved the camera will follow it. In addition, in Ray Dream Designer, 3D cameras can be moved in a way that's similar to the operation of motion picture cameras. For example, a camera can *pan* (rotate horizontally around its own center point), *dolly* (move in 360 degrees around the model) and *track* (move alongside a model). Cameras are described in more detail in "Working With Cameras" starting on page 140.

Changing lenses
Desktop 3D cameras are available with at least three conical lens types: normal (**A**), wide angle (**B**) and telephoto (**C**). Telephoto lens can usually be made to zoom in or out on a scene. Many programs also make it possible to create custom cameras with particular, specified focal lengths.

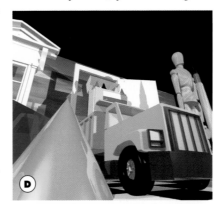

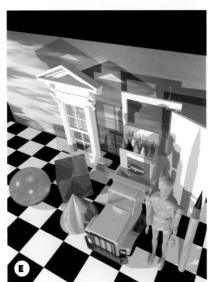

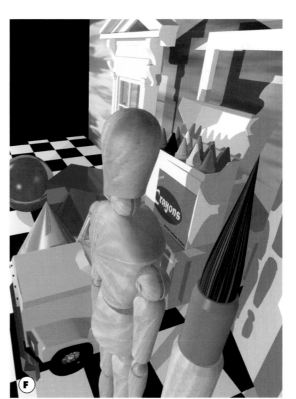

Differing viewpoints
Cameras can be placed virtually anywhere in a 3D model, to capture views that would be hard to duplicate in real world scenes. We used a low camera to create a worm's eye view (**A**) and a high camera to get a bird's-eye view (**B**). A camera placed at the right end of the model, near the mannequin, creates a very different view than that of the camera used for the view on page 22 (**C**).

RENDERING

Just as traditional painters use *chiaroscuro* or "light and dark" areas to create the illusion of modeled, solid forms, computer 3D programs use shading to apply light and dark values to the surfaces of opaque objects so that they look as though they are real objects illuminated by lights. Shading is made possible through a process called *rendering*, in which the computer makes calculations about the effects of lighting on the model. Rendering is the last step in the computer 3D process.

The rendering process produces a two-dimensional image of the model, taking into account three main elements: first, the "geometry of the model" including the position and orientation of all the objects relative to the camera; second, the surface attributes applied to the objects, including their color, texture, reflectance properties and so on; and third, the lighting environment, including the position, color, intensity and type of lights. The simpler the model, the faster it will render.

A model can be rendered any number of times. Each rendered image is saved as a separate file and does not effect the model file. A single model can be rendered from different camera viewpoints, or with different lighting setups, or with changes in surface mapping or even with changes in the geometrical objects in the model. This ability to make changes and variations in a model and produce multiple renderings makes it possible to create many different images from the same basic elements. There are various methods of rendering, which range from simple, fast and coarse to complex, time-consuming and detailed.

METHODS OF RENDERING AND SHADING

The ability to create "shading" in 3D computer art has evolved gradually over the past 30 or so years from simple flat shading methods to the very sophisticated ray tracing methods offered by most desktop 3D programs today. The simpler methods work faster and can be used to check the appearance of models before the time-intensive ray traced rendering. Following are some of the rendering methods included in desktop 3D programs.

BOUNDING BOX

In this method of display, each object in a model is shown simply as a rectangle drawn with lines at the appropriate size.

WIREFRAME

All the polygons making up the surfaces of the objects in the model are drawn with lines, almost as though chicken wire had been applied to them. In a wireframe view, there is no indication of lighting or color and no difference in display between solid objects and hollow objects.

WIREFRAME WITH HIDDEN LINES REMOVED

Some programs display true wireframe drawings (with all edges included) while some display wireframes with the hidden edges and surfaces removed. With hidden-line removal, wireframe objects look more solid and are easier to "read."

FLAT OR POLYGONAL SHADING

Each flat polygonal surface (such as the three visible faces of a cube, for example, or the small polygonal units making up the surface of a sphere) is colored with a single flat color. The brightness of the color is determined by the orientation of the polygonal surface toward the light source, so that polygons that are facing the light source will be brighter (lighter in color) than polygons that are facing away.

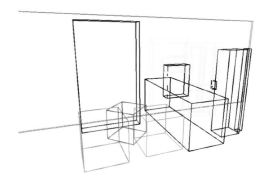

Bounding box

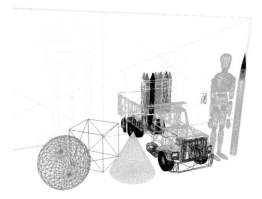

Wireframe

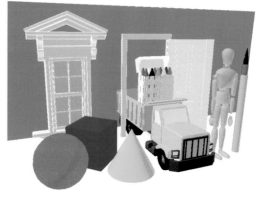

Flat or polygonal shading

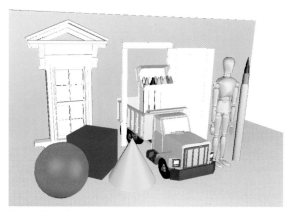

Gouraud shading

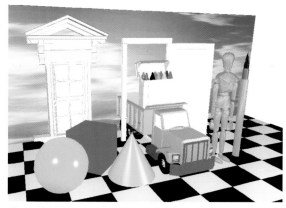

Phong shading

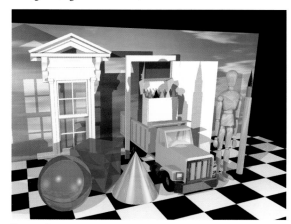

Ray tracing

Until the image is rendered, a three-dimensional scene is, technically, just an ugly pile of math.
—Don and Melora Foley, *Animation and 3D Modeling on the Mac* (Peachpit Press, 1995)

GOURAUD SHADING

This rendering method is named for Henri Gouraud, who proposed it in 1971. Its algorithm calculates the color intensity at the vertex (corner point) of each polygon making up the surface of an object and then uses these values to average the shading across the whole surface of the polygon. This is known as an *interpolation* method since shading values are determined by computing intermediary values between known values.

This rendering method creates a continuous transition of color across a surface so that objects look fairly smooth. Since adjacent polygons share some corner points, the transitions between them are smoothed. However, if the tonal value changes a great deal across a border shared by two adjacent polygons, there may be a banding effect.

Gouraud shading is fairly fast and is an efficient way to get a quick rendering of a model, in order to check color, shading and highlights. However, it does not render surface texture maps or create cast shadows.

PHONG SHADING

This method of rendering is able to compute specular reflections and was described by Phong Bui Tuong in 1973 as part of his doctoral thesis, *Illumination for Computer Generated Images*. It is similar to Gouraud shading in that it is based on interpolation, but values for reflected light are computed for each pixel in the image, resulting in a very smooth image and the ability to create shiny highlights. Phong shading can also calculate the effects of surface maps and in some versions it can create cast shadows. However it cannot render the translucence and refraction of materials like water and glass.

RAY TRACING

This method of rendering traces the path of each "ray" of light reaching the picture plane backwards through the model to determine whether it came from a light source, or was reflected off of an object, or was refracted through a translucent object. All these factors determine the color and intensity of each pixel on the surface of the model and permit the creation of photorealistic images that include shadows, depth of field, reflections and refractions. In a ray traced image, objects that are translucent (such as water or glass) really look translucent and objects that are hard and reflective (such as shiny metal or mirrors) contain reflections of other objects that are near them. The effect of texture maps and atmospheric effects such as fog can be seen in detail. Ray tracing requires intensive calculation and can take hours to complete for a complex model with many surface details and multiple lights.

In addition to straightforward ray tracing, some programs make it possible to add special filtered effects during the ray tracing process, to produce a more hand-drawn style.

How Computers Draw
PAINTING VERSUS DRAWING

There are two basic computer graphics formats, which differ in the way they encode visual information. In a "paint" or *bitmap* image, information is recorded as a map of tiny bits or *pixels*, much like a pointillist painting. In a "draw" or *vector* image, visual information is represented by equations that describe particular lines and curves and shapes and how they are to be colored and filled. Both formats are used in 3D graphics.

BITMAPS
The pixel is the basic unit of a computer image. It is a small square that forms part of a grid of thousands of squares. This grid is called a bitmap. On most computer screens, bitmaps are displayed at a resolution of 72 pixels (or "dots") per inch, so that each square inch area on the screen contains 5184 (72×72) pixels. At high magnification, a bitmap might look like a random pattern of differently colored squares. But viewed at a normal magnification, these tiny areas coalesce to form an image (just as a painting composed of small separate brush strokes might look meaningless up close but look like a recognizable picture from a suitable distance).

BIT DEPTH
The *bit depth* of a pixel refers to the number of computer bits of information assigned to it, which determines how many different colors it might be. In a 1-bit graphic, each pixel can be either black or white. In an 8-bit graphic, each pixel can be one of 256 shades of gray or 256 different colors. In 24-bit graphic, each pixel can be one of over 16 million colors.

BITMAPS IN 3D
Bitmapped images are always two-dimensional images. All scanned images are bitmaps and images created in so-called "paint" programs such as Photoshop or Painter are bitmaps. Bitmaps do not contain any logical information; that is, the computer does not know whether the image it displays is a square or a circle, a horse or a cow. It knows only what the color of each pixel is. Bitmaps are used in 3D graphics, but only as surface textures, such as a scan of real wood that might be applied to the surface of a model of a table.

VECTOR DRAWINGS
By contrast, in a "draw" image (sometimes called an "object-oriented" drawing) each line or shape is represented in the computer's memory as a mathematical entity, telling the computer that there is a certain two-dimensional object (a line, a curve, a closed shape and so on) located in a certain place. These 2D objects can be transformed (scaled and rotated) and moved independently, without affecting their neighbors.

POSTSCRIPT AND BÉZIER CURVES
Today most draw programs use the PostScript language, in which lines and shapes (also called *paths*) are described by a series of Bézier points connected by curves (or *path segments*). Unlike a curve drawn in a paint program (which is just a pattern of squares in a bitmap) a Bézier curve is a logical entity which can be precisely edited. When a Bézier curve segment is selected on-screen, its "control points" or vertices are highlighted. Each vertex point has a set of handles associated with it, which represent the tangent to the curve at that point. The two ends of this tangent line (the handles) can be moved in order to change the curvature of the path on either side of that point.

Bézier curves are *resolution-independent*, which means that they will be smoothly drawn at the highest resolution provided by the output device (the printer or imagesetter, for example) and are not limited to the resolution of the system on which they were created. However, in computer 3D even objects created without Bézier curves can be resized and will also render smoothly at any size. Most 3D programs provide tools for drawing Bézier curves. Shapes drawn this way can be transformed into 3D objects, by being extruded or by being lathed (see Chapter 4, "Creating 3D Objects").

Drawing versus rendering
An editable object drawn with a Bézier curve tool displays its characteristic handles and control points (**A**). In a typical screen display all lines segments are straight (**B**). However, in a rendering, the image is broken down into pixels (**C**). The curved edges appear smooth because of anti-aliasing, as shown in this blowup (**D**).

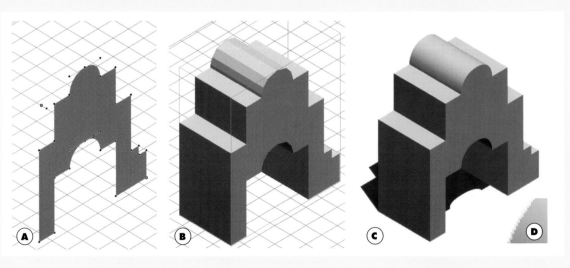

4 | Creating 3D Objects

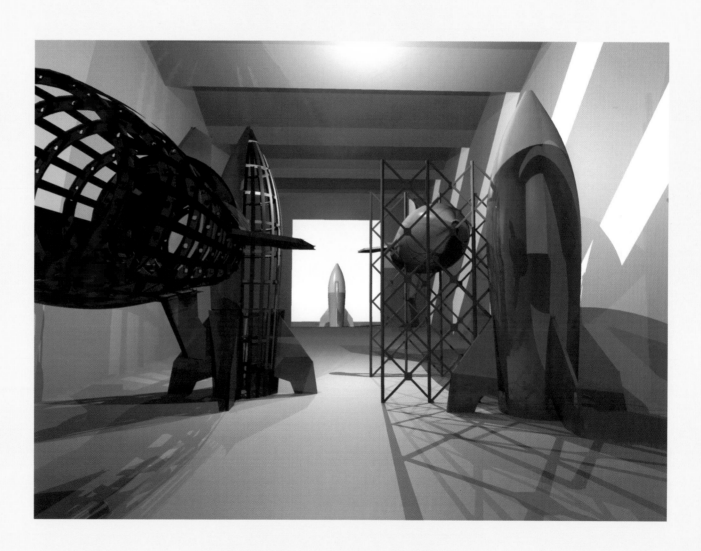

Using Geometrical Primitives

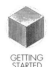
CUBES, SPHERES, CYLINDERS AND CONES

Virtually all 3D programs include ready-made shapes called "primitives," which usually include a cube, a sphere, a cylinder and a cone. These basic shapes are provided because they are the building blocks of so many other forms and common objects, both natural and human-made. In fact, the great French painter Cezanne believed that all forms in nature are based on the cone, the sphere and the cylinder. His goal in painting, according to art historian H. W. Janson was to "uncover the permanent qualities beneath the accidents of appearances." This search for underlying forms is one of the first and most useful approaches to develop as you work with 3D modeling. Learning to see the primitive shapes that make up complex objects will help you create models that duplicate reality in a convincing way. Using primitives is also efficient, since these objects require less memory than others.

PRIMITIVES ARE SMALL AND RENDER FAST

In most 3D programs, primitives take the least amount of memory and render the fastest of any objects. That's because primitives are described and generated within the computer using predefined programs that are part of the 3D software. So when you choose the "cube" tool in your program, for example, and use it to draw a cube, the shape is calculated by what's called a *procedural method*. Since these mathematical descriptions are "built in," primitives can be created and rendered quickly. So models constructed of primitives are especially efficient.

Sometimes other shapes are included as primitives in a 3D package. These include the torus (a doughnut shape), prism, cube with rounded corners and icosahedron (a regular icosahedron is made of 20 equal equilateral triangles, similar to a geodesic dome).

CUBE HEXAHEDRONS

SPHERE ELLIPSOID CYLINDER ELLIPTICAL CYLINDER

CONE ELLIPTICAL CONE

Drawing primitive shapes and variations
Primitive shapes are created in most 3D programs by selecting the appropriate tool (cube, sphere and so on) and either clicking in a window workspace to produce the shape (which will often be equilateral by default) or by clicking and dragging. Irregular primitives, such as a rectangular box or an elliptical sphere, are created by clicking and dragging to enlarge the shape in one dimension. In most Macintosh-based programs, holding down the Shift key while dragging a primitive object will constrain it to equal sides, while holding down the Option key will draw it from the center. In most Windows applications, holding down the Shift key works to constrain, while holding down the Alt key enables drawing from the center. For more precision, most programs also provide a dialog box for each primitive tool in which numerical values for height, depth, diameter and other dimension can be entered.

The shapes shown here were created in Adobe Dimensions and saved as Adobe Illustrator files. Screen shots of each model in wireframe mode show the construction of the shapes, in which curves are approximated by flat segments. These models were easy to make by simply clicking and dragging with the corresponding tool.

> *"When we mean to build,*
> *we first survey the plot,*
> *then draw the model ..."*
> —Shakespeare, *King Henry IV*

Starting simple

In most cases, primitive shapes are the starting point for other, more complex forms. But even unmodified primitives can be used effectively as elements for illustration, especially when the finished 3D image is edited in a paint program such as Painter or Photoshop. We started in Dimensions by creating a set of children's blocks, using the dialog boxes for the cylinder and cube tools to enter the dimensions of actual toy blocks. The finished model was rendered and then exported to Adobe Illustrator format. The Illustrator EPS file was opened in Photoshop, where the contrast was adjusted in Levels to lighten the color (**A**). We softened the edges of the image with the Gaussian Blur filter, applied the find Edges filter and increased contrast in Levels to saturate the color (**B**). We then inverted the image to produce an illustration with a glowing, neon effect and used it in a book cover (**C**). For more techniques on applying special effects to 3D renderings see "Applying Filter Effects" on page 158.

A

B

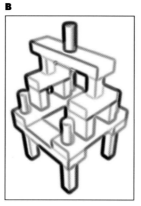

C

BUILDING BLOCKS
Day Care and American Business

THE ROYAL ROAD: A SHORT COURSE IN GEOMETRY

These definitions of basic geometrical shapes are adapted from the *Oxford English Dictionary* and the engravings are from *Heck's Pictorial Archive of Nature and Science* (a 1994 Dover Publications reprint of an 1851 original) and together they prove again the adage that a picture is worth a thousand words. It may take a little head-scratching to become reacquainted with geometry, especially if it's been a long time since your last high school class, but your efforts will be rewarded. As Euclid said in 300 B.C., "There is no royal road to geometry."

We've also included some of the examples given in the OED of common usage of geometrical terms, since these humorous passages provide an idea of how basic shapes can be used as metaphors, both in language and in graphics.

CUBE
from a Greek word for a die used for playing games
One of the five regular solids. A solid figure contained by six equal squares and eight rectangular solid angles. A regular hexahedron.

Mr. Benn's host never went on an expedition without a large carton of cubes, which he handed out generously to those Mongolians whose tents they visited.
—from an issue of *Discovery* magazine, August, 1935

CYLINDER
from a Greek word meaning "to roll"
A solid figure of which the two ends are equal and parallel circles and the intervening curved surface is such as would be traced out by a straight line moving parallel to itself with its ends in the circumferences of these circles.

His smiling face, taken in conjunction with the bottle of wine which he carried, conveyed to Gordon Carlisle the definite picture of a libertine operating on all six cylinders.
—P. G. Wodehouse, *Hot Water*, 1932

SPHERE
from a Greek word meaning "ball"
A figure formed by the complete revolution of a semicircle about its diameter. A round body of which the surface is at all points equidistant from the center.
Each knows little about what goes on in any other sphere than his own.
—J. H. Newman, *Sermons*, 1839

CONE
from a Greek word for a pine cone or spinning top
A solid figure or body, of which the base is a circle and the summit a point and every point in the intervening surface is in a straight line between the vertex and the circumference of the base.
Such reasoning falls like an inverted cone Wanting its proper base to stand upon.
—William Cowper, 1781

Creating Extruded Objects

WHAT IS EXTRUSION?

An extruded object is one in which a two-dimensional shape or outline—a circle, a square, a letterform and so on—is extended along a path to create a solid object, similar to the way toothpaste is pushed through the round mouth of a tube or the way cake frosting oozes through a star-shaped cap on a cake decorating bag. The outline that forms the basis of an extrusion is called different names in different 3D programs, including *cross-section* (Ray Dream), *template* or *rib* (StudioPro), *base* (Dimensions), and *silhouette* (Infini-D). We'll use the term cross-section most often.

The simplest form of extruded object is one in which the extrusion path is straight and the starting cross-section is identical with the ending cross-section. For example, the outline of a letter "W" might be extruded along a straight path to create a solid "W." However, extrusion methods can be varied to create more complex shapes. These variations include extruding along a curved path; rotating, scaling or repositioning cross-sections along the path; using more than one cross-section shape along a path and extruding compound shapes to create solids with "holes" in them (such as the hole [*counter*] in a letter "A"). We'll discuss all of these methods in this section.

EXTRUDING ALONG A STRAIGHT PATH

In this simplest of extrusion methods, a cross-section is extruded along a path that runs in a straight line perpendicular to the plane of the cross-section. The length of the path is defined by the user. The 3D program then fills in the side walls of the object, so to speak, by connecting the corresponding points and lines on the front and back surfaces of the object. This method is commonly used to create three-dimensional lettering and is available in most 3D programs.

Connecting the surfaces
When a 2D outline is extruded, the 3D program places a copy of the outline at the end of the extrusion path and then creates planes that connect the front and back outlines to create a solid object, as shown in this isometric diagram.

EXTRUDE: A CHANGING MEANING

The word *extrude* comes from the two Latin words for "out" (*ex*) and "thrust" (*trudere*) and originally meant to cast out a person, thing or idea, such as a traitor, hen's egg, or hate, respectively. ("An extruded cat moans woefully." Blackie, *Lay Sermons*, 1881). After the development of industrial processes of manufacturing, *extrude* also came to mean the process of shaping metal (and later, plastic) by pressing it through a die. This later meaning was incorporated into the terminology of computer 3D.

A

B

C

Extruding a shape
A two-dimensional shape, such as the outline of a letter "W" (**A**), can be extruded any distance along a straight path to produce a three-dimensional letter that's either thin (**B**) or thick (**C**).

As in any work of art, the concept must dominate the technique. Make a sketch first of what you would like to do, or have your goal clearly in mind.
—from the section on cake decorating in *Joy of Cooking* by Rombauer and Becker, 1964 edition.

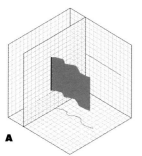

A

B

C

EXTRUDING ALONG A CURVED PATH

In this type of extrusion the path taken by the extrusion as it is thrust into 3D space is not a straight line but deviates either by curving or by zigzagging in a sequence of straight lines segments at different angles. The curve or zigzag may occur only in two dimensions or may move through all three dimensions.

A 2D CURVED PATH

Let's say that the direction of an extrusion path is along the conventional z or depth axis. Then it may be curved or otherwise deviate from a straight line by moving up and down (along the conventional y or height axis) or from side to side (along the conventional x or width axis). For example, a straight line or thin horizontal rectangle extruded along a path that waves either in the x or the y dimension could produce an object that looks like a flag rippling in the wind.

Waving the flag
Working in Ray Dream Designer, we started with a thin, vertical rectangle as a cross-section and extruded it three times along different curving paths to create a series of three waving flags. The curves that define the extrusion paths are visible on the bottom and side planes of Designer's working boxes for these objects. We curved the extrusion path from side to side (**A**), up and down (**B**) and in both these dimensions at once (**C**).

Each 3D program handles curved path extrusion in a slightly different way. Ray Dream performs straight and curved extrusions in the same window. However, in some programs extrusion along a straight path and extrusion along a curved path are done in two different modeling boxes or "workshops."

OPEN OR CLOSED?

Most programs make it possible to specify whether the 2D outline being extruded is filled in to create a solid shape (such as a circle being extruded into a column) or is left unfilled or hollow (such as a circle being extruded into a pipe). This can usually be done with three different variations: with both ends closed to create a solid object (**D**), with one end closed to create something like a box or container (**E**) or with both ends open to create a hollow object (**F**). However, it's not possible to define the thickness of the wall that's created with a hollow object. If you want a thick wall, you'll need to extrude a compound object in which an outer outline is grouped with an inner outline (see the section on "Extruding Compound Shapes" on page 46).

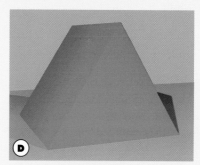

D

E

F

A 3D CURVED PATH

A path may also curve through both the height and width dimensions at the same time. In the case of our flag (see previous page), this might produce a violent waving in strong wind. This feature can also be used to produce objects that meander through space and even curve back on themselves, such as the tubular framework for a modern, Breuer chair or the curved metal of a potato masher.

IMPORTING CURVED PATHS

Curved extrusion paths can be drawn directly in a 3D program, using the drawing tools available. However, for more precision, paths can be created in a PostScript illustration program and imported. In addition, paths can be based on scanned art work, such as clip art, which has been autotraced and converted to PostScript outlines through autotracing. For more information on importing outlines see "Importing Extrusion Cross-sections" on page 49 and "Importing Lathing Outlines" on page 52.

500 YEARS
OF FURNITURE DESIGN

Twisting through space
German designer Marcel Breuer brought seating design into the future in the 1920s when he designed streamlined chairs like this one, originally manufactured of tubular steel. Ray Dream Designer provides a clip art version of the famous Breuer chair, shown here in side, top and perspective views. The tubular frame was created in 3D by extruding a circle along a path that twists through all three dimensions, following the curves of the side and top view shown and leading back to its point of origin.

COMBINING CURVED EXTRUSIONS TO MAKE A COMPLEX SHAPE

What if your program doesn't come with an extrusion modeler that is capable of continuous extrusions in all three axes? Then you might try breaking up the object into a series of one-axis extrusions that can be duplicated, rotated and *welded* together by positioning the pieces using careful alignment (see page 77) and interpenetration (see page 67).

It does not matter whether one paints a picture, writes a poem, or carves a statue, simplicity is the mark of a master-hand.
—Elsie De Wolfe, 1934

TRANSLATION VERSUS PIPELINE METHODS

Many programs make it possible to extrude a cross-section along a curved path in two different ways. With the *translation* or *flat* method, the cross-section always retains its original orientation of being perpendicular to the ground plane, so that all the sections along the path are parallel to each other. In a *pipeline* extrusion, the cross-sections are angled as they are swept along the extrusion path so that at any given point, the cross-section plane will be perpendicular to the path, whatever its angle happens to be at that point.

You would choose the pipeline method to extrude a circle into a garden hose, for example, or a piece of cooked spaghetti. But the translation method might be used to extrude a thin rectangle into a three-dimensional letterform that looks like calligraphy, with thick and thin areas where the path curves.

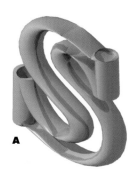

A

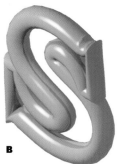

B

Comparing the two methods
The translation or flat method of extrusion causes an attenuation of the shape of the extrusion on curves (**A**). Pipeline extrusion, on the other hand, keeps the cross section perpendicular to the path at all times, regardless of how much the pathway curves (**B**) .

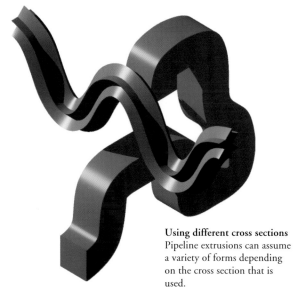

Using different cross sections
Pipeline extrusions can assume a variety of forms depending on the cross section that is used.

Modeling unusual objects with translation extrusion
Because it is often difficult to predict exactly how a translation pathway will behave, pipeline is the method most often used in extrusion. However sometimes translation or flat extrusion is just the right method for creating a special shape. For example, we took advantage of the attenuation caused by the translation method to model this camshaft. The actual pathway is shown at right.

Creating edible pipeline extrusions
We edited a sinuous circular pathway to ensure that it undulated in all three axes and extruded a circle cross-section along it. We then we duplicated the single strand of pasta to make a bowl full of noodles.

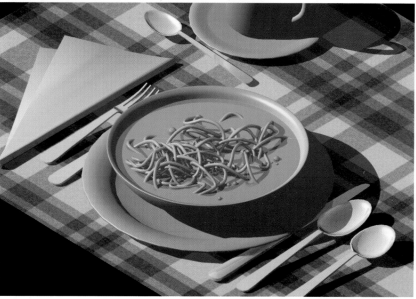

TRANSFORMING CROSS-SECTIONS ALONG A PATH

Positioning, scaling and rotating are *transformations* or changes that can be applied to an object, either in 2D or 3D computer graphics. These operations can be used to transform an entire object, such as rotating a line or rotating a model of an airplane in space (see "Transforming Objects" on page 66). But transformations can also be used to alter parts of objects, such as the cross-section outlines that are used to define extruded objects, making it possible to produce 3D objects in an infinite variety of shapes.

The objects shown on this page demonstrate what happens to a basic prism shape when one of its cross-sections is transformed. Each of these simple shapes is defined by only two cross-sections, in this case a triangle at each end of the extrusion. However, it's also possible to create multiple intermediary cross-sections and each of these can be transformed (for more information see "Creating Multiple Cross-sections" on the next page).

Changing the position of a cross-section

To demonstrate the effects of transforming cross-sections we started with a simple prism shape created by extruding a triangle (**A**). A diagram shows how the front and back triangle cross-sections are joined by lines and planes between the corresponding points and lines of the triangles, to create a three-dimensional object with five sides. We repositioned the second (closest) cross-section by moving it to the right, creating a crooked prism in which the side walls are no longer perpendicular to the front and back faces (**B**). We moved the second cross-section in only one dimension (left to right), but it could also have been moved up or down.

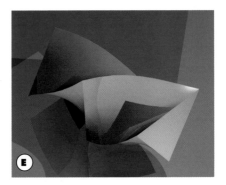

Rotating a cross-section

Some programs make it possible to rotate a cross-section in two ways: without a twist or with a twist. We rotated the second cross-section of our prism by 180% so that the triangle was standing on its apex. We first specified no twist, so that the points and lines of the starting and ending triangles were joined in as smooth a manner as possible (**D**). We also specified the same rotation with a twist, so that the prism was twisted in the same way that a prism-shaped column of clay would be twisted if you turned one end of it around (**E**).

Scaling a cross-section

To create a tapered shape, we reduced the size of the second cross-section by scaling it to 33% of its original size and positioned it so that its bottom line aligned with the bottom line of the first cross-section (**C**). We could also have centered both cross-sections to create a symmetrical tapered shape.

**HOT TIP
Imaginary cross-sections**

Ray Dream Designer suggests that you visualize the object you're trying to model and cut it into slices with an imaginary knife. If all the slices look the same, than a simple extrusion along a straight path will model the object. If the slices have the same shape but different sizes, then you must scale your cross-sections along the extrusion path. If the slices have different shapes, then model so that you change cross-sections along the path.

Creating intermediary cross-sections
We started by extruding a square along a straight path and then specified five intermediary cross-sections (**C**). Ray Dream Designer automatically created five square cross-sections equally spaced between the starting and ending cross-sections.

CHANGING CROSS-SECTIONS ALONG A PATH

Changing cross-sections along an extrusion path is sometimes called *skinning* and cross-sections used in this context are sometimes called *ribs*, in an analogy to the way our skin is stretched over the complex understructure of our bones.

HOT TIP
Measuring real objects with wire
Here's a method of generating lathe or extrusion outlines that works with everyday objects that are small enough and accessible. Wrap flexible wire around an object you are trying to model, either as extrusion cross-sections or as lathing profiles. Carefully remove these wire shapes and place them on your scanner. Scan them, autotrace the bitmaps to produce PostScript outlines and import the outlines into your 3D program.

CREATING MULTIPLE CROSS-SECTIONS

In addition to changing or transforming the starting and ending cross-sections of an extruded shape, many 3D programs make it possible to create multiple cross-sections along the path of an extruded object. Each one of these cross-sections can be transformed (positioned, scaled, rotated) or changed to create a multitude of shapes.

Changing the ending cross-section
Starting with the same prism shape shown on the previous page, we changed the ending cross-section from a triangle to a circle (**A**) and to a square (**B**). Computer 3D programs make as smooth a transition as possible to create a "skin" for covering extruded objects with dissimilar starting and ending cross-sections.

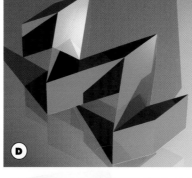

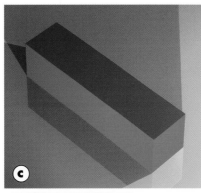

Changing and transforming the shapes of intermediary cross-sections
Finally, we selected each of the last six cross-sections in our original shape and either changed its shape completely (we used a star, triangle and circle) or scaled it (**G**).

Repositioning the intermediary cross-sections
We selected each one of the intermediary cross-sections and moved it to create a zigzagging extruded shape (**D**).

Scaling and rotating intermediary shapes
Returning to our original extruded square, we selected each one of the intermediary cross-sections and scaled it up or down to make it bigger or smaller than the original (**E**).

Again starting with the original shape, we selected each of the last six cross-sections and rotated it 22.5% clockwise to create a twisted shape (**F**).

EXTRUDING COMPOUND SHAPES

A compound shape is one in which two or more shapes are overlapped and combined so that their areas of overlap become transparent. The concept is used often in PostScript illustration, especially with type. For example, a letter "A" is a compound shape, with the outer outline of the letter combined with the inner shape (called a "counter" in typography) to produce a character with a hole in it. The same concept is carried over into computer 3D in the use of compound shapes as cross-sections for extrusion. In this way, extruded type can contain holes, as can myriad other extruded objects.

It's possible to apply all the transformations (positioning, scaling, rotating) to extrusions based on compound shapes and also to change compound shapes along the extrusion path. It's also possible to combine several shapes that do not overlap into a compound shape. As with any other cross-section, extrusions based on compound shapes can also be extruded along a curved path.

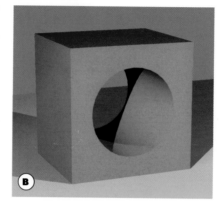
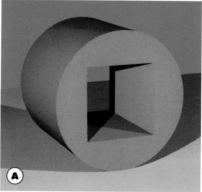

Creating "holes" in 3D shapes
We combined an outer circle and an inner square into a compound shape and used this as the cross-section for an extruded object, which looks like a round tube with a square hole through it (**A**). We combined the circle and square in a different way to produce a block with a round hole (**B**). We created a third extruded shape by using the circle with square hole as the starting cross-section and the square with round hole as the ending cross-section (**C**). Compound shapes can be especially useful when modeling mechanical parts.

Varying the extrusion path
Compound shapes, such as the three columns above, can also be extruded along a curved path, as with any extrusion cross-section (**E**).

Letters with "holes"
The use of compound shapes makes it possible to create objects containing interior "holes," such as a letter "A."

Combining multiple outlines
In addition to knocking holes in shapes, the creation of compound shapes makes it possible to group a number of outlines that are not overlapping into a single extrusion cross-section (**D**). This saves time over creating each element separately and assembling them.

ADDING A BEVEL TO AN EXTRUDED SHAPE

Bevel is a word of obscure French origin which has been used since at least since 1600 to mean planing or cutting a surface to any angle that is not "square—" that is, not 90 or 45 degrees. As a technical writer named Moxon stated in 1677, "Any sloping Angle that is not a square, is called a Bevil [sic]." In desktop 3D, the term is used to describe a slant placed on the square edge of an extruded object. But the meaning of bevel has been expanded to mean any special treatment of an edge, since the shape of a bevel can be curved as well as slanted. So beveling can also create effects similar to the types of shapes traditionally used in wood molding, as in the sometimes elaborate floor and ceiling moldings seen in old buildings.

Most programs make it possible to choose a predefined bevel shape and also to edit bevel shapes by manipulating vertex points. It's also possible in many programs to import your own bevel outlines.

BEVELING EXTRUDED OBJECTS VERSUS TYPE OBJECTS

In most programs, bevels can be added to the edges either of extruded objects or text objects, which often are created in different windows or "workshops." In this section we will describe the techniques of adding beveled edges to extruded objects that are not type. (We describe the creation of beveled type in "Creating Beveled Type" on page 150.)

LIMITS ON BEVELING

In some programs a bevel can be applied only to a straight-line extrusion in which the beginning and ending cross-sections are identical. (This type of extrusion is automatically used when 3D type is created in a text window.) So some complex extrusions, such as those along a curved path, may not be candidates for beveling. Check your program to find out what sort of beveling it

Using standard types of bevel

The standard bevel outlines that come with many programs include straight angle, concave and convex outlines. In addition, many programs make it possible to create custom bevel outlines.

Note that bevelling is executed not by cutting into the volume of the original shape but by actually adding to its volume, extending its boundaries beyond the flat faces.

Extrusion without bevel

Small angled bevel

Large angled bevel

Double angled bevel

Small convex bevel

Large convex bevel

Double convex bevel

Concave bevel

Editing a bevel

In most programs the amount of bevel is linked in a fixed proportion to the depth of the extrusion. By editing the bevel settings, you can control the relationship between the extent of the bevel and the depth of the extrusion.

HOT TIP
For best results use only simple iconic shapes when making beveled extrusions.

No, I am that I am; and they that level
At my abuses reckon up their own.
I may be straight though they themselves be bevel;
—William Shakespeare, Sonnet CXXI

supports. Many programs include a palette or dialog box through which a beveled edge may be applied to any extruded object, whether it started with a type outline or not. However in Ray Dream Designer, for example, the window used for creating extruded text objects *does* include an option for bevels, but there is no automatic bevel option for other extruded objects. (In Designer this type of beveling would have to be done by editing the cross-section outline and/or the sweep path of an extruded object to include bevels.)

WHY ADD A BEVEL?

Expanding on the metaphorical meaning of "straight" as *regular* or *proper*, Shakespeare used the word "bevel" in a sonnet to imply *improper* behavior. However, in desktop 3D beveled edges are considered decorative and can soften the edges of extruded objects, creating a more refined look. In addition, a bevel serves as a way of embellishing a model by creating another planar surface which can reflect light, adding to the appearance of highlights on objects with a shiny surface definition. As with improper behavior, bevels can create delightful effects but should probably be used with restraint.

Creating complex bevels
Adobe Dimensions provides a library of complex bevel outlines—such as the "jaggy" bevel shown here—and makes it possible to draw or import your own custom bevels.

Beveling a scan
We made a line art scan of a comb by placing an actual comb on the scanner glass. We autotraced the scan to convert it to PostScript outlines, imported the art into a 3D program and extruded it with a bevel, which added to the bulk of the comb's teeth.

Making industrial objects from bevels
Our truck's convex-beveled radiator started as a compound shape drawn in a Postscript drawing program and imported, but most of the other beveled shapes in the model are extrusions based on cross-sections drawn with a rounded rectangle tool.

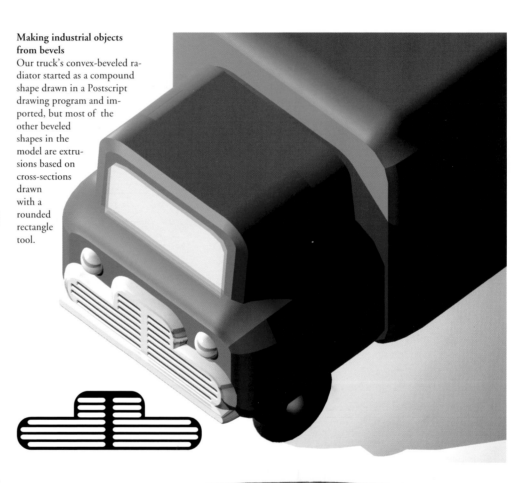

IMPORTING EXTRUSION CROSS-SECTIONS

You can use the 2D drawing tools included in most 3D programs to create outline shapes for use in extrusion and lathing. Most programs provide at least simple 2D drawing tools such as circles, squares and lines and some also include a Bézier curve tool. However 3D programs *don't* provide many of the features (such as alignment tools) that we rely on in 2D drawing software.

DRAWING IN A POSTSCRIPT PROGRAM

For the creation of outlines that are complex or that require precision, it may be better to use a PostScript drawing program such as Illustrator, CorelDraw or FreeHand, since these programs provide many more drawing tools and functions than those available in 3D programs. PostScript art created in these programs can be imported into many 3D programs for use as cross-sections, lathe outlines and also as extrusion paths.

USING SCANNED ARTWORK

You can also scan 2D clip art or make scans of hand-drawn artwork and autotrace the bitmaps to create two-dimensional PostScript art that can be imported into a 3D program. Blueprints and technical drawings can be sources of cross-sections for 3D work, as can collections of black-and-white art. Sometimes it's also possible to scan an actual object and use it as a template for producing outlines for extrusion, as we've done here with a computer SCSI plug.

Scanning an object
To create a convincing 3D model of a computer SCSI plug we first scanned an actual plug by holding it upright on the scanner glass (**A**). We cropped the image, improved the contrast and then imported the scan into Illustrator where we used it as a guide for drawing a series of shapes that follow the main contours of the plug (**B**). We created four separate outlines that define the plug and saved them as EPS files (**C**).

Extruding the shapes
We imported each EPS outline as an extrusion cross-section in our 3D program and extruded each outline an appropriate amount along a straight path to create the face, screw plate, rim and pins of the plug. The outlines for the screw plate and for the pins contained multiple paths which were combined into compound shapes. In the case of the screw plate, this created an extruded shape with holes in it. We applied a dull neutral color to the face and a shiny, gray metal surface to the other parts.

Finishing the model
We positioned the extruded elements as though we were actually assembling the plug and then added cylinders of various sizes to create the screws, screw handles and cable. The body of the plug was created by making a copy of the face object and scaling it.

Changing the view
To create a dramatic close-up of the plug we added a new camera to the scene and made a rendering through this view.

Creating Lathed Objects

WHAT IS LATHING?

In computer 3D, a *lathe* or *lathed object* is one made by rotating a 2D outline around an axis to produce a shape. The term comes from the woodworker's craft of lathing in which a stick of wood is turned rapidly around its long axis and a cutting tool is applied to carve symmetrical curved forms such as decorative legs for chairs and tables. The process is also similar to that of forming a pot by pressing and shaping clay as it turns on a potter's wheel. In computer 3D a lathed object is also commonly known as a *swept object*, referring to the idea that the 2D outline sweeps through space as it revolves around the axis of rotation.

OPEN, CLOSED, FILLED, HOLLOW

Lathing is often used to create curved, symmetrical objects, such as a vases and bottles. Such objects can be filled (solid) or unfilled (hollow). However the process of lathing can be varied to produce different types of objects. For example, the lathe outline (the shape that is being revolved) can be either an open path (such as a letter "S") or a closed path (such as a circle). Also, the outline can be touching the axis of rotation at one or more points or can be located at some distance from it. In addition, a lathe outline can be doubled back on itself in order to define a hollow object with walls of a certain thickness and shape.

Lathing an open outline
A simple example of a lathed object made from an open path is a vase, in which a curved line that touches the axis of rotation at one point is revolved 360 degrees around that axis (**A**). Such an object will have thin walls and can be left unfilled or be filled to create a solid object (**B**). If the outline is offset from the axis of rotation, the resulting shape will be hollow (**C**) but can also be filled to create a solid volume.

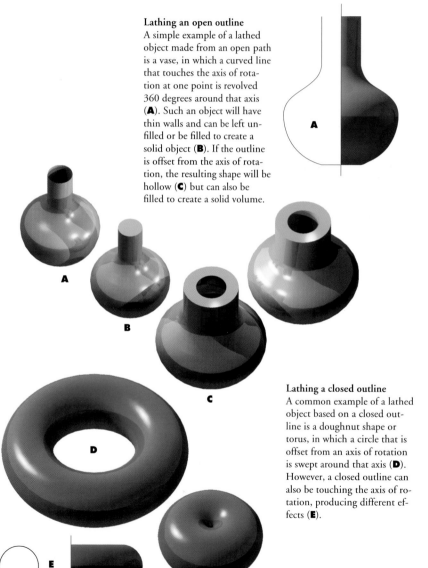

Lathing a closed outline
A common example of a lathed object based on a closed outline is a doughnut shape or torus, in which a circle that is offset from an axis of rotation is swept around that axis (**D**). However, a closed outline can also be touching the axis of rotation, producing different effects (**E**).

It's also possible to create a partial lathe by rotating less than 360 degrees. In most lathing, the axis of rotation is parallel with the long axis of the lathe outline, but this can also be varied so that the rotation axis is tilted to some other angle.

FILLED OR UNFILLED LATHE OBJECTS

When an open-ended lathe outline is distant from the axis of rotation, the result is a hollow shape. For example, if an arc were rotated at some distance from the axis of rotation, the result might be similar to a wedding ring, with an open center. Most programs make it possible to filled in the open area to create a solid object, or it can be left unfilled.

PARTIAL LATHING

Usually a lathed object has had its outline shape rotated a full 360 degrees. But most 3D programs also make it possible to create a partial lathe, in which an outline is revolved less than 360 degrees. This process can be useful for creating cutaway views of objects.

CREATING A SEGMENTED LATHE

When a curved outline is rotated around an axis to create a lathed object, the 3D program is actually creating many small polygons which give the appearance of a smoothly curved surface. However, sometimes a faceted look is desirable, so some programs make is possible to specify the number of polygons or segments that will be created.

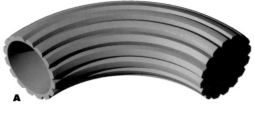

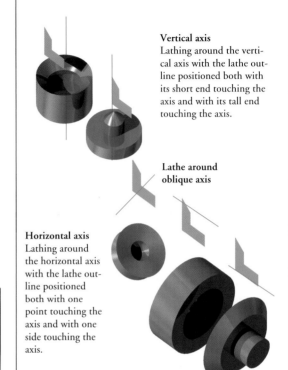

Lathing a shape on different axes
We rotated the same modified L-shape around several different axes, with the shape oriented in different ways toward the axis of rotation, to produce seven completely different lathed shapes.

Vertical axis
Lathing around the vertical axis with the lathe outline positioned both with its short end touching the axis and with its tall end touching the axis.

Lathe around oblique axis

Horizontal axis
Lathing around the horizontal axis with the lathe outline positioned both with one point touching the axis and with one side touching the axis.

Offset lathe around vertical axis

lathe around ...tal axis

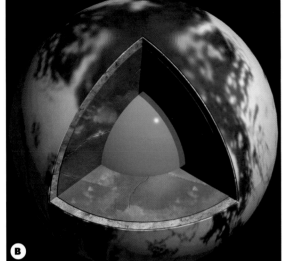

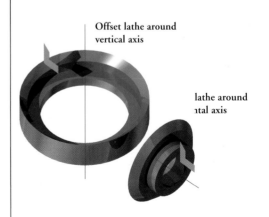

Lathing less than a full circle

We created a piece of canelloni by lathing a serrated ring shape 90 degrees around an offset axis (**A**). This type of "partial lathing" can be used not only to create segmented objects, but can be used to create "cutaway" details. For example to create an illustration of the earth (**B**), we created the southern hemisphere by lathing an arc 360 degrees as a filled shape to create a solid half sphere. But to create the northern hemisphere, the same arc was inverted and lathed only 270 degrees to reveal the earth's "core," a red sphere placed at the center of the model. In the same way, the outer part of a tire model (**C**) is also a 270-degree lathing and reveals the inner steel-belted structure, which is a full-rotation lathed object.

LATHING WITH A TWIST: CREATING SPIRALS

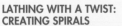

A spiral, which is sometimes called a sweep, is a lathed object in which the cross-section being rotated remains at a fixed distance from the axis of rotation but is continually changing position in one direction along the length of the axis, to produce an object like the spiral binding of a notebook.

Using segmented lathing

To make a smooth, rounded lathed object, a 3D program actually generates hundreds of small line segments which give the appearance of a rounded surface. But in some programs it's possible to reduce the number of line segments to produce an angular lathed object. The square-sectioned legs of our glass-topped table were formed by lathing a curved profile 360 degrees, specifying only four segments. The decorative boxes on the table top were formed by lathing in six segments (**D**).

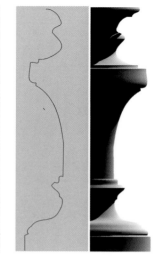

ADVANCED TYPES OF CURVES

The world of computer 3D has developed to include many advanced concepts of modeling and spacial organization. Many of these concepts operate automatically in the popular, all-purpose 3D modeling programs and it's not necessary for the average user to understand them. However, we're including some of the more commonly discussed concepts having to do with curves, which you may encounter in 3D manuals.

SPLINE

Originally, the term *spline* was used to describe a lath or thin piece of wood used to construct furniture and other objects, especially those with curved surfaces such as ship's hulls. In computer graphics a spline is essentially a curve that is defined by control points which have slope continuity so that it can be assembled with other splines to create uniformly curved surfaces. The terms *spline*, *spline object* and *splineform object* are often used in desktop 3D to refer to objects that are curved.

B-SPLINE

A *B-spline* is a type of spline or curved line whose shape is determined by control points that influence the curve of the line segments on either side of them through equations called *basis functions*. The goal of B-spline mathematics is to make sure that the curve is continuous or smoothly changing through all its control points and also to limit the effect that control point editing has on the curve so that changes are more local rather than global, as with a Bézier curve.

NURBS

NURBS stands for Non-Uniform Rational B-Spline and refers to a special class of B-spline curves which have additional parameters for control points such that they are especially good for accurately describing arcs and ellipses.

IMPORTING LATHING OUTLINES

As with extrusion, outlines for creating lathed objects can be drawn directly in a 3D program, using the drawing tools available, or they can be imported as PostScript outlines from a PostScript illustration program. Often it's better to use a PostScript program if you want your lathe outlines to be exact; for example, if you want several lathed components to fit precisely inside each other, as with the bottles and liquid shown on the next page.

PostScript drawing programs are also good tools for creating outlines based on hand-drawn art or on 2D clip art. These types of images can be scanned and converted to PostScript outlines through autotracing. For more information on importing EPS outlines also refer to the section on "Importing Extrusion Cross-sections" on page 49.

Drawing in the round
To create an illustration in the style of Maxfield Parrish, we combined the classical geometry of short lathed pillars with the softness of romantic landscape elements. We started with a scan of an ancient balustrade and traced its profile in a PostScript drawing program. Next we imported the EPS file of the profile into our 3D modeling program (Vision 3D) where it was lathed 360° in 36 segments. We made an assembly of three balustrades, each with a cap and a stepped base created with modified cubes, saved the group as a DXF file and imported it into our rendering program (Bryce). We arranged four copies of our DXF balustrade file using the alignment tools and used Bryce's terrain and sky functions to add various scenic elements to the model.

Thirty spokes unite in one nave and because of the space between the spokes, we have the use of the wheel.
Clay is molded into vessels and because of the space where nothing exists we are able to use them as vessels.
Doors and windows are cut in the walls of a house and because of the space which is empty, we are able to use them.
—Lao Tzu, *Tao Te Ching*

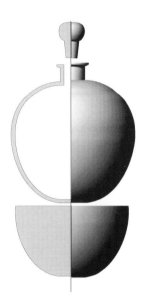

Making the parts fit
We took advantage of the precision drawing tools of a PostScript drawing program to craft the profiles for a glass bottle, stopper and the liquid contained within the bottle. We copied the inside sections of the bottle outline and used them to create the outside outlines of the "liquid" object. By importing and lathing these profiles we were able to create a liquid object that fit snugly inside its vessel.

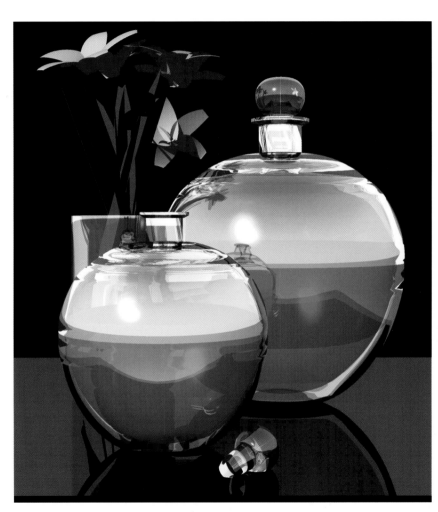

EXTRUDING AND LATHING: DIFFERENCES AMONG PROGRAMS

The modeling of extruded and lathed objects is handled differently by different programs, though the concepts upon which these functions are based are similar.

EXTRUSION

Some programs, such as Ray Dream Design, handle all types of extrusion through one "workshop." Other programs, such as StudioPro, provide an extrude tool or function which will extrude a single 2D outline along a straight path, but use different tools or working windows for extruding along a curved path or for changing cross-sections along a path, Some programs refer to the process of creating an extruded object with multiple cross-sections as *skinning* or *lofting*. Some programs automatically add a bevel to extruded objects, some don't.

LATHING

Some programs (such as StudioPro and Dimensions) stay with the metaphor of wood lathing and use terms such as *axis of rotation* and *lathe outline* to describe the parameters of lathed objects (although Dimensions refers to lathed objects as *revolved* objects). Other programs (such as Ray Dream Designer and Infini-D) handle lathing as though it were a form of extruding in which the lathe outline is actually a curving extrusion path. However, Ray Dream Designer makes it possible to create extruded and lathed objects in two different modeling windows, which operate differently.

Our sections describing extruding and lathing describe the kinds of functions that are possible in most desktop 3D programs. However, you'll have to explore your own software to determine exactly how your program handles each of these functions.

Advanced Modeling

BOOLEAN OPERATIONS

A Boolean operation in 3D modeling involves the combining of two or more overlapping shapes. In subtractive or intersecting operations, one of the shapes acts as a sort of "antimatter" and takes a bite out of the other shape. In union operations the shapes are fused into one object. In many 3D programs, shapes combined in this way are converted into polygon mesh objects, which can be further modified using mesh editing (see "Working with Mesh Objects" on page 57).

SUBTRACTION

This Boolean function is particularly useful if you prefer to work with primitive shapes, or if your program does not provide more advanced modeling functions. Subtraction will enable you to make quite complex objects by combining basic shapes. In some programs, such as Bryce, Boolean subtraction is not permanent; the combined primitives remain primitives and are not converted to mesh objects.

INTERSECTION

Intersection can create interesting shapes by producing objects that represent only the area where two objects overlap. This function provides an efficient way to carve out convex shapes—the curved surface of a monitor screen, for example.

UNION

What *union* accomplishes can sometimes more easily be done by grouping. However, separate objects that are joined through union become a single object and can have a surface applied to them uniformly, as opposed to objects that are grouped. In the later case, each separate element receives the surface map independently, which may create discontinuities at places where the objects overlap.

Three basic Boolean functions
Subtraction and intersection can transform objects in dramatic ways. Union joins two shapes together—a task than can also be accomplished by grouping or linking.

Subtraction
One object gouges out a space in another object.

Intersection
The overlap of the two objects remains and all that is outside the overlap area is removed.

Union
The two objects are fused together into a single object.

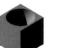

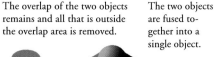

From simple to complex
Bryce has wonderful textures but no modeling functions beyond the provision of primitive shapes. So to create a fanciful tower in this program we started by stacking primitive shapes such as spheres and cuboids and then modified these shapes by using Boolean subtraction. The elements forming the main structure of our tower are shown in blue and the shapes we subtracted from it are shown in red (at left). When all these shapes were combined through Boolean subtraction, the tower acquired fluted columns and various other perforations. We then applied surface maps to the resulting shapes.

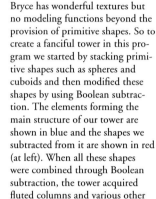

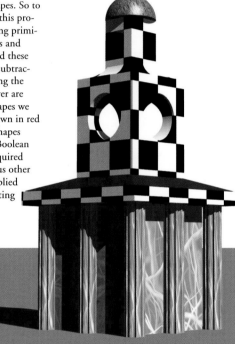

Fusing translucent shapes
The Boolean union can be used to combine translucent shapes so that they appear to be one seamless object, as in this light bulb. We used Boolean union to fuse three primitive shapes into a seamless, translucent object.

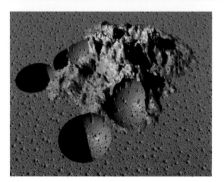

Alien territory
Spheres were subtracted from a cuboid to carve these craters into the surface of an inhospitable planet.

An Exercise in Boolean Intersection

HOW TO MAKE A SHARP-LOOKING PENCIL IN 3D

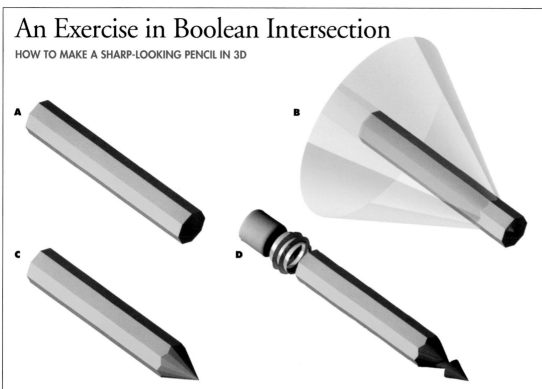

A

B

C

D

A Boolean pencil sharpener

We take the shape of the sharpened pencil for granted, but it's a rather complex piece of geometry. Yes, a cone can be placed at the end of an elongated eight-sided cylinder, but this solution won't stand up to close scrutiny. To make that characteristic scallop-shaped edge where the sharpened end meets the shaft, Boolean modeling is required. The trick is to make a cone-shaped Boolean "sharpener" and use the Boolean Intersect function.

Working in StudioPro, we used the 2D polygon drawing tool and specified an 8-sided polygon, then used the extrusion tool to extrude the shape into an unsharpened pencil shape (**A**).

Next we generated a cone primitive and positioned it so that its apex aligned with one end of the pencil shaft and its base aligned with the other end (**B**). (The pencil shapes were interpenetrating [see page 67], with the pencil shape inside the big cone.)

We then combined the two shapes using a Boolean intersect function. This had the result of lopping off the small part of the pencil shaft that extended beyond the shape of the cone, leaving a crisp point (**C**). We converted the sharpened pencil to a mesh object so that the tip and the shaft could be given different textures. The finishing touches were provided by adding elements for the lead, the eraser and the metal ring (**D**).

DEFORMING OBJECTS

Many 3D programs include special modeling functions called *deformers* that make it possible to change the shape of objects automatically, often by entering values in an associated dialog box. Deformers can be used to change objects in certain useful ways, without having to do a lot of modeling and arranging "by hand," so to speak. For example, in Infini-D the deforming functions are called Twist, Bend, Taper, Shear, Bulge, Linear Wave and Scale, and they deform objects in the ways described by their names. In Ray Dream Designer the deformers include Atomize, Bend and Twist, a vortex effect called Black Hole, Dissolve, Explode, Punch, Shatter, Spherical Morph, Spike, Stretch, Warp and Wave. Some of the changes caused by deformers can be animated so that an object can appear to change in stages over time; for example, an object can gradually explode or dissolve and disappear.

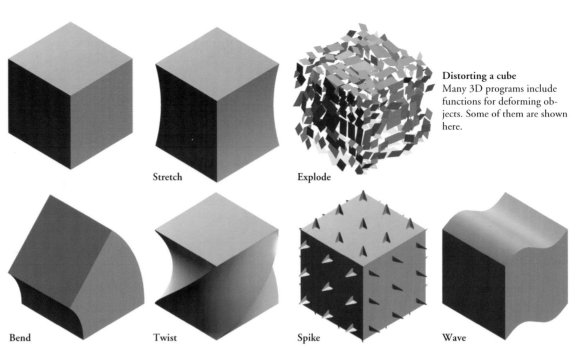

Stretch Explode

Distorting a cube
Many 3D programs include functions for deforming objects. Some of them are shown here.

Bend Twist Spike Wave

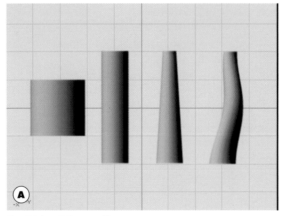

(A)

Combining deformer effects
Using Infini-D's deformer functions, we started with an elongated cylinder and applied Taper to taper one end of it and Linear Wave to make it crooked like a tree branch (**A**). The resultant shape was repeated at different scales and angles to form the trunk and branches of a tree (**B**).

Deforming a complex model
We used the Wave deformer to modify a model of a car in Ray Dream Designer. This created an eye-catching illustration for an advertisement.

(B)

*She had not understood mathematics until [her father]
had explained to her that it was the symbolic language
of relationships. "And relationships," he had told her,
"contained the essential meaning of life."*
—Pearl S. Buck, *The Goddess Abides*, 1972

WORKING WITH MESH OBJECTS

Objects created with primitives or through extrusion or lathing can be converted to *mesh objects* and edited through a *mesh editor*, which makes it possible to change their shapes in very precise and sophisticated ways. The process is especially useful for modeling forms which are organic or irregular in appearance, such as plants. Mesh editing is based on the idea that the surfaces of three-dimensional objects can be described as sets of vertex points, edges and polygons, making objects look on-screen as though a fishnet stocking were pulled tight around them. The mesh is made up of hundreds of small polygons, which define both curved and flat surfaces, similar to the way that the triangles making up a geodesic dome define its rounded, spherical shape.

In mathematics, a *vertex* is a particular point in space, identified by *x, y, z* coordinates. Vertex points (*vertices*) are the fundamental building blocks of computer 3D, used for constructing edges, facets, polygons and polyhedra. An *edge* is the line that can be drawn between any two vertices. A *polygon* is a shape defined by a closed series of straight lines, such as a triangle or a square. A *polyhedron* is a multifaceted solid object constructed of polygons. The whole grid of vertices, edges and polygons is often called a *polygonal mesh*.

In fact, all 3D objects are converted to polygonal mesh during the rendering pro-cess so that the image can be rendered through calculations that proceed polygon by polygon. But with mesh editing, the process of conversion is done deliberately, before rendering, so that editing of the object's shape can be done.

Breaking up objects into polygons makes it possible to change and mold the object's overall form in powerful ways. Many 3D programs provide a mesh editor, typically a window or workspace in which objects are displayed as mesh objects. In most mesh editors it's possible to select a vertex point and transform it in 3D space to create a change in the shape of the object. In some programs it's also possible to select and move edges and polygons.

CONVERTING OBJECTS TO POLYGONAL MESH

Most 3D programs make it possible to convert an object created as a primitive or as a lathed or extruded object into a mesh object. (Note that this conversion may alter the appearance of the object slightly. For example, an object created as an extrusion may have a very rounded extrusion cross-section, created by drawing Bézier curves. When this object is converted to a mesh object, the curves will be approximated by a series of connected short lines.) Most programs make it possible to choose how an object is converted to mesh, allowing the user to specify either an *optimal* number of polygons or a greater or lesser number. The more polygons, the more finely the object can be edited. However, rendering time increases with higher numbers of polygons (see "Rendering Images" on page 144). To aid in the rendering process, polygons are usually broken down into triangles, through a process called triangulation (see "Defining the Mesh" on page 59).

Vertex
Edge

Revealing the mesh geometry
When primitives and lathed or extruded objects are converted to mesh objects they become "faceted" so that their surface is divided up into many small flat planes that come together to form the shape. These facets actually underlie the geometry of all computer-generated objects, but special algorithms, either in the modeling or the rendering process, can make the surface appear smooth.

EDITING MESH POINTS

Desktop 3D programs provide various tools to help with the manipulation of mesh vertex points. In most programs points can be transformed (repositioned, rotated and scaled). Many programs also make it possible to add and delete vertex points individually. However, programs differ quite a lot in providing other functions for mesh editing. Of the full-featured 3D modeling and rendering programs, Ray Dream Designer provides a particularly sophisticated mesh editor. For example, this program makes it possible to add and remove vertices in an entire object (to make the mesh more or less coarse), link and unlink vertex points so that there is or is not an edge connecting them and "weld" vertex points in order to combine separate objects into a single mesh object. While not all programs include these special functions, most 3D programs provide some aids to mesh editing.

SELECTING VERTEX POINTS

Selecting individual vertex points or groups of points can be difficult because of the welter of mesh points and lines that appear on-screen. Some programs provide functions designed to make selection easier. For example, Ray Dream Designer makes it possible to save and restore selections, to invert the current selection (so that the selection switches to all points except the originally selected points) and to hide selections.

MAGNETISM OR GRAVITY

Some programs include a function that seems to pull on mesh objects, so that when a vertex point is moved the points near it also move. The strength of the "pull" can be defined by entering values that determine how many points will be affected, how much they will be affected and how far the vertex point being moved can move in relation to the other points. This force is called *gravity* in some programs, *magnetism* in others.

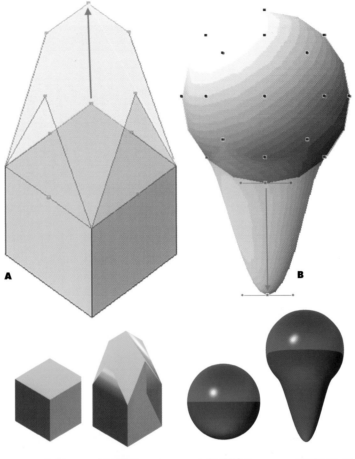
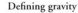

A **B**

Stretching a point
In many 3D programs, vertex points along the surfaces of mesh objects can be selected and moved to modify the original shape. Repositioned points may distort the object in a linear way (**A**), or with Bézier curves (**B**), depending on the program being used.

Defining gravity
Specifying the amount of "gravity" or "magnetism" in a mesh editing operation determines the degree to which neighboring points are affected by the motion of a given point or group of points. We moved the top middle vertex of a sphere upward vertically, first without gravity (**C**), then with low gravity (**D**) and, finally, with high gravity (**E**).

C **D** **E**

Shaping parts

To make the cockpit of the plane in the airport scene below, we deformed a sphere by dragging the mesh vertices in the lower half of the sphere straight outward to form a nose (**A**). The shape was further refined by pulling in the vertices on either side of the nose to make a more tapered shape (**B**). Other parts of the model that were created using mesh editing include the wing root, the engine pod pylon and the tail-cone.

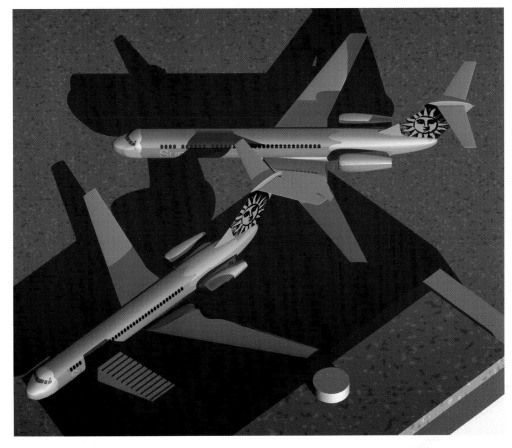

 A **B**

DEFINING THE MESH: WORKING WITH PATCHES AND FACETS

The polygons that make up a polygonal mesh are defined very carefully so that a 3D object can be rendered smoothly and economically.

SMOOTHNESS AND SURFACE PATCHES

An individual polygon in a polygonal mesh is often called a *patch* or a *surface patch*. The geometry of a patch is defined so that there is continuity of slope (angle) at its boundaries. *Continuity* means that the angle of the slope and its rate of change are calculated for points on the edges between patches. When these two factors are taken into account, there is a seamless transition in slope from one patch to another and it is impossible to visibly detect the joins where the edges of the patches in the mesh touch each other. This makes it possible to model very smooth, continuous curved surfaces. The complex calculations required are carried on by the 3D program beneath the surface, so to speak. The user need only be aware that surface patches or polygons exist, since he or she may be asked to specify the fineness of their detail—that is, how many patches to generate for a given surface. The more patches, the smoother the curves in an object will appear, but the longer it will take to render.

FACETS AND TRIANGULATION

In mathematics, a *facet* is a portion of a surface that occupies a single plane. For example, each side of a cube is a facet. Facets are especially useful in computer 3D because it's easier to render the surface characteristics (such as color, texture or reflection) of a flat surface than of a curved surface. However, not all squares or polygons with more sides are flat or *planar*.

So in order to make sure that all the facets of a 3D object are flat, programs use a process called *triangulation* to break down the polygons of the mesh into triangles. This is done because a triangle is the simplest polygon that is always flat.

Polygons can be nonplanar
If you place a square or rectangular piece of paper flat on a table, each of its corner points will be approximately in the same plane. But if you lift up one corner of the paper, then only any given group of three corner points are in the same plane.

Triangles are always flat
If you place a triangle-shaped piece of paper flat on a table, all three corner points are in a single plane. Now lift up one corner of the paper. All three corner points are still in one plane, even though that plane is no longer parallel with the plane of the table.

Creating Natural Elements

MODELING NATURAL PHENOMENA

While mesh editing is useful for creating many organic-looking objects, there are some natural elements—such as water, fire, waves and trees—that are too complex to be modeled in this way. So processes of *natural phenomena modeling* have been developed which use random numbers generated by functions such as fractals and noise to produce objects that are detailed and irregular.

FRACTALS

A *fractal* is a shape that is self-similar; that is, it exhibits a certain shape when seen from a distance and portions of it seen close-up show the same shape. Fractal geometry is used in the modeling of such things as coastlines, clouds and landscapes.

NOISE

The term *noise* usually refers to any unwanted "signal" or information in a system. But noise (or, sets of data that are generated randomly) is used in 3D graphics model natural phenomena.

Natural phenomena modeling includes the creation of *terrains* or objects that simulate the earth's surface and also *particle systems*, which include objects such as fountains of water, clouds, areas of fog and fire.

TERRAIN MODELING

In computer 3D, a terrain is a rectangular block with a top surface that has variable vertical heights, so that it appears to be covered with peaks and valleys, similar to a natural earth terrain. In effect, the surface of a terrain object is covered with a triangular mesh and the vertex points on this mesh, are raised or lowered to create a bumpy surface (see "Working with Mesh Objects" on page 57).

Desktop 3D programs vary quite a lot in their handling of terrain objects. Some, such as Infini-D, provide specific tools for creating terrain objects. In others, such as StudioPro and Ray Dream Designer, terrains must be created as a form of mesh object. One program, Bryce, is specifically designed for the production of terrains and other natural-looking landscape elements. (For more information see "Creating Natural Forms with Bryce" on page 62.)

A terrain can be created in three main ways: (1) by creating a rectangular box, converting it to a mesh object and individually editing some of the vertex points to raise or lower them; (2) by using an array of randomly generated numbers to define the height of each vertex; or, (3) by using the gray values in an imported grayscale image to determine the ups and down of the terrain surface. The first method, using manual editing of mesh vertex points, can be done in any 3D program that supports mesh editing, but creating terrains in this way can be tedious. Both Infini-D and Bryce make it possible to use noise and fractal geometry to generate random number-generated terrains. These programs can also be used to create image-based terrains, and these can be created in Ray Dream Designer using a third-party extension called SuperMesh.

Self-similarity
In this fractal image, known as a Julia Set, the same shapes seen at smaller scales are apparent at higher magnifications.

Mesh editing of terrains
We created a rectangular box, converted it to a mesh object and raised and lowered some of the mesh vertex points to create a crudely bumpy terrain.

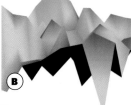

Random number-generated terrains
We used Infini-D to create terrains based on random numbers generated by noise (**A**) and by fractals (**B**).

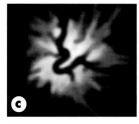

Image-based terrains
To create a natural-looking irregular terrain, we created a grayscale image in Photoshop (**C**) and imported it as a PICT to serve as the basis for vertical heights in a terrain (**D**). With image-based terrains, the white areas of the image will produce high areas in the terrain, the black areas will produce low areas and the gray values will produce in-between heights.

PARTICLE SYSTEMS

Some special effects in natural phenomena modeling are created using *particle systems* in which groups of separate particle objects are controlled with numbers that determine their location in space, size, lifetime and velocity. Particle systems—water fountains, for example—change over time and these changes can be captured when rendered as an animation sequence, although particle effects are also visible in a single-image rendering.

FOUNTAINS

A fountain can be used to simulate the look of a geyser or tornado. It can be edited with regard to many parameters, including angle of spray, density, gravity, swirl, particle size, speed and so on.

VOLUMETRIC EFFECTS

In addition to particle systems, Ray Dream Designer and Bryce also include functions for producing volumetric effects such as clouds and local areas of fog and fire. These all can be edited with regard to size, density, color and edge fall-off.

Using volumetric textures
When a geometrical object, such as a cube or a sphere, is given a volumetric texture, its original surface is not evident at all; rather it becomes the locus of a soft-edged effect that occupies the volume of the object, but whose boundaries are nebulous. The clouds in this landscape rendering are all spheres that have been given volumetric textures.

Using environmental primitives
The particles emanating from the rocket engines are "fountain" particles. The flames and the smoke clouds are also particle effects applied to spheres and cylinders.

The whole secret of the study of nature lies in learning how to use one's eyes.
—George Sand, *Nouvelles Lettres d'un Voyageur,* 1869

GETTING
STARTED
WITH 3D

62

CREATING NATURAL FORMS WITH BRYCE

Natural forms, including landscapes, are made up of many complex and irregular shapes. Most 3D models fall short of the complexity that's needed to make landscapes look realistic. Although most 3D programs provide functions for modeling terrain, using these functions "from scratch" can be difficult. One way around this is to use Bryce, a program that's specially designed to create terrains and other landscape objects.

WORKING WITH RANDOMNESS

Randomness is a key element in nature and randomness is employed by Bryce, which is optimized for producing natural forms. Bryce takes advantage of fractal mathematics to create terrain objects (such as mountains) with peaks, valleys and surface features that are defined by random numbers, providing the irregularity that's crucial to natural forms (see "Modeling Natural Phenomena" on page 60). Bryce also includes tools specifically designed for creating water surfaces, skies with clouds, ground planes and rocks. All of these elements can be edited after they're created. Bryce also includes a large collection of ready-made textures and skyscapes.

Working in Bryce is easy if you're comfortable with randomness (see next page). But it may take some trial-and-error to get the results you want. Fortunately the program is fast enough to allow a number of quick test renderings in thumbnail size so that the overall layout, texturing and lighting can be checked before a final image is produced.

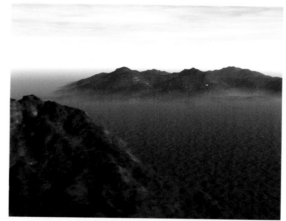

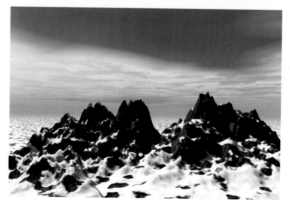

Realism right out of the box
We used Bryce to generate these diverse landscapes using some of the program's many built-in terrains, textures, skies and atmospheric effects.

A special terrain editor allows users to control the amount of erosion and the jaggedness of mountain forms. The bluffs in the river scene were created using rock objects. The mountains in the other scenes are terrain objects.

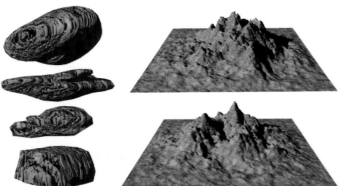

Seeing the forest
We chose one of Bryce's standard trees and replicated it 30 times into rows. The rows of trees were selected and their positions on the ground plane were randomized to produce a natural-looking spacing. At the same time, their size was also randomized. We then added a fog effect to create the image of a misty forest.

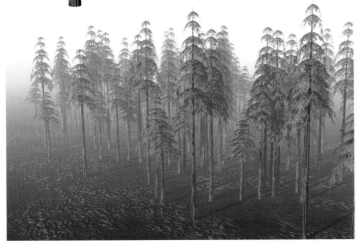

Working randomly
The problem of making repeated elements look natural and not regimented has been neatly solved in Bryce with a special "Randomizing" control. Each new rock or terrain object we create in Bryce is different from the last one, since random numbers are used to generate these forms. So our role as designer is more like that of a critic than a creator. We can accept or reject each object Bryce creates, or try some editing if the object is almost right. At left are four rocks and two terrains created in sequence.

WORKING WITH WATER AND SKY

Sometimes you don't have to work hard to get amazing results. The secret is knowing how to make the best use of Bryce's powerful built-in objects and textures. For example, we created a realistic model of an island (see next page) using only four elements: an infinite ground plane, a sky texture, a terrain element and a cloud. We started with a ground plane, applied a water texture to it and then specified an appropriate sky environment. (Bryce's skies come with their own light sources and also generate atmospheric perspective and a transition at the horizon. These parameters can be modified if you don't find a sky you like in the selection of ready-made skies.) We used the terrain tool to create an island, enlarged it, positioned it offshore and adjusted our camera angle to a high "helicopter's-eye" view, in order to catch the shimmer on the water. We added a cloud and positioned it midway in front of the island to give a sense of the island's scale.

COMPLEXITY MEANS TIME

Bryce's random number generation produces complex forms and realistic images, but this sometimes means long rendering times. (Our island model took about one hour to render on a Macintosh 7600/120 with 144 MG of RAM.) But given enough computing power, we could duplicate our island, randomize the copies and arrange them into an entire archipelago of volcanic islands.

HOT TIP
When many copies of a complex object (such as the trees in our forest) are included in a model, rendering may take many hours. To reduce the number of objects needed in the more distant parts of the model, try using a heavy atmosphere. This will disguise or soften the gaps where no objects appear.

Establishing sea and sky
To create a volcanic island model in Bryce (see next page) we began by creating an infinite plane and applying a water texture (**A**). Next we selected a sky environment (**B**) and made a small 640 × 480-pixel ray-traced test rendering (**C**).

And as imagination bodies forth
The forms of things unknown, the poet's pen
Turns them to shapes, and gives to airy nothing
A local habitation and a name.
—William Shakespeare, *A Midsummer-Night's Dream*

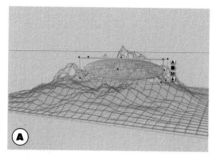

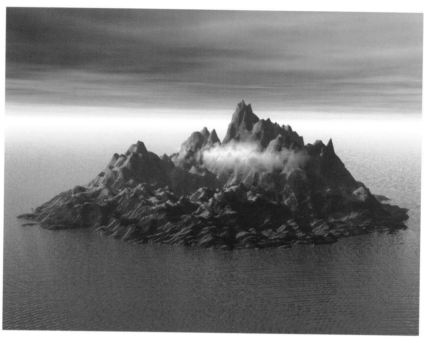

Multi-channel texture. Pebble beach with grass, rocks appearing with extreme slope. Very realistic!!!

Simple&Fast
Planes&Terrains
Rocks&Stones
Waters&Liquids
Clouds&Fogs
Wild&Fun
Complex fx
Miscellaneous

Also for use in wrapping onto sphere for volumetric clouds...

Simple&Fast
Planes&Terrains
Rocks&Stones
Waters&Liquids
Clouds&Fogs
Wild&Fun
Complex fx
Miscellaneous

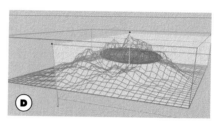

Creating the terrain

To complete the volcanic island model (see previous page) we used the terrain tool to create a fractal island (**A**). We maneuvered it off into the distance and enlarged it somewhat. Then we applied a texture chosen from Bryce's built-in library of mountain textures (**B**), which contains graphic descriptions of their characteristics (**C**). Our cloud (or ominous smoke) is made up of a simple ovoid hovering near the peak. The cloud texture we applied to the ovoid completely breaks down its uniform surface, leaving a convincing-looking vaporous mass that casts a soft shadow.

Making an infographic

To create a cross-section of the island to illustrate an article on volcanos, we used Boolean subtraction to combine the island with a large cube that sliced through it (**D**). This created the outline shape we needed. Then we scanned a piece of geological art (**E**) and pasted a portion of it into our rendering of the mountain cross-section in Photoshop (**F**).

5 | Manipulating 3D Objects

Transforming Objects

BASIC TRANSFORMATIONS

The term *transformation* enters computer jargon from mathematics, where it refers to the idea of performing an operation on one or more of the three Cartesian coordinates (x, y, z) that define three-dimensional objects and space. But in computer graphics, *transformation* means making any one of three basic changes to an object: positioning it (moving it around), scaling it (changing its size), or rotating it (changing its angle). These transformations are performed in relation to a matrix of points and axes that underlies the computer graphics system.

POSITIONING

A 3D model or scene usually involves a collection of many objects. As with arranging furniture, the task of positioning these objects in three-dimensional space can be tricky, although with desktop 3D you have the luxury of ignoring gravity. If you are accustomed to using a two-dimensional drawing program such as Adobe Illustrator or CorelDraw, then you're already familiar with the way objects can be positioned on a computer screen. As with

2D art, 3D objects can be moved around either by clicking and dragging with the mouse or by entering values in a dialog box.

MOVING OBJECTS BY DRAGGING

In 2D graphics, as the hand moves the mouse, the computer records its position in terms of vertical and horizontal distance on a flat plane and moves the object on the screen accordingly. But 3D programs provide a third axis to consider (depth), which can be difficult to accommodate on the two-dimensional monitor screen (especially when viewing a model in a perspective view, as opposed to one of the flat, orthographic views such as front or side). In some programs it is possible to simply select an object in a perspective view and drag it to move it in all three dimensions at once. But positioning can quickly get out of control with this much freedom, so most programs provide ways of constraining movement to only two dimensions at a time, either by choosing from a selection of different move tools or by holding down a modifier key while dragging.

Avoiding spacial absurdities
Moving and positioning objects by dragging them with the mouse is an easy and intuitive way to work. But when dragging is done in a perspective view, the visual feedback can be deceptive. For example, a group of cubes that appear to be stacked on top of each other may look correct in one view and be out of alignment when viewed from another point. Our stack of cubes looks correct when viewed in a straight-on view (**A**), but is it really aligned? The same visual appearance could have been produced either by a truly orderly stack of cubes, as seen from another angle (**B**), or by an arrangement of floating cubes (**C**). So it's best to position objects in orthographic views (such as front, side or top) and to check at least two orthographic views to make sure objects are in the right place. Then check the final results in a perspective view.

A top view shows positioning in the width (x) and depth (z) dimensions.

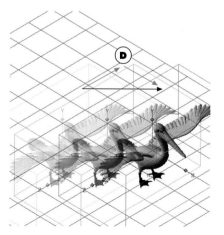

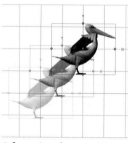

A front view shows positioning in the width (x) and height (z) dimensions.

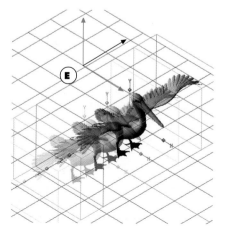

Moving in two axes at a time
Orthographic views provide a more accurate way of positioning 3D objects, since they allow movement in only two dimensions at a time. A top view, for example, allows positioning in the width and depth axes (**D**) while a front view allows movement along the width and height axes (**E**). After positioning has been done in an orthographic view, the results can be checked in a perspective view. It's handy to keep more than one view open while working.

When positioning objects, it often helps to use an orthographic, or nonperspective view, so that you are seeing only one plane. It's also helpful to open multiple windows showing the model from different angles simultaneously (such as top, side, front) so that you can see how a move in one plane affects the object's position in other planes. If your program will not display mul-

HOT TIP
Ray Dream Designer makes it possible to select two objects and automatically determine their distance from each other (from center to center). Then one object can be locked in position and the other object moved toward or away by entering a lower or higher distance number into a dialog box.

tiple view windows, try switching views frequently to check the position of your objects. Unless you check your model from several angles, you may create a spacial absurdity in which objects *appear* to be correctly positioned when seen from one perspective, but are juxtaposed in strange ways when viewed from another angle.

In addition to moving by dragging, many programs also make it possible to move selected objects small distances by "nudging" them by pressing the arrow keys.

MOVING OBJECTS NUMERICALLY

As well as visually guided movement of objects using the mouse or arrow keys, objects can be moved in a very precise way by entering numerical values into fields for the x, y and z axes in special windows, palettes or dialog boxes. Many programs also provide numerical readouts of the spacial coordinates of objects as they are moved. For more information on precise positioning of objects see the section on "Measurement, Alignment and Grids" starting on page 76.

POSITIONING LIGHTS AND CAMERAS

All 3D programs make it possible to position lights and cameras, as well as objects. Positioning a light close to or

CREATING NEW SHAPES WITH INTERPENETRATION

In the real world, we're accustomed to dealing with objects that are solid and maintain discrete boundaries. But 3D objects, though they do have definable boundaries, can nevertheless be pressed into each other as though they were made of clay, without losing any of their original shape. This potential for *interpenetration* makes it possible to overlap 3D objects to create compound objects with unusual and intriguing shapes. Two pyramids, for example, can form a complex star shape when combined. Parts of objects can disappear into other objects and re-emerge on the other side. Curved objects meeting at similar angles can create sinuously intertwined shapes that resemble organic forms (see "Stylized Human Figures" on page 90). The examples shown here were created with primitives (cones, spheres, cubes and cylinders). In the case of the exotic car model, the interpenetration of overlapping elongated spheroids forms a roof line and a doorpost upon a tinted glass cabin, and a stretched, flattened cylinder protruding at the rear gives a hint of a tail fin.

far from an object, or above or below, makes it possible to determine how surfaces will be lit and how shadows will be cast. Positioning a camera makes it possible to determine what view of the model will be captured for rendering. For more information see Chapter 8, "Lighting, Viewing and Rendering" starting on page 127.

SCALING

Scaling, or resizing of objects, can be done proportionately or disproportionately. Proportionate scaling makes objects simply bigger or smaller, while disproportionate scale distorts their shape by making them bigger or smaller in only one or two dimensions.

PROPORTIONATE SCALING

With *proportionate scaling*, an object's measurements in all three dimensions retain their original ratio. So, for example, a cube that is 3 inches wide will retain its cube shape when it is proportionately scaled to a size of 6 inches wide. Proportionate scaling is helpful for resizing parts of a model that are created in different modeling windows and may not fit together in the model as a whole. It's especially helpful for combining objects from different 3D clip art sources, which may have been modeled at different scales.

DISPROPORTIONATE SCALING

With *disproportionate scaling*, either one or two of an

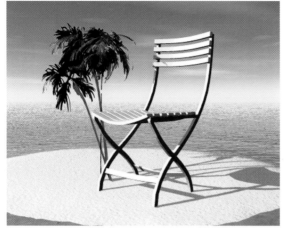

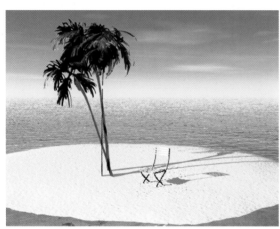

Avoiding inadvertent surrealism
When we imported the chair (from Cyberprops) into a Bryce model, it materialized at the same size as the palm trees. We scaled the chair to 25% for a more normal effect.

Glory is like a circle in the water,
Which never ceaseth to enlarge itself,
Til by broad spreading it disperse to nought.
—Shakespeare, *King Henry VI*, 1591

object's dimensions are changed in size, without changing the remaining dimension or dimensions. This causes a distortion in the original shape of the object. For example, when only one side of a 3-inch wide cube is enlarged to six inches, it becomes a rectangular box. Disproportionate scaling can be used with primitives such as cubes, spheres and cylinders to create a variety of other useful shapes, such as boxes, ovoids and columns. It can also be used with more complex models to create various intentional distortions.

As with positioning, the process of scaling in 3D uses conventions similar to those used by 2D illustration programs, but with features designed to accommodate the third dimension of depth. As with positioning, scaling can be done either with the mouse or by entering numerical values in a dialog box or palette.

SCALING BY DRAGGING
In computer 3D programs, each object is surrounded by a *bounding box*, a virtual wireframe box drawn around the outermost boundaries of the object. In some pro-

grams the corner points of this bounding box can be selected and dragged in order to scale an object, just as corner points are selected and dragged to scale objects in many 2D illustration programs. Most programs make it possible to scale by dragging in one, two, or three dimensions at once and provide a number of different methods. For example, by holding down modifier keys (often the same ones used for these functions in 2D programs) it's possible to scale an object in all dimensions proportionately, or to scale in only one or two dimensions, so that the result is disproportional. It's also possible in many programs to scale from the object's center, as well as from an edge. Some programs provide different types of scaling tools. For example, Infini-D provides one for resizing proportionately and one for disproportional scaling in only one dimension at a time.

SCALING NUMERICALLY
It's also possible to scale by entering values into x, y and z fields in a dialog box or tool palette. You can scale by entering numbers that refer to the actual size of the

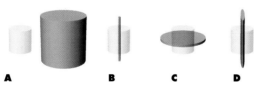

Scaling to create new shapes
We scaled a cylinder 200%, retaining the original proportions (**A**). Then we reduced the shape in the width and depth axes to 10% of the original size to make a thin rod (**B**). We reduced the shape vertically and enlarged it in depth and width to make a flattened disk (**C**). Finally, we stretched it along the depth axis to form an ellipsoidal rod (**D**).

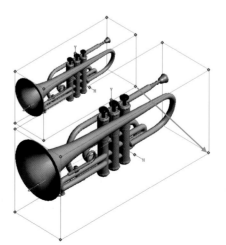

Dragging a corner handle
In most programs, dragging a corner handle of an object (or a corner of a bounding box) with a special tool will allow you to scale the object by eye. Holding down a modifier key will usually preserve the object's original proportions in all axes.

object (for example, change the *x* dimension from 10 to 8 inches) or by entering percentage values (for example by changing the *x* value from 100% to 80%).

KEEPING SURFACES ALIGNED WHEN SCALING

When scaling an object that is right next to another one, or is resting upon another object, you may find that the object you're scaling either penetrates into its neighbor or shrinks away from it. For example, enlarging a cup that's sitting on a table may sink the bottom of it into the table, while reducing the cup's size may leave it floating above the table.

When scaling by dragging, this problem can be avoided by selecting one of the objects's corner points that is not in contact with the neighboring object. For example, if one of the top corners of the cup's bounding box is selected and dragged up or down to enlarge or reduce its size, its bottom surface will remain in contact with the table.

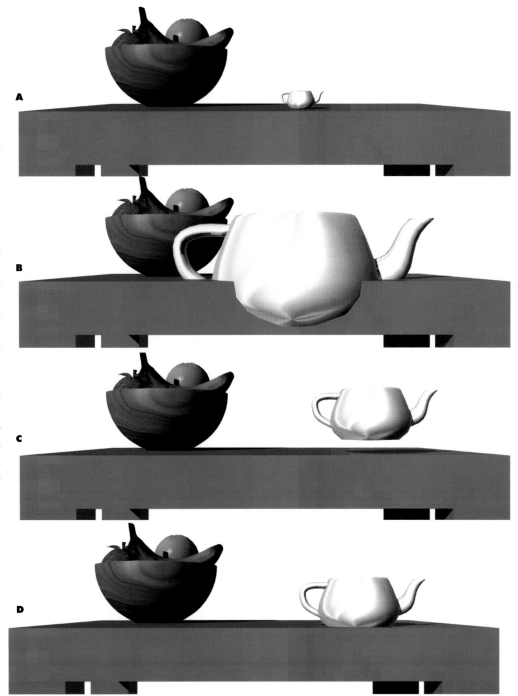

Encountering alignment problems when scaling
Although our teapot is resting firmly on the surface of the table, it is too small (**A**). But when we scaled it 400%, we overshot the mark a little. Now, not only is the teapot too big, but it's also half-buried in the table! (**B**) Scaling it back to a more plausible size, however, left it levitating above the table (**C**), before final repositioning (**D**).

ROTATING

All desktop 3D programs make it possible to rotate objects and provide several ways to do it. As with positioning and scaling, rotation can be done either by clicking an object and dragging with the mouse or by entering values in a dialog box.

ROTATING BY DRAGGING

Rotation by dragging can usually be done either in all three dimensions at once or in only one or two dimensions at a time. Different programs provide different tools or modifier key combinations for switching between rotation axes and methods. Most programs make it possible to rotate in a perspective view with a trackball type of tool that rotates objects freely in all directions.

Controlling rotation
Trackball-type rotation by dragging in a perspective view can quickly get out of control.

Most also provide ways of constraining movement to one dimension at a time. Rotating in all three dimensions at once can be dizzying and produce unpredictable results. So it's often best either to rotate in an orthographic view (such as front, side or top) so that rotation is possible in only two dimensions at a time, or to choose a rotation tool that constrains rotation to one or two axes at time.

MODIFYING CLICK-AND-DRAG ROTATION

As with 2D computer graphics, holding down a modifier key while rotating will enable various functions, such as constraining rotation to 45- or 90-degree increments or leaving behind an unmodified copy of the original. Shift, Option (Mac) or Alt (PC) and Command (Mac)

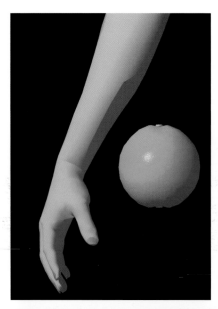

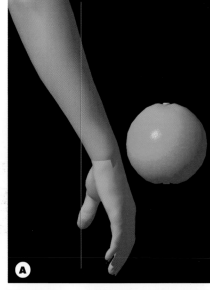

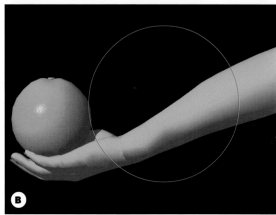

One axis at a time
We first pivoted the arm around the vertical axis 180 degrees (**A**). Then we rotated it around the depth axis 270 degrees (**B**). We rotated the arm 270 degrees again around the horizontal axis (**C**).

or Ctrl (PC) are the keys most commonly used to modify the action of tools, although the effect of a particular key varies from program to program. For example, in most programs the Shift key is used to constrain rotation to 45-degree increments, however in Infini-D it's used to constrain rotation to the depth axis.

ROTATING NUMERICALLY

As with positioning and scaling, most 3D programs make it possible to rotate objects by entering values for rotation (from 0 to 360 degrees, both plus and minus)

in the x, y and z fields of a rotation palette or dialog box. Some programs also allow you to specify whether the rotation is local (with reference to the object itself at its current orientation) or global (with reference to the object's orientation to the scene).

ADJUSTING THE CENTER OF ROTATION

Usually objects are rotated around their geometric center (picture a car on a turntable in a showroom). This center point is determined when the object is created and is referred to by different names in different pro-

Thus a roll causes a yaw and a yaw causes a roll ... When, as often, a pitch is also introduced, it soon becomes apparent why the problem is a difficult one.
Encyclopedia of Aviation, 1935

Rotation with local and global coordinate systems
We rotated a flashlight (**C**) 45 degrees in all axes (**D**). For this first manoeuver it didn't matter whether the rotation was *local* (relative to the object) or *global* (relative to the "world"). But when the object was rotated a further 90 degrees in all axes the results for global rotation (**E**) and local rotation (**F**) were different. This is because local rotation sets the new position relative to the current position of the object, whereas global or absolute rotation sets the object's orientation relative to fixed global coordinates.

grams, including *object origin point*, *hot point*, or *centerpoint*. However, most programs make it possible to change the location of this point. When this is done, then rotation (as well as scaling and positioning) takes place in reference to the new location of this point. So for example, if the centerpoint of a 3D auto is located some distance from it, rotation will have the effect of making the car drive around in circles.

ROTATING MULTIPLE OBJECTS

Many programs make it possible to select several objects and apply a transformation to all of them at once. Different programs apply different conditions to these multiple transformations. For example, in some cases rotating a collection of selected objects would cause each separate object to rotate around its own centerpoint. In other cases, a collection of selected objects can be grouped and then rotated around another reference point.

ROTATING LIGHTS AND CAMERAS

In addition to rotating 3D objects such as cubes and cylinders, most programs also make it possible to use the same tools to rotate lights and cameras. Rotation of a directional light, such as a spot light, makes it possible to aim it directly at a particular object. Rotation of a camera makes it possible to capture a view of a scene from any angle, even upside down and sideways. For more information see Chapter 8, "Lighting, Viewing and Rendering" on page 127.

DIFFERENCES IN TERMINOLOGY

Most 3D programs use the language of Cartesian coordinates to describe rotation, referring to this function as taking place around the horizontal (*x*), vertical (*y*) or depth (*z*) axes (see "Where Am I? Descartes and X, Y, Z" on page 29). However, Ray Dream Designer, one of the most popular desktop 3D programs, describes rotation with the terminology of aviation, using the terms *yaw*, *pitch* and *roll* to refer to rotation around the vertical, horizontal and depth axes respectively. Strata StudioPro also uses these terms to refer to the rotation of cameras. For more information see the "Manipulating Objects" on page 24.

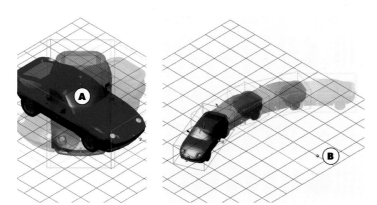

Setting the center of rotation
Objects are usually rotated around their center point, which is by default at the geometric center of the object. When we rotate our car around its natural centerpoint on the vertical axis, it spins as if it were on a turntable (**A**). However, the centerpoint can be moved, to enable different types of rotation. When we moved our car's centerpoint some distance away from the car and again rotated it around the vertical axis (**B**), the car pivoted as though it were turning a corner. The distance of the centerpoint from the object determines the radius of the turn.

Duplicating Objects

COPYING AND PASTING

The familiar functions of *Copy*, *Cut* and *Paste* are available in most 3D programs. In general, any object that can be selected can be copied (or cut) and will be stored in the computer's clipboard, a form of short-term memory. The Paste command will then paste whatever was last copied or cut, taking a copy from the clipboard into the 3D model. Usually a pasted copy is offset a small distance from the original and is selected, so it's easy to see which is which. Copying and pasting can be useful when working in two-dimensional views, as when creating a lathe outline or an extrusion cross-section. The Copy and Paste commands can also be used in many programs to copy an object from one model file to another. However, for more precision in placement and manipulation, a *Duplicate* function may be better when making copies, especially multiple copies, of 3D objects.

DUPLICATING AND REPLICATING

The *Duplicate* command, available in most programs, accomplishes the task of copying and pasting in one step, which saves time. In addition, Duplicate places the copy of the selected object (including all its associated surface attributes) in exactly the same location as the original so that it can then be transformed (positioned, scaled or duplicated) in relation to the position of the original.

Sometimes only one duplicate of an object is needed. For example, creating a cross requires that a stick be

Creating a fan by duplicating with offset and rotation
We made this old-fashioned fan by duplicating a simple shape along with an offset and a rotation. Working in Ray Dream Designer, we created and grouped together a fan blade and a wedge of cloth. Then we repositioned the center of rotation toward the end of the blade (**A**). Next we duplicated the blade and moved the copy behind by about half the thickness of the blade and also rotated it 6 degrees within the vertical plane. We then duplicated the transformed blade and duplicated again, which created a copy that was offset and rotated by the same amounts as before. By repeating the duplicating command 19 more times the fan was completed (**B**).

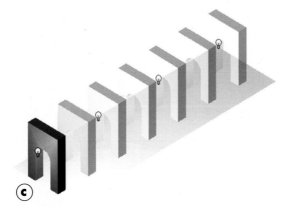

Adding depth by repetition
To create an illustration of a receding hallway, we drew an archway outline with StudioPro's filled Bézier shape tool and extruded it (**C**). We added a floor and a nearby point light source illuminating the archway. Then we used the Replicate Objects dialog box to replicate the arch six times with an offset going back in depth. We also replicated the light source three times so that a light appears at every other arch. The alternating light sources form an interesting pattern of shading, and a touch of fog adds to the sense of depth.

LONG-TERM INVESTMENT PLANNING

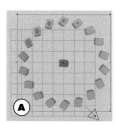

Creating an ancient stone circle
After creating a monolith in Bryce using a stone object, we moved and rotated a duplicate stone, then used Bryce's Multi-Replicate dialog box to duplicate it with the transformations 18 times (**A**). The original stone was then put back into the center of the ring. We added a ground terrain, a sky and fog to create a convincing-looking scene.

The moment that people stop copying you, it means you are no longer any good, and you have ceased to be news.
—Elsa Schiaparelli, 1954

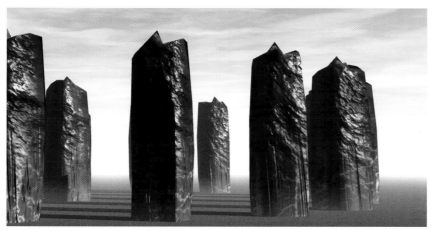

the replicating function is included in the Duplicate command. So for example, the first time the Duplicate command is used, it places a copy in the same location as the original. But if that duplicate is transformed and then selected and duplicated again, the new duplicate will be transformed in the same way.

Either way, in many programs, the process of replicating or duplicating with transformations is done by choosing the Replicate or Duplicate command over and over, once for each new copy. However some programs, including StudioPro and Bryce, provide a Replicate dialog box in which values for position, scale and rotation can be entered along with the number of duplicates desired. Then all the duplicates, with the specified transformations, are created in sequence with one action.

duplicated once and the copy rotated 90 degrees around its center in one dimension. But in many cases, modeling requires the duplicating and transforming of a series of objects—for example, copying and rotating a stick around a center point several times to create evenly spaced spokes for a wheel. For this type of modeling, the process of *replicating* or "duplicating with transformations" is very useful and powerful.

REPLICATING, OR DUPLICATING WITH TRANSFORMATIONS

In most 3D programs it's possible to *replicate* an object, which means to duplicate it along with whatever positioning, scaling or rotating transformations were last applied to it. This makes it possible to create a series of duplicates in a step-and-repeat fashion to model objects such as a fan or a spiral staircase, in which a series of identical elements are offset from each other.

In some programs, this function is called replicating in order to distinguish it from the process of duplicating a single copy, and there are separate commands for Duplicate and Replicate. However, in some programs

DUPLICATING WITH SYMMETRY

Some programs, including Ray Dream Designer, include a function for duplicating an object with symmetry; that is, the duplicate copy is reflected across an axis. Designer's interface allows the user to choose which of the three planes will function as the mirror plane for reflection. This feature is very useful for modeling objects that are symmetrical—such as human figures, vehicles and furniture—as it means that only one half of the object need be modeled. It can then be selected and duplicated with symmetry to create the other half.

Duplicating with Symmetry
A complex, variable cross sectional shape, such as a ship's hull (**B**), might be difficult to make perfectly symmetrical. But by making only one half of the model (**C**) and then using symmetrical or mirrored duplication (**D**), the two halves can be brought together in perfect symmetry.

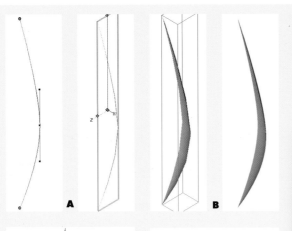

A

B

MAKING JUNGLE FOLIAGE WITH REPEATED SCALING AND ROTATING

Our jungle fern began as a single Bézier curve (**A**). Next we lathed it with 24 degrees of rotation to form a single, curved leaf shape (**B**). In the top view, we replicated the leaf shape 12 times, each time moving it back 1 unit in depth, scaling it 90% and rotating it 6 degrees on the vertical axis (**C**). Next we aligned the replicated leaves along the left side (**D**). Then the whole process was repeated with a flipped copy of the leaf to form the other half of the jungle

frond (**E**). We grouped the finished frond and moved its center point to the base of the stem (**F**). To make the entire plant we replicated the frond 8 times with a 90% scale, 45 degree rotation on the vertical axis and an offset of 1 unit on the vertical axis (**G**). In all, the original lathed leaf shape was repeated 192 times.

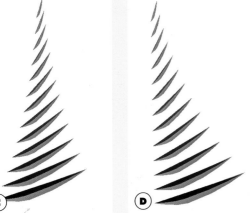

C

D

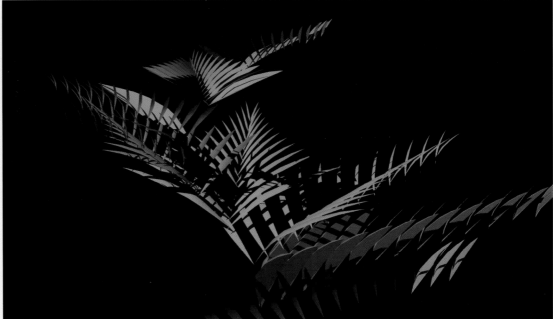

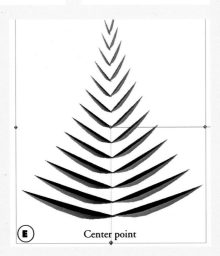

E Center point

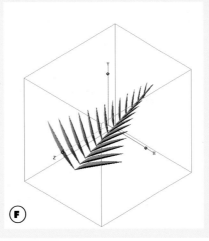

F

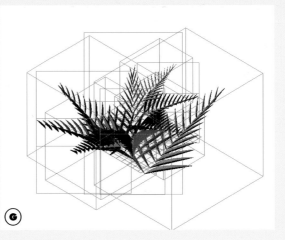

G

Tis beauty truly blent, whose red and white
Nature's own sweet and cunning hand laid on:
Lady, you are the cruell'st she alive
If you will lead these graces to the grave / And leave the world no copy.
—Shakespeare, Twelfth Night

MASTER OBJECTS AND INSTANCES

Many models include elements that are identical but are in different position or orientations or at different sizes; for example, the leaves on a tree (see opposite page), the petals of a flower, or the knobs on a control panel. We have seen that identical copies can be created by using Copy-and-Paste or a Duplicate or Replicate command. But an even more powerful way to copy an object is to create an *instance* of it, based on a *master* object. (In some programs, a duplicated or replicated object or even a copied-and-pasted object is automatically an "instance" of a master object.)

A master object is a kind of mold or prime object. It may not appear in the model itself, but instances of it do. The master object can be edited to change its shape or can even be completely replaced with another shape, and whatever changes are made will be made to all the instances currently in the model. This feature provides a quick and easy way to make changes to many elements of a model at once. In addition, in some programs using instances can save memory and rendering time.

In general, objects that are "instances" cannot be edited with regard to their "geometry" or shape. This type of editing must be done to the master object. In some programs an instance *can* be edited, but it thereby becomes a new master object. However, in most programs instances can be transformed (positioned, rotated or scaled), their centerpoints can be moved and their surface attributes can be changed, all independently of the master object.

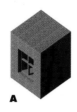
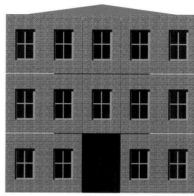

Creating a model from repeated master objects
We used a few simple extrusions to create a master object—a window cut into a brick-textured cube (**A**). Next, we generated many instances of the master object and stacked them neatly to form the facade of a building.

Modifying the master object
When we added a balcony and a lintel above the window on the master object (**B**), the change was instantly reflected throughout the entire building.

Altering the instances
Without changing the master object we rotated some of the instances in the building model 45 degrees. We also changed the texture of parts of some of the instances. In order to do this we first had to sever the link between the instance and the master object.

Missing the links
We altered the master object by deleting the balcony, adding more window panes and changing the lintel over the window (**C**). As might be expected, all the instances reflected these modifications, except the objects whose textures were modified, because their reference to the master object had been disconnected.

Measurement, Alignment and Grids

HOT TIP
As a rule of thumb with small objects, try modeling at exact size. For example, create your 3D telephone at the same size as a real telephone. Then a coffee cup model, also modeled at actual size, will look appropriate when positioned next to the phone.

GETTING STARTED WITH 3D

76

MEASUREMENT IN 3D

There are two aspects to measurement in desktop 3D: first, the setting of units of measure, such as inches or picas; second, the setting of the size of the "working space" in which a model is created, such as 12 inches wide or 12 feet wide. Units of measure are sometimes important so that imported objects can be correctly scaled within an existing model. But measurement is especially important so that the sizes of texture maps and the objects to which they are applied can be coordinated to get the desired result (see "Making Textures Fit the Model" on page 112).

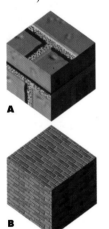

A

B

Considering object size when applying a texture
The size of an object affects the appearance of a texture applied to it. For example, the same brick texture applied to a 1-inch cube (**A**) looks different when applied to a 10-inch cube (**B**). If a texture is out of scale with an object, you can adjust the scale of either the object or the texture.

UNITS OF MEASUREMENT

Most programs make it possible to specify the units in which objects, working spaces and grids are measured. Choices include English measures (inches, feet, yards), metric measures (millimeters, centimeters, meters) and units used in graphics (pixels, points, picas). Some programs, such as StudioPro, also make it possible to define and name a custom unit of measurement. For example, you might define a unit called "hand-span" and specify that it is equal to seven inches. (Note: Bryce, a program designed for creating landscapes, uses its own units of measure, which bear no relation to any real-world units such as inches or points.)

THE SIZE OF THE WORKSPACE

Another aspect of measurement in the size of the visual "workspace" in which models are constructed. This space is known by various names in different programs, including *world*, *universe*, *scene* and so on. It is often desirable to keep the elements of a 3D model within the boundaries of your program's visible workspace because it contains grids that help with locating and aligning objects. So you may want to make sure that the working environment is a little larger than the largest object you plan to create. Each program handles workspaces and sizes in a slightly different way. Default values can usually be changed through a dialog box. The size of the working space is infinite, in theory.

"SNAP-TO" FUNCTIONS

The palettes or dialog boxes used for setting units of measure are also sometimes used for defining "snap to" parameters for alignment and for setting up grids. For more information on these functions see "Working with Grids" on page 80 and "Snapping Objects to a Grid" on page 81.

MODEL SIZE VERSUS IMAGE SIZE

Despite the many systems of measurement available in desktop 3D, the size of the model is always "virtual" and bears no relation to the size of any final images generated from that model. That's because the size of the rendered image is determined by the position of the camera (close or far away from the model) and the dimensions of the view frame (the boundaries of the camera's view). The view frame can also be specified in a variety of systems (inches, picas, pixels and so on). For more information see "Setting the Image Area" on page 141.

C

E

D

Setting the workspace
To make it easier to manage the modeling process it's advantageous to scale your model neither too small (**C**), nor too large (**D**), but just the right size to fit the workspace or grid environment (**E**).

Getting close to the point
A one-inch large image of an object can readily become a three-inch large image with the same resolution if it is rendered through a larger view frame.

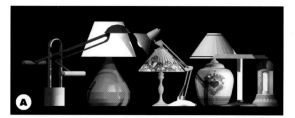

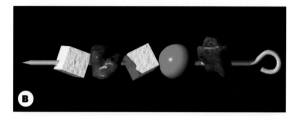

USING ALIGNMENT AND DISTRIBUTION

Desktop 3D programs include many features designed to automate and provide precision for the positioning of objects, so that elements need not be arranged "by hand," so to speak. Most useful are the functions for alignment and distribution, which are very similar to those found in 2D illustration programs, but with the addition of the third dimension of depth.

ALIGNMENT

The word *alignment* means simply an arrangement of items along a straight line. Likewise, alignment in desktop 3D means that objects are lined up along a straight line, like pickets in a picket fence. The straight line in question can be either the horizontal, vertical or depth axis. A single file of objects can be lined up along any of these axes, like acrobats in a circus.

MANAGING ALIGNMENT IN THREE DIMENSIONS

The addition of the third dimension of depth means that objects being aligned along a single axis can be lined up with reference to either or both of the two other dimensions (as opposed to only one other dimension, as in 2D illustration). In a 2D program, pieces of clothing can be positioned along a horizontal clothesline and then aligned with reference to their vertical position above or below the line. But in a 3D program, the clothes can also be aligned with regard to their position in depth, so that they are hanging directly below the line or hanging in space either in front of or behind it. In a front view of the clothes, only their up-and-down or vertical positions can be seen, while the front-and-back or depth positioning can be seen in a top view or a side view.

Likewise, when objects are spread out along the vertical axis, as in a tower of blocks, their position can vary with regard to the other two dimensions, either horizontal (from side to side) or depth (from front to back). Finally, when objects are spread out along the depth axis, as with a line of toy soldiers coming towards us in single file, they can be aligned with regard to the horizontal (side to side) or vertical (up or down) axes.

However, in the alignment palettes or dialog boxes provided by most programs, fields for each of the three dimensions allow alignment to be made only with regard to one other dimension. So to get objects lined up in all three dimensions, it's necessary to apply at least two alignment functions at once. So for example, to line up a group of parking meters along a horizontal street, it would be necessary to specify alignment with reference to both the vertical and depth dimensions.

ALIGNING BY CENTER OR SIDES

Most programs make it possible to align objects with reference to their centers or to either of two of their opposite sides. So, for example, objects strung out along the horizontal axis, such as clothes on a clothesline, can be aligned with reference to their tops or bottoms or centers.

Aligning on the three axes

Vertical axis alignment is shown by an assortment of lamps aligned at bottom (**A**), a skewered kebab aligning at center (**B**) and a string of bunting aligned at top (**C**). Horizontal axis alignment is shown by three piles of wood aligning left (**D**), center (**E**) and right (**F**). Depth axis alignment is represented by a fence crossbar aligned back (**G**), center (**H**) and front (**I**).

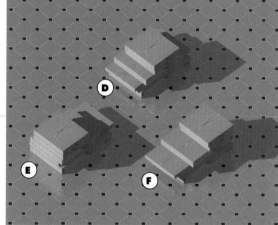

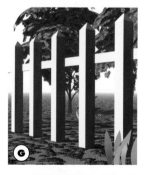

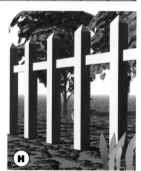

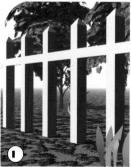

Center-aligning multiple objects
When a number of various-sized circles, drawn haphazardly, are combined with a sphere (**A**) they can be brought together by using alignment or centering so that the objects' center points are all at the same *x, y, z* location. The result is an orderly approximation of the planet Saturn (**B**).

DIFFERENCES AMONG PROGRAMS

As with so many functions in 3D, different programs use different conventions for defining alignment. In addition, the results of alignment can differ depending upon whether it is done with reference to a modeling "box" or "workshop" or with respect to the larger model.

The terminology of the dialog boxes can sometimes be confusing since it's not clear whether "horizontal alignment", for example, means the alignment of objects strung out along the horizon, or the position on the horizontal axis of objects that are stacked vertically or receding in depth. For example, when StudioPro indicates "horizontal alignment" and provides left and right as reference options, the intent is not to provide a function that could align the clothes hanging on a horizontal clothesline but rather to align a series of flags stacked up and down along a vertical flag pole. So to get the best results, you'll need to learn and experiment with the alignment function in your own program to discover exactly how it works.

CENTERING MULTIPLE OBJECTS

Most programs make it possible to align objects so that their centerpoints are all in the same *x, y, z* location. This is *centering*, not *alignment*, but the centering function is sometimes done through an alignment dialog box or sometimes through a separate centering dialog box. Often the centerpoint of the "oldest" or first created object is used as the reference location; sometimes the first selected object's centerpoint is used. In addition, some programs make it possible to *align* or center any number of objects to the center of the workspace, so that their center points are located at the *x, y, z* coordinates of 0, 0, 0.

Using distribution to make a layout
We used Ray Dream Designer's Distribution and Alignment functions to place these insects exactly equidistant so that they would align with the four panels of a fold-out leaflet. Distributing and aligning the objects along the horizontal axis was accomplished in one step. The vertical alignment was set so that the bugs would align at bottom, in contact with the tabletop.

DISTRIBUTION

Many programs provide a distribution function, which is used to position a group of objects so that they are evenly spaced along a particular axis. Usually the two outermost objects remain in their original positions and the in-between objects are evenly spaced between them. Again, distribution can be applied on any of the three axes and is often used together with alignment. So for example, after aligning a group of randomly spaced fence pickets so that they are all at the same height and in the same plane, we could then distribute them so that the pickets are evenly spaced between the two end pickets. As with alignment, distribution can be done with reference to the centers of the objects or with reference to either of two opposite sides.

HOT TIP
Alignment functions are especially useful for modeling human-made objects, which tend to be regular and orderly. However, Bryce, which specializes in the creation of natural-looking landscapes, also includes a Randomize function that will disperse or scatter objects randomly. This could be applied to a selection of trees on a hillside, for example, to achieve the random spacing of a natural forest, as opposed to the orderly rows of an orchard.

Safe spacing
Our red sports car is tailgating the truck, which is keeping a safe distance behind the old car in front of it (**A**). To even things out, we selected all three vehicles and distributed them from their centers (**B**).

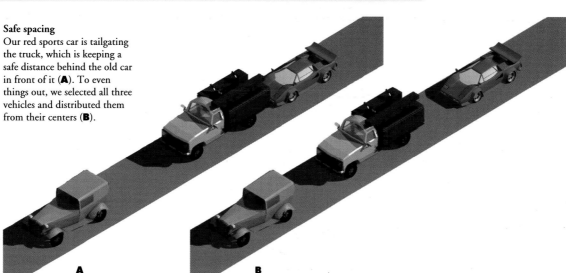

A B

Using a grid as a visual guide
In a 3D model a visible grid system helps you orient your model in space. These grids are only guidelines and do not appear in the final rendering.

WORKING WITH GRIDS

First used by the ancient Egyptians, a grid is a mathematical device that artists have used for centuries to calculate proportions or translate small sketches to larger sizes. Similar to frets on a guitar, a grid "quantizes" an approximate position to a precise location within a predetermined matrix. In desktop 3D, a grid can function in three different ways: as an unseen, underlying matrix that objects "snap to"; as a framework for helping

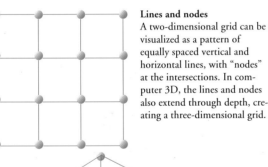

Lines and nodes
A two-dimensional grid can be visualized as a pattern of equally spaced vertical and horizontal lines, with "nodes" at the intersections. In computer 3D, the lines and nodes also extend through depth, creating a three-dimensional grid.

to contain and orient a model; and as a visible grid of lines used as a drawing aid in a modeling window.

GRIDS AS INVISIBLE STRUCTURE

The grids used in desktop 3D are similar to those used in 2D illustration, but with the addition of the depth dimension. So instead of a two-dimensional array, similar to a checkerboard, there is a three-dimensional array, similar to a jungle gym. As in 2D programs, it's usually possible to specify at least four grid parameters: spacing, frequency, snap-to and visibility.

SPACING

The units of measurement to be used in a grid can be specified (see "Measurement in 3D" on page 76). For example, a grid can be set so that a grid line appears every 2 inches.

FREQUENCY

It's usually possible to specify whether grid lines will be drawn at every unit increment, or at every two units or more. So if the grid spacing units are set at 2 inches and the frequency is set to 2, for example, then a grid line would be drawn every 4 inches.

SNAP-TO

Most programs include a "snap-to" function which can be turned on or off. When snap-to is enabled, then any object moved along a grid will jump or snap to the nearest grid intersection. (See "Snapping Objects to a Grid" on page 81).

VISIBILITY

Visible grid lines can be an aid in drawing and modeling but can also add unwelcome visual clutter to your view of a scene, so most programs make it possible to make grids visible or invisible. Some programs also make it possible to change the color of the grid lines, which makes it easier to distinguish different grid planes. If the

snap-to function is turned on, it will operate whether the grid is visible or invisible.

GRID AS VISIBLE GUIDES

Not only do grids provide an invisible underpinning for 3D modeling, but grids can be made visible to make it easier for us to orient ourselves in 3D space. For example, Ray Dream Designer provides a sort of modeling "box" which consists of a floor and two side walls which intersect to create something like the corner of a room. The floor and wall planes appear as square grids and help us to see immediately whether the objects in our model are right side up, so to speak. Other programs provide similar sorts of grid-like containers or ground surfaces for the model. Some examples of different programs' screen views of the working space are shown in "Viewing the 3D world" on page 26.

Using or not using grids
The freeform shape on the left (**A**) was made with the snap-to function turned off and appears chaotic when compared to a similar one (**B**) made with the snap-to function enabled.

Changing the grid scale
Using a one-inch grid with "snap-to" enabled, we were able to create stairsteps that were uniform and architecturally correct (**C**). To make the more detailed railing we changed the grid frequency to 1/16 inch and made the visible grid 1/4 inch (**D**).

SNAPPING OBJECTS TO A GRID

Snapping is an alignment feature that has been programmed into 2D drawing and layout programs for over a decade and has been carried over into desktop 3D. Snapping relies on the existence of a grid, whether visible or invisible, which underlies the visible computer graphics interface (see opposite page). The spacing of this grid can be defined, and when a "snap-to" feature is enabled, an edge or corner point or centerpoint of any object that is drawn, moved, or imported will be automatically aligned to the nearest grid intersection. This feature is also sometimes called "gravity" because the grid intersections seem to pull objects toward them. Most desktop 3D programs include a "snap-to-grid" feature. Infini-D also includes a "snap-to-guides" feature that snaps objects to guides that are positioned by the user. Bryce also includes features that snap objects to the ground plane and to the center of the working space.

Often it is the centerpoint of an object which snaps to the grid node, not an edge or corner (unless the "centerpoint" has been repositioned to an edge (see "Setting the Center of Rotation" on page 71).

Turning on a snap-to function will not affect the position of objects already in the model. It will only affect objects that are moved after the snap-to function is turned on.

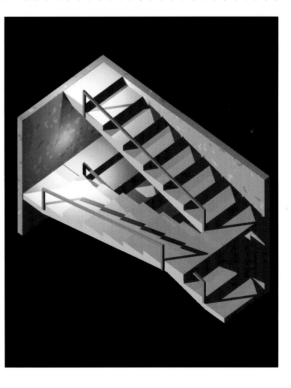

Using a grid to extrude and align
We used grids in the horizontal and depth axes to gauge the correct mount of extrusion and aid in the visual alignment of the replicated elements of the stairs (**E**). A vertical axis grid helped us to align the extruded stair well with the top of the steps (**F**).

Using a grid for precise alignment

The seamless transition between the surfaces of the cylinders and spheres was accomplished by creating the primitive shapes in whole number sizes made up of the same units as those of the grid. For example, each sphere and cylinder might be 4 inches in diameter, on a grid with 1 inch spacing. Then each element can be smoothly interpenetrated by snapping each one to the underlying grid.

Making precise curves

Grids are also useful in generating precise curves and lines to use as cross-sections for extruded objects. The grid not only helps in placing the control points of the curves in the right places, but also helps to keep these control points neatly lined up so that the curved shapes are consistent.

FINE-TUNING GRIDS AND SNAP-TO INCREMENTS

Sometimes it's useful to have a finely spaced grid in order to have small increments for snapping and nudging. However, a very high-frequency grid can clutter up your on-screen view. Some programs make it possible to specify subdivisions of "snap-to" so that the snap-to increments are smaller than the units of the grid. So if the grid is set to draw a line for every one inch, for example, with a snap-to subdivision of 2, then objects would snap in half-inch increments. If your program doesn't provide this feature, you can work around it by specifying small grid increments (to which objects will snap) and specifying a grid line frequency that's greater than 1. For example, your grid could be set to quarter-inch increments (for the sake of finely tuned snapping), but the frequency could be set to draw grid lines at every four units (for the sake of a more widely spaced grid appearance on screen).

HOT TIP
Many programs give the option of defining your grid or measurement system in terms of feet, inches, centimeters, picas, pixels or points. Since the 3D model is an artificial world with its own self-referential coordinate system, the unit of measure you select makes no difference to the scale and appearance of the model.

object two inches, from grid line to grid line. Some programs also make it possible to specify subdivisions of "nudge." So a nudge factor of 8 in a 2-inch grid would move objects in increments of one quarter inch.

GRIDS AS AIDS TO DRAWING AND MODELING

In addition to providing a structure for alignment and snap-to and to providing a visible workspace, grids are also important aids to drawing in the two-dimensional planes in which outlines for lathing and extrusion are created. The curves and lines of these outlines sometimes require precise alignment to produce well-formed objects.

NUDGING

In some programs the grid spacing determines the "nudge" factor—that is, the increments of movement produced by moving objects with the keyboard's arrow keys. So, for example, if a grid is set up with a spacing of two inches, each press of an arrow key will move an

Using a grid with a visible spacing wider than its underlying structure

For our extruded horse we used an underlying grid in millimeters with a snap-to of 2 units, while the visible grid is set to 10 units. Even when drawing organic shapes, a snap-to grid helps keep the lines elegant. This is useful when points on overlapping shapes coincide.

Organizing Objects within a Model

Grouping to apply a texture
In some programs grouping allows a single texture map (inset) to be applied uniformly to several different objects.

CREATING HIERARCHIES OF OBJECTS

As a desktop 3D model is created, it can come to contain hundreds of separate parts. It can be difficult trying to pick your way among myriad small, unrelated cubes, spheres and other objects, so most programs provide ways of organizing the many separate parts of a model into groups of items that belong together. In particular the functions called *grouping* and *linking* are used to create what are called object hierarchies, which aid in the organization of complex models.

In general, the function of *grouping* is used to organize elements of a model into logical collections of related items that belong together, such as the spokes of a wheel. Any two or more objects—including lights and cameras, as well—can be grouped into a unit that functions as one. (In this way lighting effects and camera views can remain with a modeled object, even when that object is moved.) By contrast, the *linking* function is used to create ties between objects which govern the movement of these objects in relation to each other, such as the movement of fingers in relation to a hand. So linking makes it possible to create objects that are *articulated* or jointed.

It's important to note that both grouping and linking create temporary ties between objects. Either can be undone at any time using an Ungroup or a Break Link command. This makes the processes of grouping and linking very flexible. Groups and links can be set up as the model is built and elements can added or subtracted from groups as the need arises.

DIFFERENCES AMONG PROGRAMS

As usual in the world of desktop 3D, different programs handle grouping and linking in slightly different ways. Some programs, such as Ray Dream Designer and StudioPro, make it possible to view a model's hierarchy

in the form of a branching flow chart. This makes it possible to select groups or individual members of groups through a hierarchy window, as well as through a model window. In Infini-D there is no Group command and the linking function serves for both grouping and linking.

GROUPING OBJECTS

Grouping makes it much easier to manage complex objects and models. Instead of having to individually select all the elements of an object, such as all the pickets in a fence, you can group elements that belong together so that one click selects them all. This is especially useful when working with composite objects that contain many small pieces, especially when some are hidden from view. For example, when models are created using the Duplicate and Replicate functions described on pages 72 and 73, it's often a good idea to group the copies that these functions generate.

When objects are grouped—as when the spokes, hub and other elements of a bicycle wheel are grouped, for example—the grouped object can be selected and transformed (positioned, scaled, rotated) as a single unit without disturbing the relationship between the elements of the group. Grouping can also be a convenient way of applying identical attributes, such as textures or colors, to many objects in one step.

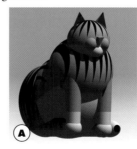

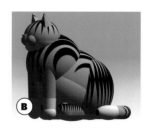

Grouping and rotation
An object made up of a number of parts, such as this cat (**A**), should be grouped before it is rotated (**B**), otherwise each individual part will rotate on its own axis, causing a partial disintegration of the model (**C**).

Some programs make it possible to select single objects within a group so that they can be transformed independently without removing them from the group or affecting other members of the group.

Since the grouping function is used often in desktop 3D, some programs provide not only a Group command that can be chosen from a menu, but also a keyboard shortcut (often it's Command-G/Ctrl-G) and a Group button on a tool bar.

Grouping and alignment
When parts that come in symmetrical pairs (such as the legs of our cat) are grouped, they can be aligned on center with other single parts.

Groups and subgroups
To make the stamens of the flower we drew a sphere and a cylinder, grouped them and replicated this group to create the elements of another group (**A**). We made a petal and replicated it to form a group of petals (**B**). Next a stem (**C**) was added to the stamens and the petals to complete a single flower. This single flower was grouped and replicated to form a bunch of flowers (**D**).

GROUPS WITHIN GROUPS

In addition to grouping single elements, two or more groups can be grouped together. So a complex object, such as a car, can be organized into a group composed of many subgroups (tire, hood, axle and so on). Multigroup groups can also be grouped until there is finally one single group that includes all the subgroups of a model. The process is similar to a series of nested boxes in which each box contains several smaller ones. Exploring the grouping organization of 3D clip art models is a good way to learn how professionals use this function to organize complex models.

GROUPING AND UNGROUPING

Groups can be split into their component parts again by using an Ungroup command. This operation does not change the position or any other attributes of the component elements, but merely breaks the relationship between them so that each one again functions as an individual. Generally, with an object that contains many levels of grouping, the Ungroup command applies to the outermost layer first. So, for example, ungrouping a complex car model would separate the subgroups from each other, but each subgroup (such as a tire) would still remain grouped. These smaller groups would have to be individually selected in order to be ungrouped.

Sometimes grouping is required in order to execute a Boolean operation, one in which one object intersects another and is combined with it or takes a chunk out of it. (For more information see "Boolean Operations" on page 54).

LINKING OBJECTS

Linking is a process of creating a specific type of physical link or tie between an object defined as a "parent" and one defined as a "child." A common use of linking is in the modeling of *articulated* or jointed structures, such as the arms and legs of animals, robots and humans. Linking is also widely used in animation so that objects can be moved in a sequence. When objects are linked, changing the position, rotation or scale of the parent will affect the child's position, rotation or scale, but moving, rotating or scaling the child will not affect the parent. In the case of a body, for example, if the torso is defined as the parent and the head as the child, then the head can be moved without moving the body (to make the head nod, for example), but when the torso is moved, the head will come with it. Or imagine that if a "parent" is selected and crosses the street, all the linked "children" cross also. But if a "child" is selected, she can cross the street by herself, leaving the "parent" behind.

TYPES OF LINKS

Programs that support linking usually provide several different types of links, which are used to allow, constrain or prevent movement of a child object in any of the three dimensions. For example, one link type may constrain movement of a child object to a particular plane. Another link type may allow rotation around the child's centerpoint in one dimension. Other link types may constrain movement to that of an object on a slider, or to something similar to a ball joint.

Linked objects can be arranged in chains so that an object such as an arm, for example, can bend in several places: shoulder, elbow and wrist.

Linking shapes to make an articulated model
Perhaps the simplest way to demonstrate articulated linking is through a linear chain of shapes, as in a toy snake. Working from the tip of the tail toward the head, we linked each segment one by one. The last link—the head—became the "parent" object of the whole chain. Moving or rotating the head would move the whole snake, but moving any other segment would leave the head behind.

To make the snake slither, we began to rotate each section slightly, working from the head towards the tail. As each segment was rotated it carried the following segments with it, leaving the segments in front of it unaffected.

6 | Creating Simple 3D Models

Combining Simple Objects

MAKING OBJECTS WITH PRIMITIVES

Creating objects with primitives has at least three advantages: first, it's easy, since primitive shapes are included in every 3D program; second, it's fast, since primitive shapes render into final images more quickly; and third, it encourages you to simplify, making it possible to create stylized illustrations without a lot of fuss. It might be just as easy to draw a simple object or scene, but one advantage of illustrating with 3D is that the same model, once constructed, can be used to generate any number of images by changing surface textures, changing the lighting, or simply by changing the camera viewpoint.

Thinking like a toymaker
One way to approach modeling with primitives is to imagine working as a wooden toymaker, building everyday objects out of blocks of wood in simple shapes. Shapes can be placed on top of each other to create objects that have a certain childlike charm, like our train engine.

Unlike wood however, 3D shapes are "soft" and can be pulled and stretched into myriad shapes not available to woodworkers, like the spheres we stretched into ovoid shapes for our airplane. In addition, computer 3D shapes can penetrate into each other in a way that blocks of wood cannot. For more information see "Creating New Shapes with Interpenetration" on page 67.

(**A**)

(**B**)

(**C**)

Illustrating in a hurry
We used primitive shapes to create a simple scene with a house, tree and picket fence (**A**). An exploded view shows the various primitive shapes of which the model is constructed (**B**). We applied ready-made textures (brick, grass, wood, leaves and so on) and rendered the image (**C**).

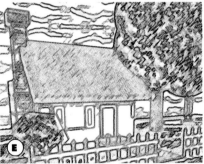

(**D**)

(**E**)

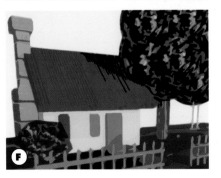

(**F**)

Altering the rendered image
To create a series of variations, we edited the rendered house image in Photoshop. After removing artifacts with the Dust & Scratches filter and correcting the contrast with Levels, we applied the Colored Pencil filter with the paper set to light blue to produce an image similar to a hand drawing (**D**). We then filtered the pencil version with Photoshop's Find Edges filter to make a bright and fanciful image (**E**). Returning to the original rendered image, we also used the Cut Out filter to create an image with the look of a silk screen (**F**).

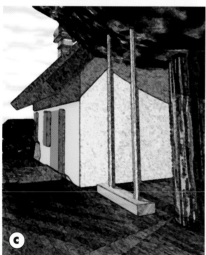

Changing the view
To demonstrate the versatility of 3D, we positioned two new cameras in the house scene and rendered images from each of the new views (**A**, **B**). We then altered each rendering in Photoshop using various filters. The side view was enhanced by using three Artistic filters in a row, Smudge Stick, Watercolor and Fresco (**C**). The front view was treated with the Sponge filter and then was desaturated, colorized and sharpened with Unsharp Mask to create a print-like monochrome version (**D**).

MODIFYING 3D IMAGES

Models composed of primitives can be made more interesting through the application of surface textures to the simple shapes. Images rendered from textured models can be modified further in an image-editing program like Photoshop to produce illustrations that belie their origins in 3D. For more information see "Applying Filter Effects" on page 158.

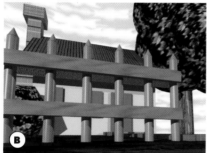

HOT TIP: THINK IN TERMS OF SHAPES

Become familiar with the kinds of shapes that each of the modeling tools in your 3D program can produce (primitives, lathes, extrusions) so that you can analyze everyday objects and break them down into component parts that you will be able to make. Also, examine the structure of imported 3D clip art and take it apart in your own program to see what sort of objects it contains and how they are assembled.

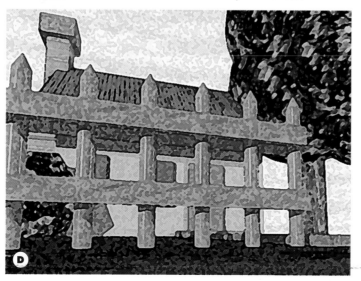

THE ART OF THE SIMPLE

Many artists have noted that ordinary objects can be broken down into basic primitive shapes. Cézanne was particularly interested in this way of abstracting reality (see "The Modeler's Eye" on page 91). Artists have also noted the emotional power that simple objects can have, especially when they are arranged and lit in the right way. Here are some quotes to inspire you in your exploration of simple 3D shapes.

"More than any artist of his day, Piero [della Francesca, who died in 1492] believed in scientific perspective as the basis of painting; in a rigorously mathematical treatise—the first of its kind—he demonstrated how it applied to stereometric bodies and architectural shapes and to the human form. This mathematical outlook permeates all his work. When he drew a head, an arm, or a piece of drapery, he saw them as variations or compounds of spheres, cylinders, cones, cubes and pyramids, endowing the visible world with some of the impersonal clarity and permanence of stereometric bodies. We may call him the earliest ancestor of the abstract artists of our own time, for they, too, work with systematic simplifications of natural forms."
—H. W. Janson, *History of Art* (Prentice-Hall and Harry N. Abrams, 1962)

"…a house of simple people which stands empty and silent in the vast Southern country morning sunlight and everything which on this morning in eternal space it by chance contains, all thus left open and defenseless to a reverent and cold-laboring spy, shines quietly forth such grandeur such sorrowful holiness of its exactitudes in existence, as no human consciousness shall ever rightly perceive, far less impart to another: that there can be more beauty and more deep wonder in the standing and spacings of mute furnishings on a bare floor between the squaring bourns of walls than in any music ever made…"
—James Agee, *Let Us Now Praise Famous Men* (Ballantine, 1974)

Art, it seems to me, should simplify. That, indeed, is very nearly the whole of the higher artistic process; finding what conventions of form and what detail one can do without and yet preserve the spirit of the whole…
—Willa Cather, 1920

Making the peg head

To create one end of the peg head we started with a 2D outline used as a guide (**A**). We created a series of rectangular ribs or cross-sections, arranged them at equal intervals (**B**) and adjusted the height of each rib to align with the edges of the template (**C**). We made the last rib the same size as the guitar's neck and offset it so that the end of the peg head would curve to meet the neck. We then "skinned" the cross-sections together, using extrusion with multiple cross-sections. The template outline was discarded. (**D**).

COMBINING PRIMITIVES WITH EXTRUSIONS AND LATHES

To make a 3D model of an object such as an electric bass requires that we spend some time analyzing which parts can be made from primitives and which from extruded or lathed objects. Because the process of working with 3D models often parallels the industrial production process, real objects that are good examples of industrial design (such as mass-produced guitars) are often straightforward and enjoyable to model.

Making the capstans

Using a PostScript drawing program, we drew a 2D circle and sliced it in two by subtracting a rectangle from its center. We imported the shape into our 3D program and extruded it to make a slotted cylinder. A flattened cone primitive was added to complete the capstan.

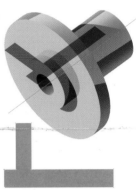

Lathing a flange

The flange that keeps the top two strings of the bass aligned was made by lathing a 2D profile drawn with straight lines. The lathing axis was offset slightly to create a hole in the center of the shaft.

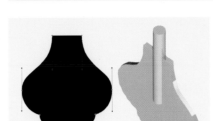

Making the tuning pegs

The pegs consist of a shape extruded from an outline drawn with Bézier curves, combined with a cylinder primitive.

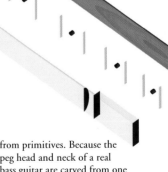

Typical section of neck

Combining a complex shape with a primitive

To complete the peg head we added a flattened cylinder primitive. The rounded end would have been difficult to accomplish with cross-sectional modeling.

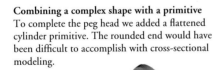

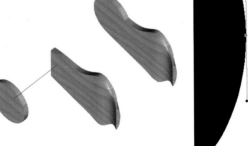

Making the neck

Like the peghead, the neck required extruding with multiple cross-sections. We used two rounded sections to form the main length of the neck. The one closest to the body was slightly enlarged to give the neck a slight taper. Where it meets the body the neck changes to a rectangular section. Next, we added the frets and dots for finger position and a rounded end all made from primitives. Because the peg head and neck of a real bass guitar are carved from one block of wood, we grouped our peg head and neck to apply an overall wood texture.

Making the pickups
Making the pickups was simple. We extruded a rounded-corner rectangle to form the body of the pickup, used four small cylinders for the pickup heads and used two larger cylinders for the mounting lugs.

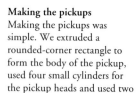
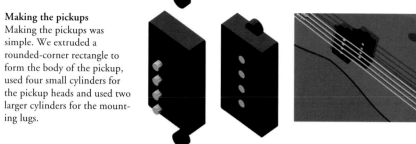

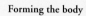

Adding strings and knobs
Both the strings and the knobs were made from cylinder primitives. The cylinders that form the strings are extremely elongated.

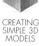

Forming the body
We used Bézier curves to create a graceful outline for the guitar body and extruded it with a rounded bevel.

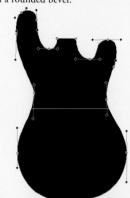

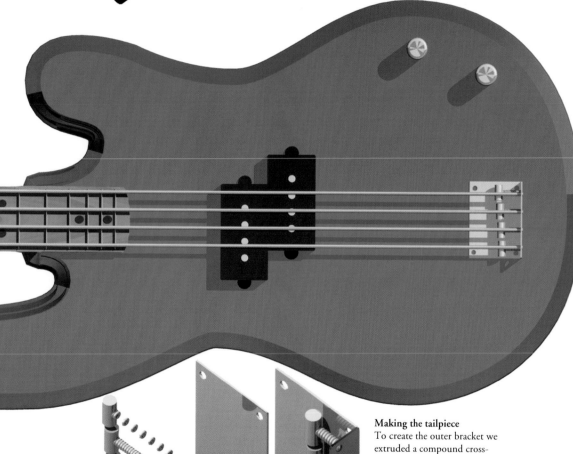

Making the tailpiece
To create the outer bracket we extruded a compound cross-section outline consisting of a rounded rectangle with circles near the four corners. The circles created the screw holes we needed. We formed the spring-mounted bridge assembly components from a series of replicated torus primitives and cylinder primitives.

Creating Human Figures

STYLIZED HUMAN FIGURES

The human figure is, perhaps, the ultimate challenge in desktop 3D modeling. Bodies contain many complex forms, which can be modeled accurately only by using organic, freeform shapes composed of polygonal mesh. (For more information see "Working with Mesh Objects" on page 57.) However, most parts of the human body, when perceived in a simplistic way, break down into elongated spheres, cones and tapered cylinders. So one way to create a human figure is to build it up from parts based on primitives. To demonstrate, we used edited primitives to create a heroic female figure. We were able to model almost all of her body parts using primitives (though details such as fingers, eyebrows and ear lobes were not included) and we found that the areas where the primitive shapes meet and overlap often form surprisingly complex shapes that are pleasing to the eye.

There is a certain elegance in the simplicity of human models made with primitives, much like the spare but expressive styles in modern sculpture. Another advantage of this approach is that models composed of primitives render much more quickly than those made of polygonal meshes.

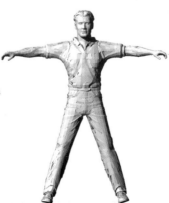

Real men are complex
This man is part of a 3D clip art collection of human figures (from Acuris), which also includes the baby on page 99. These highly realistic models are constructed from polygon mesh.

Primitive body parts

The human body can be broken down into four main components: the head, the torso, the arms and the legs. An exploded view of the torso (**A**) shows that the breasts are made of a combination of spheres and cones and the trunk consists of two overlapping tapered cylinders. (Two views of the completed torso are shown below). When parts of the face are exploded (**B**), we see that the cheeks are a heart-shaped conjunction of two tilted elongated spheres. The spherical chin tucks in below (**C**). The shape where the hairline meets the face, (**D**), is caused by the overlap of the spherical objects. An elongated sphere forms a ponytail. A bump map provides a suggestion of locks in the hair. A cylindrical neck completes the head.

The limbs

The arm is made up of a tilted cylinder for the upper arm, a sphere for the elbow and a tilted elongated sphere for the forearm. The hand is merely an elongated cone (**E**). The thigh is made of an elongated sphere fitting into a tapered cone (**F**). When assembled, the knee and the calf muscle are almost buried, giving a graceful curve to the leg.

HOT TIP

When working in Ray Dream Designer, it is possible to duplicate objects with symmetry, So after modeling the left leg, for example, it could be duplicated and flipped to create a right leg. In other programs, it is necessary to model the left leg, make note of the degrees of rotation of all the parts, duplicate it and then change the angles of any rotated elements by entering *double* the corresponding negative values in the duplicate.

Adding clothing
Selecting parts of the torso of the unclothed model (**A**) and making them a different texture created a skintight leotard (**B**).

To create a skirt we added a simple cylinder whose cross section was carefully elongated to form a tangent with the hips. The parts of the leotard below the waist (**C**) were colored the same as the cylinder to form the complete skirt (**D**).

C D

Striking a pose
Grouping or linking parts of the body makes it possible to rotate them without all the smaller pieces flying apart. Some human figures available as clip art are segmented so that pivoting joints can be made. (For more about linking and pivoting see page 84.)

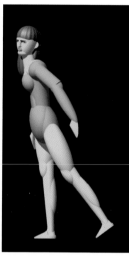

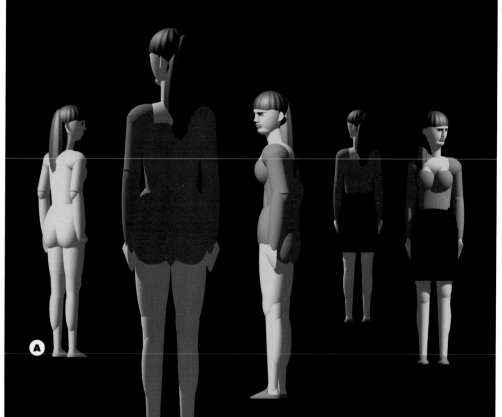

A

B

HOT TIP
A program called Poser, from the makers of Ray Dream Designer, includes ready-made 3D models of male and female adult and adolescent human figures as well as human skeleton and mannequin models. These can be stretched and squeezed to create myriad human forms. Both nude and clothed figures are included, and models can be posed to create different postures and positions.

THE MODELER'S EYE
Human figures are so complex that trying to model them realistically in a desktop 3D program can be a daunting task. However, very satisfying results can be obtained by abstracting the human form a little, following the lead of many painters and sculptures of the modern era. In Cubist art, for example, human figures are often constructed of geometrical forms and planes. Consider Picasso's painting, "Les Demoiselles d'Avignon," in which the women's forms are constructed of rough shapes. Though not exactly a Cubist, the French painter Cézanne believed that all forms could be reduced to primitive shapes such as spheres, cones and cubes. He applied this principle to still life paintings, landscapes and figures:

"Cézanne discerned and described the basic shape of all forms and then showed their relationships … Cézanne relentlessly examined the structure, texture and colors of bottles, fruits (he used waxed fruits because real ones spoiled as he painted, studied and then repainted them) and tablecloths, often the most alive element in his still life paintings. Traditional conventions of spatial representation, perspective and color have been abandoned and the still life has become a visual analysis translated into paint. To Cézanne it really did not matter whether he was painting an apple or a man—the search for the underlying structure of form and color was the same."
—*Art of the Western World,* Bruce Cole and Adelheid Gealt (Summit Books, 1989)

Designing Stylized Landscapes

USING PRIMITIVES TO CREATE A LANDSCAPE

While desktop 3D programs can provide breathtaking realism, that is not always the desired result. The book or product design for which you are illustrating may call for a playful, stylized approach. Here, details are less important than the feeling, tone and content of the overall image. If your model has a simplified appearance, it can often do a better job of conveying sophisticated abstract ideas by lifting them out of the realm of the real and entering a dreamlike, visionary state.

As an example, we took a simple sphere primitive, distorted and repeated it and added a texture map to convey a bumpy road over rolling hills. Next we added a small figure and with a little yellow fog, made an image for a magazine cover.

Creating a repeating texture map
In Photoshop we painted a series of horizontal black lines on a brown background. The Diffuse and Median filters were used to break up the regularity of the furrows. The gray sliver of road on the left edge will double in width when repeated as a symmetrical "tile." The texture map image is unusually wide to ensure that the roadway does not repeat to the left or right of the camera's field of vision.

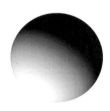

Starting with a sphere
We created a sphere using the sphere tool from the primitive tool palette.

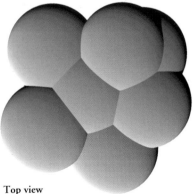

Side view

Original Squashed

Top view

Squashing and multiplying
We squashed the sphere in the vertical axis with the scale tool and duplicated it six times, positioning the duplicates so that they intersect.

Top view

Grouping and repeating
A copy of the first group of spheres was placed behind the first to extend the virtual "landscape."

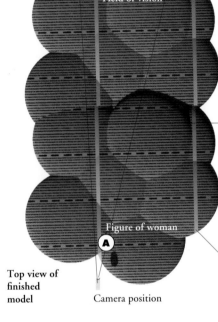

Field of vision

Image of roadway within field of camera view

Figure of woman

(A)

Top view of finished model

Camera position

Repeated image of roadway outside field of camera view

Applying the texture map to the group
Applying the overall texture in the top view, as shown here, had the effect of printing the road and ploughed fields onto the landscape. We selected planar mapping and set the tiling pattern to repeat infinitely and be mirrored. (In some programs the grouped spheres might have to be converted to mesh objects in order to apply a single texture map across their combined surfaces. (See "Making Textures Fit the Model" on page 112.)

Looking down at the model we can see our main road on the left. Note that the repeat of the road, on the right, is outside the range of the field of vision. Next we added a figure of a woman (**A**) and positioned her standing on the roadway.

An overview of the model

The camera was located so that it viewed the main road from front to back (**B**). An isometric view of the model (below) shows how all the parts fit together and how the planar texture map flows over the humps of the squashed spheres. The small figure of the woman on the road can be seen just to the right of the camera. Being very close to the ground, the camera is at the eye level of the woman, allowing us see the world from her perspective in the final rendering.

cone — sphere
— cylinder
lathed forms
— sphere
— sphere
cone —
cube —
— stretched sphere
cone —

A figure made of primitives

Most of the shapes that make up this simplified female figure are cones, cylinders and spheres. We used primitive shapes because they render faster than complex objects. (For more details on making human figures from primitives see pages 90–91.)

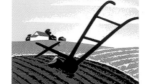

The inspiration for our 3D graphic came from this 1930s poster by Emannuel DeColas.

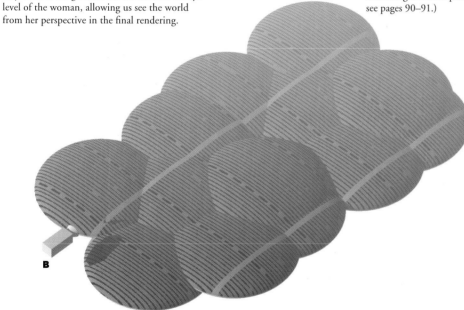

B

A millenium of progress: losses and gains

The road ahead for women

C

D

Shooting through the lens

StudioPro's camera window (**C**) provides either a wire frame or shaded view. Before making the final rendering we made many small "snapshots" (test renderings) (**D**) through the camera window to check composition, lighting, texture detail, shadows and atmosphere.

Creating a ground plane

Working in Infini-D, we made an infinite plane to create a ground surface in our model and applied a soft green color (**A**). Next we used the color wheel to select a blue background (**B**). To avoid an abrupt transition at the horizon we applied a fog effect using the same color as the background (**C**).

USING SIMPLE REPEATING SHAPES

In open country, trees are often planted in rows to break the wind. These graceful arcades of trees are not only a prudent measure against erosion and a boon to cyclists, but they are an inspiration to artists and 3D modelers.

In this model we created a simple tree and repeated it along a road to produce a simple, yet powerful design that pulls the viewer right into the picture. Shadows falling across the road create a secondary pattern that echoes the rhythm of the first. Even such a simple model can produce a charming and effective image, as seen in the menu cover on the next page.

A simple model can also provide the opportunity to test composition, color, lighting, atmospheric effects and viewpoint before attempting more complex modeling.

HOT TIP

Use simple shapes to build a sketch of your model. Work out the lighting, camera angles and other effects before you make the final, detailed model.

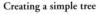

Editing a cylinder to create a road

To create the road, we made a cylinder with the primitive tool, lengthened it so that it stretched from front to back in the model and shortened the vertical dimension so that its cross-section became a flattened ovoid rather than a circle (**D**). This rounded shape imitated the camber of a real road when we positioned it to sink into the ground plane (**E**). We used Photoshop to create a tile to be used as a texture map (**F**). When the texture was applied it painted gray asphalt and a yellow line down the middle of the road.

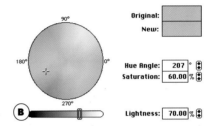

Creating a simple tree

A vertical cylinder was slimmed down and stretched to make a tree trunk (**F**). To create simple foliage we started with a green sphere (**G**) and elongated it vertically to create an ovoid (**H**). Then we duplicated the ovoid, rotated the copy slightly and embedded it into the original (**I**).

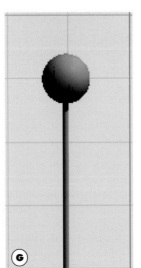

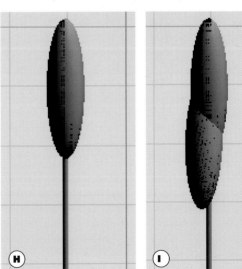

Repeating and varying trees
The three elements of the tree were grouped so that they could be duplicated together (**A**). To avoid monotony, each duplicate was positioned at a slightly different height and rotated around its vertical axis in 30 degree increments (**B**).

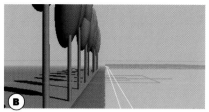

Finishing the illustration
We imported the finished image into Adobe Illustrator and added a border and lettering to complete our menu design.

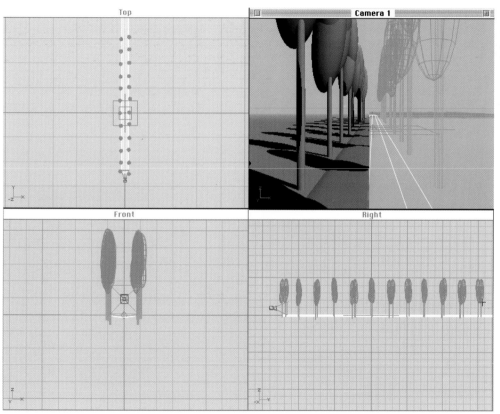

Seeing from different angles
Viewing the model in top, front and side views shows the location of the camera we used to capture the final image. A view through that camera shows the wireframe model on the right and a draft ray tracing on the left. We ray traced half of the image to check the shadow detail before final rendering.

Using 3D Clip Art

An assemblage of parts

To create a fanciful illustration about do-it-yourself home improvements, we combined elements from six files imported from Ray Dream Designer's Dream Models collection and modified and arranged them to create a hardware person. A dust pan became the head, a pail became a rakish hat, a drill bit was repeated to become a fringe of hair, eyes were made from a face plate removed from a model of an electric socket, a wrench became a nose, a nut removed from a wing nut assembly serves as a mouth.

SHORTCUTS TO MODELING

Understanding the basic techniques for creating 3D objects and manipulating them makes it possible to create models of many real-world and fantasy scenes. But these 3D skills can also be put to good use in working with ready-made 3D "clip art" —objects and models that are available either through a library that came with your 3D program or through third-party vendors. By using 3D clip art you can quickly create models that will produce the illustrations and designs you want, without having to take the time to start from scratch or to master the fine points of complex modeling. Clip art models can be edited using the techniques described in Chapter 5, "Manipulating 3D Objects" (starting on page 65) and their surfaces textures can be changed using the techniques described in Chapter 7, "Designing Surfaces" (starting on page 101). In addition, bits and pieces from different clip art objects and scenes can be combined to create new scenes, and unique lighting can be set up. For illustrators and designers who want to use 3D but don't have time to master all the techniques of modeling, clip art can make it possible to produce good results in a relatively short time.

For more examples of clip art see the illustrations in Chapter 3, "The Basics of Desktop 3D", starting on page 21. Also, to see how renderings based on clip art can be altered to get interesting effects see the section on "3D Images in Illustration" starting on page 156.

IMPORTING 3D CLIP ART

Some 3D programs include a batch of clip art objects, which may range from a few to hundreds. In addition, many 3D software companies provide clip art libraries that can be purchased separately. These include models which are in the native format of the program. There are also many third-party developers who sell 3D clip art in generic 3D formats such as DXF and 3DMF, which can be opened by many full-featured 3D programs. A listing of software companies and other vendors is included at the back of the book.

FILE FORMATS

The DXF format (Digital Exchange Format) was developed by AutoDesk and is used for transporting information on a model's geometry (and some color information) between CAD programs (CAD stands for Computer Aided Design). The DXF format is relatively old and does not support curved surfaces, such as those constructed with splines (see "Advanced Types of Curves" on page 52). Instead, curves are approximated with polygons. The import filters of various programs often contain options for specifying levels of smoothing.

The 3DMF (3D Meta File) is a more

recent format created by Apple to provide easier exchange of 3D files between programs. It saves everything in a scene including objects (with image maps and surface properties), cameras and lights.

MODIFYING 3D CLIP ART

Imported 3D objects can be assembled into a scene with little or no modification except for scaling (see "A Children's Book Illustration" on page 99). But objects can also be altered to fit your illustration needs. Imported objects can be transformed (scaled, rotated, positioned) in the same way as any other objects. They can be broken down into their component parts and rearranged. Some pieces can be used and other pieces deleted. In addition, the surface textures of imported objects can be changed to produce interesting effects.

CHANGING SURFACE TEXTURES

Another way to modify imported 3D objects is to apply the "wrong" texture. Try applying a blue sky with clouds texture to a house, or a brick wall texture to an apple, or an animal skin texture to a human figure. Textures and objects can be combined in surprising ways to create illustrations that speak in metaphors (see "Surrealism and 3D" on page 98).

CLOSE-UPS AND CROPPING

One of the simplest ways to use 3D clip art to produce illustrations quickly is to open a clip art file of a single object and arrange your camera to capture a dramatic close-up shot. This works especially well with objects that have complex and interesting curves and shapes and reflective textures, such as musical instruments or flowers.

SUPER-REALIST IMAGES

Imported 3D models of cars, motorcycles, airplanes and other manufactured items can be used to create images in the style of the Super Realist painters of the 1960s. Try cropping in close, using bright lighting and increasing the shininess and reflectiveness of metal surfaces.

Close-ups provide drama
We aimed our camera towards
the bell of a trumpet to get
a dramatic shot of this shiny
instrument from Ray Dream
Designer's Dream Models col-
lection. The original textures
were left unchanged.

Unlikely textures
A simple cup and saucer are covered with a furry
leopard skin texture to create an improbable im-
age, reminiscent of Meret Oppenheim's Surreal-
ist sculpture, "Cup, Saucer and Spoon of Fur."
 A C-clamp is given extra value by applying a
precious gold texture to the steel parts, a glossy
metallic surface to the "C," and a mirrored sur-
face to the ground.

Beyond realism
We increased the shininess, highlight and reflective-
ness of the red metal and chrome surfaces of this
motorcycle from Ray Dream Designer's Dream
Models collection and placed it in an environment
of equally shiny surfaces. One bright spotlight
throws shadows to the right and creates the kind of
interplay of reflection, shadow and light that distin-
guishes the Super Realist paintings of the 1960s.
This style is typified by a lack of aerial perspective,
bright lighting, hard shiny surfaces, lots of reflective
or translucent surfaces, emphasis on interplay be-
tween reflective surfaces, urban subjects and still life
images of human-made objects.

The man who cannot visualize a horse galloping on a tomato is an idiot.
—André Breton

SURREALISM IN 3D

The Surrealist art movement in the early part of this century produced many striking images based on unlikely combinations of objects. In *Beyond Painting*, artist Max Ernst describes the process: "The association of a sewing machine and an umbrella on a surgical table is a familiar example, which has now become classical, of the phenomenon discovered by the surrealists, that the association of two (or more) apparently alien elements on a plane alien to both is the most potent ignition of poetry." This style can produce very evocative images and is especially well suited to 3D graphics both because 3D renderings have a realistic look that's similar to the straightforward realist painting of the Surrealists and also because it's so easy to combine disparate objects in a 3D scene. It's especially easy to create odd differences in scale, following the style so often used by René Magritte (1898–1967), who would paint a room filled with one huge apple, for example. Describing Magritte's work, Jacques Meuris writes:

> *"[Magritte's] painting choice was based, from the very beginning of his definitively Surrealist period, on an observation whose actual implications were not understood until later: namely that by the most faithful reproductions of objects, things—including people—and all that we see around us in everyday life, one can force the beholders of these images to question their own condition. There is one proviso, however: it is necessary for these objects and things to be combined or contrasted in some unexpected, or in other words, unaccustomed, manner. In this way Magritte turned traditional logic inside-out like a glove and, in so doing, he played an intimate part in an enterprise to undermine the commonly accepted meanings of words and things.*
> —Jacques Meuris, *René Magritte*, Benedikt Taschen, 1994

Rooms full of objects
To create two images in the style of Magritte, we modified one of Ray Dream Designer's room models and placed two different objects into it: a double cheeseburger imported from Dream Models and a fat man imported from "18 Perfect People" from Acuris. The man's body was enlarged so that his head and lower legs extend beyond the boundaries of the room.

To see how these images were altered after rendering see "Applying Filter Effects" on page 158.

Exaggerated scale
To create a monumental chair by the ocean, inspired by Magritte's 1948 painting *La Légende des Siécles*, we imported a chair from the Cyberprops collection of 3D models into a scene created in Ray Dream Designer and added a paint tube imported from Designer's Dream Models.

3D programs often come with sample models to get you started. If you're not yet familiar with the program we recommend examining these models first to find out how they are put together.

To make this sample illustration we loaded some objects beginning with the letter "B"

from Ray Dream's Browser palette into a template room from Ray Dream's *Scene Wizard* palette. We deleted the extra light sources that traveled with each imported model because a buildup of these lights would bleach out the entire scene when rendered.

Making a montage in 3D is just as much

fun as making a 2D montage. But objects cast shadows on each other and can be made to either penetrate or bury each other's surfaces, so there are a lot more options in finding a pleasing composition. With 3D images we can enter a fantasy realm where bulldozers and buttons disappear into walls.

Rooms for rent
One of Ray Dream Studio's many environment templates includes this empty room with a tiled floor. These standard scenes include lights, props, backgrounds, cameras and light sources.

Models to go
Some of the hundreds of beautifully made, detailed models that are included with Ray Dream Studio.

Bus
Baby
Butterfly
Bulldozer
Building
Button
Boat

Where do babies come from?
Not from Ray Dream, apparently. Ray Dream's otherwise excellent model library is weak on human forms. This infant is from *18 Perfect People* by Acuris.

CREATE YOUR OWN LIBRARY OF SHAPES

After working with desktop 3D for some time you'll probably find yourself making the same basic shapes again and again. If you were making a room interior, for example, you would need to create a window, but you may find that same window useful in a different context in another model—the cabin of a ship, for example. That's why we suggest keeping a library of your own work, so that elements you have already created are always handy.

Shown here are examples of shapes that we have found useful. Many are quite simple and can be used to extend the range of the primitives that are built into 3D programs.

HOT TIP
A couple of simple shapes can take on a really complex appearance when they are repeated in the model many times.

Making your own primitives
We made a tapered cylinder, a dome and an elbow by the lathing process. These handy shapes extend the range of what can be created using primitives. Combined with basic shapes such as cones and cylinders, they were used to make a teakettle.

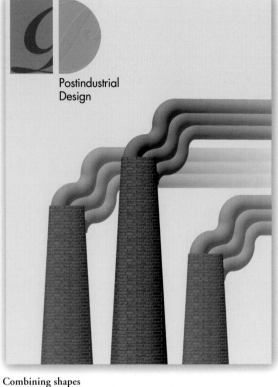

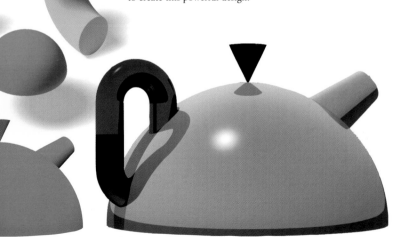

Combining shapes
We used our tapered cylinder shape and the elbow shape in conjunction with a regular cylinder to create this powerful design.

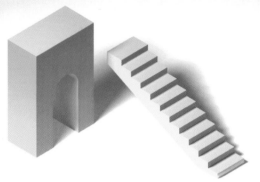

Creating architectural elements
Our arch and flight of stairs are simple elements that can be combined to create an illustration in the style of Escher.

Making recurring elements
Windows and leaves are two examples of objects that are used often and tend to be repeated many times in models.

7 | Designing Surfaces

Model from Bryce 2 Accessory Kit

Working with Color and Texture

MAKING MODELS LOOK REAL

Whether simple or complex, it's often the surface treatment of an object that tells us what it is. A mountain range and a fried egg can be exactly the same shape, but it is their surface characteristics—color, pattern, surface irregularities, reflectivity, transparency—that provide the vital cues that tell us whether we are actually looking at a landscape or our breakfast.

APPLYING COLOR AND TEXTURE

It is the application of color, texture and other surface properties that really gives life to the bare geometry of 3D models. The color, reflectance, translucence, texture and other properties of a particular material, such as corduroy, glass, or wood, are applied to the surfaces of a computer 3D object so that when that object is rendered, light reflects off those surfaces in the same way that real light would reflect off a real object made of corduroy, glass or wood. Of course, the calculations required to accurately imitate the complexity of natural surfaces are immense, and rendered 3D models never look exactly like the real thing. But they look accurate enough to produce images of satisfying realism.

Not only does surface definition make objects look real, it is much faster (both in modeling and rendering time) than trying to create texture by adding geometrical elements to a model. For example, it is much easier to apply a scan of a brick wall to a single flattened cube, than to build a model of a wall brick by brick using hundreds of separate objects. Desktop 3D programs include many predefined textures for common surfaces such as wood, glass and metal and also make it possible to create custom surfaces to fit special needs.

IS IT A MAP OR A TEXTURE OR A SHADER?

The terminology of surfaces is a little confusing. The topic of applying patterned color (such as stripes or a scanned photo of grass) to models is often called *texture mapping* (referring to the texture or pattern that is being painted onto a surface) but is sometimes called *surface mapping* (referring to the surface that is receiving the pattern). A *map* itself (or *texture map)* is usually defined as a two-dimensional pattern of pixel intensities (in other words, a bitmap) that is created either procedurally (that is, mathematically, as with stripes or checkers) or input from another source (for example, a scan of a textured material). The process of *mapping* involves making a one-to-one correspondence between points on the flat surface of the map and points on the surface of the model to which the map is being applied. The process is similar to the geometric procedures required to apply a flat map of the world to a round globe.

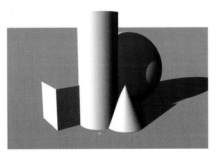

Taking advantage of textures
Applying textures and colors to surfaces makes a great difference in the appearance of the model. All of the textures shown here are from the built-in library of Bryce.

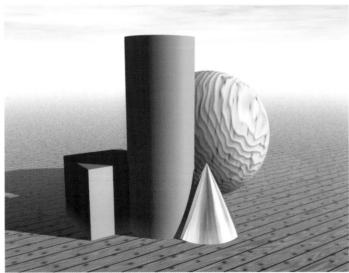

Textures and other surface properties

Adding color to an object can enhance its appearance, but adding texture can transform it completely. All of the images below (even the puff of cloud) were created by applying different textures to a sphere. While most programs include a full library of standard textures, you can also create textures from your own scans and graphics (see page 109).

Imported textures

Textures made from scanned photos or other imported art are known as *texture maps* and often include a *bump map* for surface detail. They can be used to imitate the look of wood, cloth, building materials (such as brick and stone) and many other surfaces.

Procedural textures

Other textures, called *procedural textures,* are mathematical functions that can be modified within the program. These include tex-

tures such as stripes, checks, wood grain and marble (for more about procedural textures see page 106).

Other surface properties

In addition to color and patterns surfaces are defined by the way they interact with the lights present in a model. This is determined by values for reflectance, transparency and refraction, among others.

IMPORTED TEXTURES

PROCEDURAL TEXTURES

In addition to the texture map, a 3D model requires the definition of other characteristics in order to look real. These are often called *surface properties* and includes parameters such as reflectivity and transparency, which determine how the object and its texture map will interact with light. Different 3D programs use different terms to refer to the whole set of surface characteristics. The set may be called a *surface* (Infini-D), a *shader* (Ray Dream Designer), a *texture* (Strata StudioPro) or a *material* (Bryce). In these and many other programs, all the characteristics of a surface can be grouped together in a single definition that can be named and saved and

edited through a single window. Some other programs handle the different aspects of surfaces separately. For example, Adobe Dimensions includes separate functions and windows for coloring, shading (reflectance and highlight) and mapping.

ELEMENTS OF A SURFACE DEFINITION

In this chapter we will describe all the elements that make up a surface definition, beginning with a discussion of color, color combinations and how color saturation affects depth perception. We'll go on to explain the use of texture maps, both procedural and image-based,

and describe the use of bump maps to define bumps or irregularities in the surface of an object (such as the pits on the surface of an orange). In addition to color, texture and bump, surfaces are defined by the particular way they interact with light. So we'll finish by explaining the additional surface properties of reflectance, glow, transparency and refraction and how these can be used to imitate the appearance of materials such as metal, water and glass.

*...No, this my hand will rather
The multitudinous seas incarnadine,
Making the green one red.*
Shakespeare, *MacBeth*

USING COLOR

Although color is rarely used alone as a surface attribute for an object, the sixteen million colors available on a 32-bit desktop computer open up many creative doors. However, the way a particular color appears in the rendered image is affected by the lighting, environmental effects and the presence of backgrounds and other colored objects in the model. For example, a color that looks rich against a black background may appear dark and muddy on a white background, while a pastel color that looks delicate when applied to an object with a white background may look garishly luminous against black. As with notes in a musical scale, colors are always perceived in relationship to each other. They can be harmonious or discordant, stable or vibrant. We've found that classical color theory based on a color wheel can be used to good effect in coloring 3D models (see next page).

HOT TIP
As a general rule, avoid using bright, saturated colors— especially greens and blues— if you want your model to look realistic. Choose your colors from the inner part of the computer's color wheel, within the white circle we have drawn.

COLOR AND REALISM

In addition to providing information on an object's identity (is that ice cream vanilla or chocolate?) color can also give us information about how large an object is and how far away it is. This is because objects that are far away have more muted colors than objects that are close to us. So if you want your 3D model to look like a real car, for example, rather than a toy, it's best to avoid vivid colors. Objects that are brightly colored are associated in our perceptual system with objects that are small and close to us, whereas atmospheric perspective makes us perceive an object as larger and more distant if

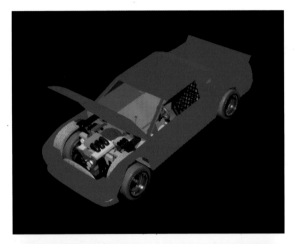

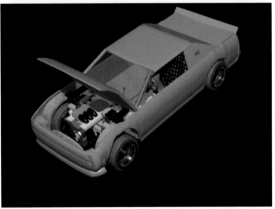

its colors are muted. Vivid colors do appear in the everyday visual world, but they tend to be confined to small areas within our field of view: flowers, butterflies, signs and lights, for example. For a realistic image it's best to reserve saturated colors for details in the scene and use more neutral tones for structures and surfaces that extend throughout the model.

Making a color faux-pas
The blue color of the car body is set at maximum blue in the RGB palette and is too intense to look real. The model looks more like a toy car than a real one.

Toning down the intensity of the color
Reducing the intensity makes the car look more real. We reduced the blue to 150 and added 50 red and 100 green to create a more neutral hue.

Applying classical color theory to 3D models

Artists have often used the color wheel to analyze and understand the relationships between colors. Although the computer version of the color wheel is slightly different and the colors are in the reverse order, the classical concepts of opposing and adjacent colors still apply.

Below is a basic model in monochrome gray. Even without color the tonal values of the objects are affected by the white or black background. In the other examples on this page, we show various types of color combinations with their respective positions on the color wheel.

When I bring you colored toys, my child, I understand why there is such a play of colors on clouds, on water, and why flowers are painted in tints.
—Rabindranath Tagore, 1913

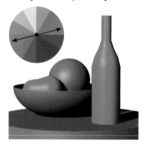

Near complements

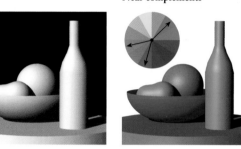

Muted colors plus one saturated color

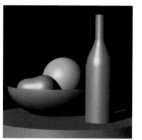

Complementary color pair

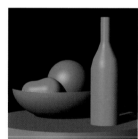

Triadic complements

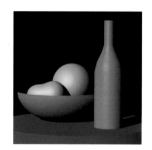

Pastel colors

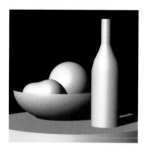

Double complements

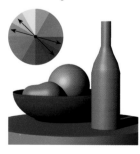

Adjacent colors

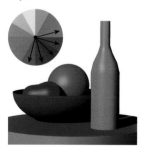

USING THE COLOR WHEEL

Combining colors in a pleasing way is often a matter of judgment and intuition. But we can also rely on the centuries-old device of the color wheel to find combinations that work well together. A basic color wheel consists of the three primary pigments (red, blue and yellow) and the three secondary pigments (orange, purple and green), arranged around a circle in the order they appear in the rainbow. Color wheels can also be subdivided to produce a larger palette, as in our 12-color wheel.

Wires function

Wires function modified

Checkers function

Checkers function modified

Checkers function color mix

Spots function

Psychedelic function

Gradient function turbulence

Wood function

Marble function

Using procedural functions in Ray Dream Designer
In Ray Dream Designer procedural textures are called "functions" and are used to determine how two different colors are mixed. Functions can also be applied to the channels for bump, transparency and reflectiveness. These functions are either geometric (checkers, wires) or amorphous (cellular, marble, wood and so on) and can be modified in various ways. Checkers, for example, can become stripes by changing the horizontal and vertical frequency of the function.

PROCEDURAL TEXTURES

A *procedural texture* is one that uses a "procedure" or mathematical function (rather than a bitmapped image) to produce a pattern. Many of the realistic-looking textures provided with desktop 3D programs—including surfaces such as marble, stone, tile and wood grain—are not based on photos of the real things but are procedural textures derived from algorithms that take advantage of noise, random number generation, fractal patterns and other mathematical functions to produce complex and varied patterns. (For more information on these mathematical factors see "Modeling Natural Phenomena" on page 60.)

Your 3D program may not use the term *procedural* to describe textures that are mathematically derived. In Ray Dream Designer, for example, procedures are called *functions* and can be applied not only to create variations in color but also in bump, transparency and reflection.

SOLID TEXTURES

Some procedural textures, such as stripes or checkerboards, are two-dimensional and are applied only to the surface of an object. But most procedural textures are three-dimensional or "solid," which means that the pattern runs through the object instead of being applied only to its surface. So objects with solid procedural textures applied appear to be carved out of a solid block of the material.

Combining procedural textures and texture maps
To get the effect of splattered mud, we used a gradient function to add a bark texture based on an image map to a procedural shader of metallic paint. The gradient function caused the texture to make a transition from a thin application at the top to a thicker application at the bottom.

Mixing Colors
Ray Dream Designer's mix operator makes it possible to combine two colors using any one of a number of procedural "functions." This screen shot shows application of the "spots" functions.

PROCEDURAL TEXTURES VERSUS TEXTURE MAPS

WHICH IS BETTER?

Textures based on scans may be more realistic than procedural textures, which can look artificial despite their randomness. However, scanned textures often take longer to render and are tied to a particular resolution. Generally, procedural textures render faster. That's because it's faster to apply a mathematical formula to determine what color each pixel on the surface of an object should be than to map correspondences between the pixel values in a bitmap (such as a scan of an ivy-covered wall) and the surface of an object. In addition, a texture map must be stored with the model, which adds to the memory required for the file. It may be a good idea to use procedural textures on smaller parts of a model, which will not be seen close-up in the final rendering and save the more memory-intensive texture maps for larger areas or objects for which no appropriate procedural texture exists.

Using ready-made procedural textures

Many programs provide ready-made procedural textures. Bryce in particular includes many procedural functions that mimic natural surfaces. We created a model in Bryce by importing dinosaurs and a volcano from Strata clip art, placing them in a terrain landscape and applying various procedural textures. Because the texture patterns are randomly generated, they never repeat, allowing large areas to be covered without the noticeable tiling that can occur with texture maps based on bitmapped images. Bryce's procedural textures also take into account factors such as height above the ground, so textures change color as they spread up a mountain.

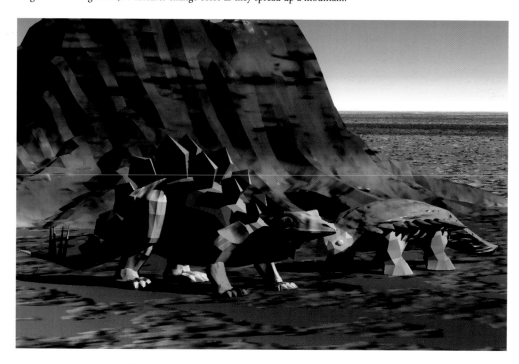

Default settings

Editing the wood

Editing the tile

Editing the marble

Editing the ripples

Editing a procedural texture

Because they are mathematically generated, procedural textures can be easily modified by entering new values in the dialog boxes provided in most programs. Working in Infini-D, we started by applying default tile, wood, marble and wave textures to the walls, boat, bathtub and water of our model, respectively, and then varied each texture. We changed the grain density, turbulence and direction of the wood; changed the color and geometry of the tiles; altered the cohesion of the marble to produce a more intricate surface; and edited the waveform generating the rippled surface of the water by offsetting the center and altering the wave frequency slightly.

TYPES OF PROCEDURAL SURFACES

Most programs make it possible to edit procedural textures to produce different effects. For example, you could edit the color of stripes and their thickness. Here are some of the main types of procedures and ideas for using them:

GEOMETRIC

Geometric patterns include stripes, tiles, bricks, polka dots and grids. They usually involve two or more colors and are useful for interiors and in architectural models.

CELLULAR

From microorganisms to distant planets, cellular patterns mimic the randomness of natural phenomena. Some patterns emphasize the cells themselves while others emphasize the connecting medium. When combined with a bump channel they make convincing reptilian skin textures, for example.

NOISE

Noise—essentially a random pattern of values—is a powerful factor used to simulate textures for terrains and rock formations or any grainy surfaces such as stucco, sandpaper or carpet. Noise-generating functions drive most of the cloud and geological formations found in Bryce 3D.

WAVE FUNCTIONS

Procedural textures can also be used to produce wave effects that simulate the look of ripples in water. In this case the procedure is applied to the "bump" channel of the overall surface definition (see "Bump Maps" on page 117). Wave functions are also used in the color channel of most wood textures. Some wave textures use the interference pattern of two or three different waveforms along different axes to create interesting "psychedelic" effects.

TURBULENCE

Turbulence functions distort patterns in a sinuous manner, similar to wave functions, but randomly and without any regular underlying geometry. When a wave or turbulence function is applied to noise, the result is rather like marble.

IMAGE-BASED TEXTURE MAPS

A texture map is a two-dimensional bit-mapped image used as a surface decoration for a computer 3D object to make it look more realistic or interesting. For example, a scanned image of grass might be applied to a flattened cuboid shape to make it look like a lawn. The texture "map," as with any bitmap, consists of a grid of pixel intensities which indicates what color or gray value exists at each pixel location in the image (see "How Computers Draw" on page 36). These values are applied to the surfaces of an object using a "mapping algorithm" that usually maps each pixel in the texture map to a particular location on the model. However, different methods of mapping can be used, to fit the shape of the object (see "Mapping Methods" on page 116).

Some texture maps are based on 2D images derived from mathematical calculations which produce patterns such as stripes or checkerboards. Maps generated in this way are called *procedural textures* (see "Procedural Textures" on page 106). But the term *texture map* usually indicates a more natural-looking image derived either from a scan or from artwork imported from a paint or image-editing program. (Art created in a PostScript program can also be used if it is rasterized to bitmap mode.) Scanned texture maps can be based either on scans of photos or scans of actual objects placed on the scanner, such as cloth or textured paper.

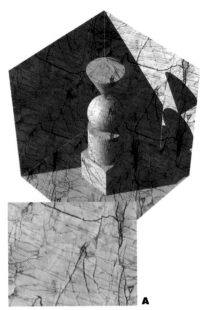

A

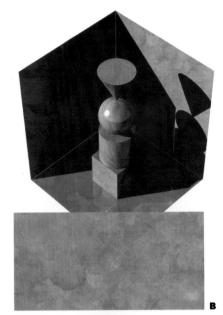

B

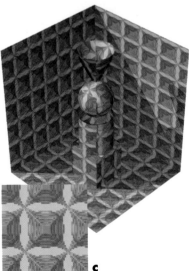

C

D

Texture maps are primarily used to vary the color of an object's surface and are often applied only to the color channel of a surface definition. However, texture maps can also be applied to the bump channel to create variations in the surface levels of an object (see "Bump Maps" on page 117). It's possible to create a bump map that matches a color map by using the same image to create both maps. After the color map is created, you can use an image-editing program to convert it to grayscale mode and adjust the contrast if necessary. All the areas that are white will

be raised and the black areas will be lowered when the image is imported into the bump channel of a surface definition. It's also possible to place texture maps into the channels for reflectance (see page 120) and transparency (see page 124). Usually only one texture is applied to a given channel of a surface definition, but some programs, such as StudioPro, make it possible to apply more than one texture map to a channel and specify how the two will be mixed.

USING READY-MADE TEXTURES
YOUR PROGRAM'S TEXTURE LIBRARY

Most 3D programs include a library of ready-made textures which include a texture map (often based on a scanned photo) along with associated specifications for reflectance, opacity and so on. Library textures can usually be edited to fit the user's needs.

THIRD-PARTY TEXTURES ON DISC

In addition, many software companies provide libraries of scanned texture maps on CD-ROM, which can be imported into most 3D programs and edited further. Both resident and imported libraries include texture maps for surfaces such as animal fur, reptile skin, foliage of various plants, clouds, fabric, wood grain, flooring, carpets, outdoor ground surfaces, fencing, brick and stone walls, laminate, marble, various types of metal, food, stone, flowers and ground covers, roofing materials, water surfaces and so on.

CREATING YOUR OWN TEXTURES

It's also possible to create your own custom texture maps either by importing art work made in a paint or draw program or by importing a scan.

IMPORTING ART WORK

Any image created in a paint program (such as Painter) or an image-editing program (such as Photoshop) can be imported and used as a texture map. Such an image might be a conventional piece of art such as a landscape (to be applied to a flat surface to create a "painting" to hang in a 3D model of a room) or might simply be a texture created by using filters such as Add Noise or Marbleize. (Detailer, a program from the makers of Ray Dream Designer, is dedicated to creating texture maps and includes texture libraries as well as specialized painting tools.)

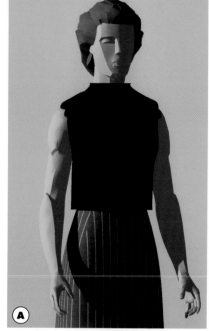

Creating art directly in a paint program
The pinstripe texture applied to the woman's skirt was created by combining filtered effects in Photoshop (**A**). We first established an overall gray background, then added a light-colored vertical stripe down the left edge with the line tool. To simulate the appearance of woolen suiting we used the Add Noise filter.

We used Painter to create a number of textures using a Splatter paint nozzle (**B**) and a stone pattern marbling effect (**C**). After converting the textures to seamless tiles (see page 113), we mapped them onto two coffee mugs and rested them on an infinite plane that was given another Painter-generated texture (**D**).

HOT TIP
To save rendering time, use an image editing program to reduce the "bit depth" of color images used as texture maps from 16- or 24-bit color to 8-bit color mode (256 colors). Most texture maps can be rendered realistically at the lower level without loss of image fidelity.

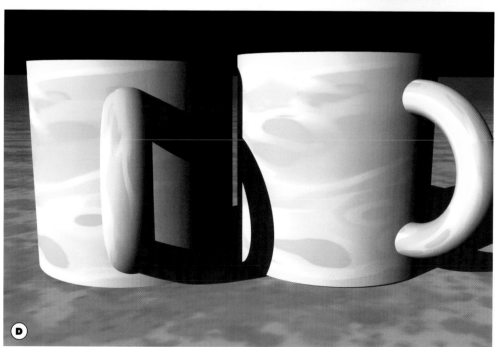

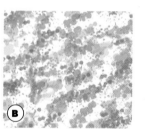

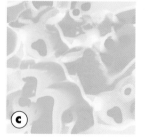

Creating your own texture maps
You can create your own texture maps either by painting directly in a paint or image-editing program or by scanning. Scans can be made of hand-drawn art, or of photos, or of real objects placed on a scanner. In addition, you can use a digital camera to bypass the scanning process and capture real-world textures directly to disk.

Look beneath the surface; let not the several qualities of a thing nor its worth escape thee.
—Marcus Aurelius (A.D. 121–180), *Meditations*

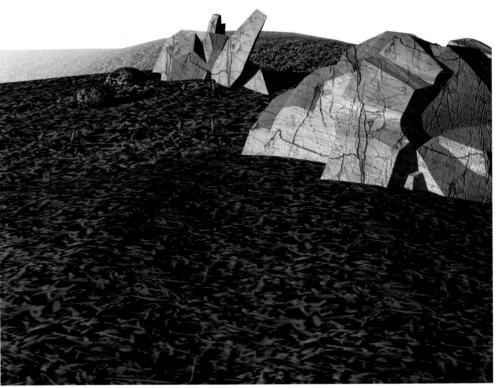

Making a package design from hand-drawn art
We scanned a watercolor painting and applied it to the 3D model in two ways: first as an overall texture mapped onto a group of paint tubes, so that each one bore a different segment of the image; then, in combination with some lettering to make a box top.

Making a landscape from a scanned photograph
A detail of a photograph of a suburban lawn was transformed into wild chaparral in this windswept landscape.

SCANNING TEXTURE MAPS

Anything that can be placed on a scanner can be used as a texture map. You can scan hand-drawn or painted art work. You can also scan photos and use all or part of the scanned image as a texture map. For example, you might select just a portion of the sky from a photograph, or just a section of a brick wall. In addition, actual objects such as paper, cloth, baskets, or other small objects can be scanned and used as texture maps.

DIGITAL CAMERAS

In addition to painted and scanned art, you can create texture maps by photographing the surfaces of real world objects with a digital camera. These direct-to-disc images can be edited in an image-editing program.

Using a digital camera image to make a texture map
A section of a digital photo of a bamboo fence provided the image map for this model of a hotel lobby decor. The brick wall and carpet come from Vision 3D's ready made image-based textures.

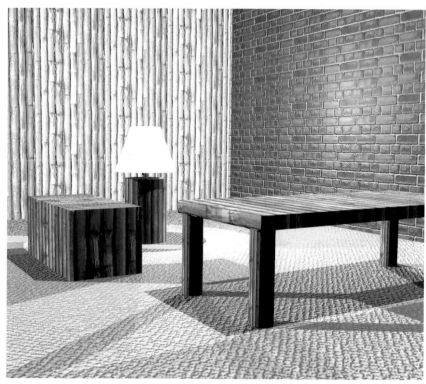

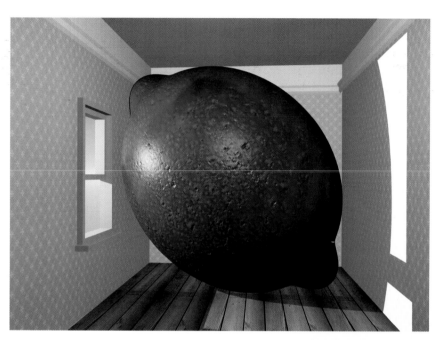

Using a real-object scan to make a texture map
We flattened a piece of actual lime peel and placed it on the scanner, then applied the scanned texture to a lathed shape in our 3D model. To add realism to the surface of the giant lime we copied the black channel from the CMYK channels for the lime skin scan and used it as a bump map. (See page 117 for more on bump maps.)

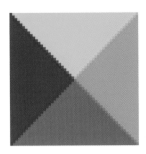

A

Scaling a texture map
A 100 x 100-pixel tile (**A**) looks appropriate when repeated on the model several times (**B**), but when the tiling frequency is greatly reduced, "stair-stepped" edges appear indicating that the tile has a resolution too low for this scale (**C**). A 500 x 500-pixel tile, however, looks smooth when applied to the model at low frequency (**D**).

Varying the vertical and horizontal scale of the tile (**E**), can generate interesting variations on the original texture.

MAKING TEXTURES FIT THE MODEL

Some textures are meant to be applied to all the surfaces of an object, almost like paint, while some textures are meant to be applied to parts of a model like decals or stickers. We'll discuss the methods used to make sure that both types of texture mapping fit the texture to the model correctly.

TILED TEXTURE MAPS

The term "texture" implies an overall surface variability, such as the nubbiness of rough cloth. However, covering a large surface area (such as the walls of a house) with a single texture (such as a scan of stucco) could mean having to create a very large texture map—far too large to be manageable. So most 3D programs make it possible to "tile" textures so that a single small image is stepped-and-repeated, in effect, across the surfaces of an object. Tiled textures are available in the texture libraries included in most programs and can also be imported either from third-party collections or from images that you create yourself.

Most of the ready-made textures that come with 3D programs are set up to be tiled and often include default values for the size and resolution of the tiles and the number of tiles to use. However, sometimes these factors must be specified in order to get the results you want. When making your own texture tiles it's especially important to plan ahead to get the size, resolution and frequency of tiling you need to make sure the texture fits the model and is rendered with the best visual quality.

SIZE AND RESOLUTION

When creating your own texture maps, or editing ready-made maps, it's important to think about their size and resolution, since these affect the quality of the finished image and the amount of time rendering will take. In

B

C

D

E

general, the size and resolution of a texture map should be related to the size and resolution of the final image you plan to make. For example, if your final rendering will be a 4 × 6-inch image at 300 dpi (1200 × 1800 pixels) and the texture map will take up about two square inches of the image (about 600 × 600 pixels), then create the map at a size of 600 × 600 pixels. The closer the map is to actual size, the better it will look in the final rendering. Creating texture maps at high-than-necessary resolutions will increase rendering time but will not improve appearance.

FREQUENCY OF TILING

Most 3D programs make it possible to specify how the tiles will repeat to cover an object's surface. This is important in order to make sure the scale of the texture map fits the scale of the object. Tiling can be specified in terms of horizontal and vertical scale and repeats can be set to infinity or a specific number of tiles, depending on your program. For example, if you want to cover a 10 foot square area with a grass texture and you've created a grass texture tile using a scanned photo of a 2 foot

square area of grass, then the tile should be repeated at least 5 times in each row to look realistic. With fewer tiles the grass blades would look too large and with more tiles the grass would look too small.

In other situations you may need to use only one image that will cover the entire object without repeating. A design for a can of soda, for example, would wrap around a cylinder once without repeating.

It's not always possible to know the size and resolution of the ready-made textures included with your program, so sometimes it's necessary to experiment with different tiling frequencies to get the results you want. Many programs also include ways to show how the texture will fit the model before rendering.

TILING PROPORTIONS

In addition to scale, frequency and coverage, you can generally set the proportion of the tile so that it covers the model in the most efficient way. Vertically striped wallpaper, for instance, could be made by a small square image map bearing one vertical stripe, enlarged vertically to cover the entire wall and reduced horizontally to repeat hundreds of times across the width of the wall.

Tiling unedited texture maps
When unedited texture maps are tiled the seams where the tiles touch each other are visible.

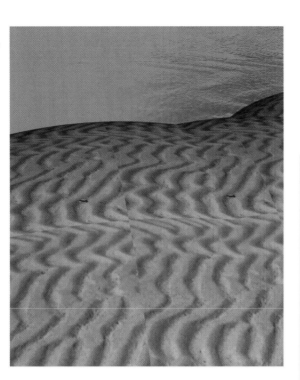

SEAMLESS TILING

When a small texture map is repeated and laid end to end across a surface, it will show seams where the tiles abut each other. To avoid this, the patterns in ready-made texture tiles are designed so that they can be repeated seamlessly, in the same way that the patterns in floor tiles or wallpaper are designed to be repeated. The textures provided by third parties are usually designed to be seamless. In addition, some 3D programs automatically perform the flipping and rotating functions needed to create a seamless tile when texture maps are imported from another source. However, if you are creating your own texture map, you can make it seamless before importing it by following a specific procedure in an image-editing program like Photoshop (see "Creating a Seamless Texture Tile" on this page).

Tiling seam-edited texture maps
To eliminate the seams, texture maps are edited to displace the pixels on the edges of the image so that the image areas on the bottom and right edges flow seamlessly into the image areas near the upper and left edges. This is done by using the Offset filter and the Clone tool in Photoshop (see "Creating a Seamless Texture Tile" on this page).

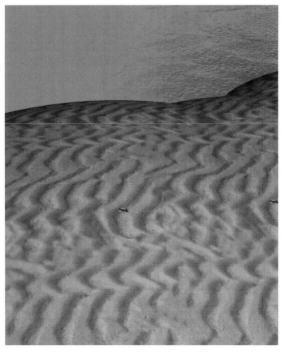

CREATING A SEAMLESS TEXTURE TILE

To create a seamless texture tile, first open your painted or scanned art file in Photoshop (**A**).

Use the Offset filter to offset the image down and to the right by enough distance so that the upper left corner of the original image is displaced to the center of the image area. Choose Wrap Around as the method for filling the Undefined Areas so that the parts of the image that were pushed off the bottom and right edges are wrapped around to the upper and left edges of the image area. This offsetting/wrap around process should reveal an L-shaped "seam" near the center of the image (**B**).

Use the Clone tool to sample parts of the image and paint over the seam so that it disappears (**C**).

*The folly of mistaking a paradox for a discovery,
a metaphor for a proof, a torrent of verbiage for
a spring of capital truths, and oneself for an oracle,
is inborn in us.*
—Paul Valéry (1871–1945)

CREATING VISUAL METAPHORS

Surface textures can be used very effectively to create images with metaphorical meanings. For example, for the cover of an ecology book for business readers, we needed an illustration that would combine images of nature with images of cities and business. Brainstorming produced the idea of a cityscape covered with green leaves, something like the abandoned and overgrown "lost city" in a short story by Jack London. We found a suitable foliage image on a CD of stock images and proceeded to build a model with basic shapes. The shapes in our city are quite simple, since modern buildings are essentially boxes, with a cylinder or pyramid here and there for variety. Getting the plants to grow on the buildings was easy. We applied the stock image as a color map to all the objects in the model, so that the leaves appeared to twine around the buildings and spread out towards the horizon in infinite repetition. In the rendering, we added a touch of fog for extra realism.

Creating basic shapes
Our mythical city, created in StudioPro, is made up of basic primitive shapes—including flat planes (**A**), cubes (**B**), cylinders (**C**), pyramids (**D**)—plus extruded shapes (**E**). (The extruded shapes could easily be replaced with simpler forms.)

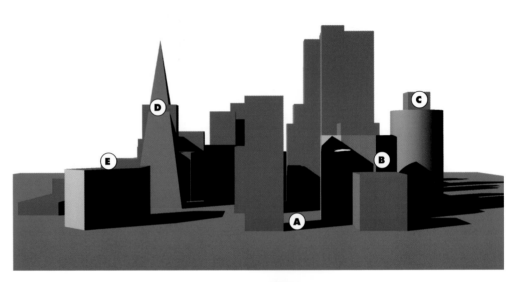

Using a scanned image
We used a photographic image of clover from *Wraptures*™, from Form and Function Co. Note that the graphic is a "tile"; that is, its edges are set up so that the image can be stepped-and-repeated without visible seams (see "Creating a Seamless Texture Tile" on page 113.)

Applying a color map
Applying the clover image as a color map over the entire model transformed the basic shapes into an whimsical ivy-covered city.

A strong directional light-source on the left created a play of shadows on neighboring buildings which added a more complex pattern of shapes to the composition. (For more about lighting effects see "Working With Lights" on page 128.)

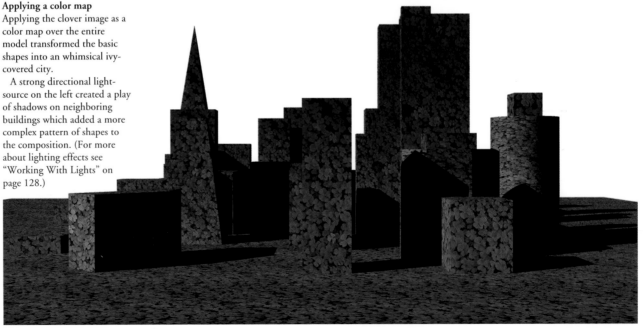

F

Finishing the cover
To create the final cover we
imported the edited 3D image
into a page layout program and
added lettering. In keeping
with the title, the title type was
colored in shades of green (for
nature) with accents in gold
(for profit).

Adding atmosphere
Most 3D applications provide
atmospheric effects which add
to the sense of scale and dis-
tance in a rendered model. (See
"Atmospheric Perspective" on
page 19). The effect is quite
striking; for example, compare
the crisp, "fogless" rendering
on the opposite page with
dusky, almost damp-looking
image at left.

We set up the fog effect by
using the rulers in Vision 3D's
view windows as guides to de-
termined how far from the
camera we wanted the fog to
begin and how much further it
should extend before objects
became swallowed up com-
pletely. We made the color of
the fog blue, which also pro-
duced the effect of a blue sky,
since after a certain distance, in
this program, 3D fog becomes
opaque (**F**). (For more infor-
mation see "Atmosphere" on
page 146.)

To make the image look best
on the white background of the
book cover we deleted the blue
sky in Photoshop (**G**) and
blurred the horizon with a ver-
tical motion blur.

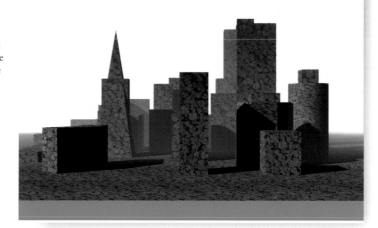

MARIAN K. PROKOP

MANAGING TO BE GREEN

Help your organization
protect the environment *and*
improve profitability

G

MAPPING METHODS

Maps can be applied to objects in several different ways. It's important to understand mapping methods so that you can choose the most appropriate method for the shape of the object you are trying to cover. It's often worthwhile to experiment with different mapping methods, until you get the results you want.

PARAMETRIC MAPPING

The default method of texture mapping in many programs is *parametric mapping*, sometimes also called *surface mapping*. This mapping algorithm assigns each pixel in the texture map to a specific location on the 3D object. If the object is distorted in shape later on (scaled disproportionately, for example) the texture map pixels will retain their relative positions on the object's surface. Parametric mapping is sometimes also called *uv mapping* because it relies on a system of uv-coordinates in which *texels* (the smallest addressable units of a texture map) are mapped onto a given surface. This mapping method can work especially well on objects that are freeform in shape, especially those created with mesh (see "Working With Mesh Objects" on page 57).

PROJECTION MAPPING

In projection mapping, the texture map is projected onto the surfaces of an invisible primitive shape (cube, cylinder, or sphere) that surrounds the object and

PROJECTION MAPPING

Cubical or Cubic Cylindrical Spherical

OTHER MAPPING METHODS

Straight or Planar Wrapped Decal

then is projected from the primitive onto the object. So in choosing a projection mapping method, it's best to choose the primitive that's closest to the shape of the object being textured. Unlike the one-to-one relationships in parametric or surface mapping, with projection mapping the appearance of the applied texture map may change if the shape of the object is changed. The primary methods of projection mapping are cubical, cylindrical and spherical.

CUBICAL OR CUBIC

The entire texture is applied to each of the six sides of a cube. If the object is not a cube, the texture is still applied from six directions, as though the object were inside an invisible cube and the texture on each face were projected onto each of the six "sides" of the object.

CYLINDRICAL

The texture is wrapped around the object as though around a tube, with the object inside. Some programs make it possible

to choose between two cylindrical methods, one which gathers the texture together at the ends and one which projects the whole texture onto the end caps of the cylinder.

SPHERICAL

The texture is wrapped around the object in the same way a flat map of the world is wrapped around a spherical globe, with the texture gathered together at the top and bottom poles.

OTHER MAPPING METHODS

Some programs also include the following texture mapping methods.

STRAIGHT OR PLANAR

The texture is pushed straight through the object from front to back so that the object appears to be carved from a solid chunk of textured material. The side edges of the object may appear streaked.

WRAPPED

All four corners of the texture map come together at the top of the object, as though you were wrapping a ball in a piece of paper.

CREATING DECAL TEXTURES

Sometimes you may want to use a single, unrepeated image as a texture map, such as when mapping a product logo onto the label of a bottle, or mapping a scanned painting onto a flattened cuboid to serve as a "painting" for a wall in a room. This type of mapping is called *decal mapping*.

BUMP MAPS

A *bump map* is a two-dimensional bit-mapped image (either black and white or grayscale) that contains light and dark areas, such as a photograph of a stone wall illuminated by a strong light from the side. When the bump map is applied to a 3D model, areas of the map that are light will appear to be raised while dark areas will appear to be recessed, creating the look of an irregular surface. For example, when a bump map of a stone wall is applied to a rectangular object, the object's smooth, planar surface looks bumpy. A bump map is often used in conjunction with a texture map, which supplies color that matches the surface irregularities. Bump maps can be used to add realism and to speed up the process of modeling. For example, it's much easier to apply a bump map of a stone wall (along with a corresponding color map) than to model a bunch of stones and pile them on top of each other.

Many different kinds of effects can be created with bump maps. Natural surfaces can be imitated using bump maps based on photographs of natural phenomena, such as ripples on a pool. Manufactured surfaces, such as riveted sheet metal or house siding, can be imitated with bump maps derived from graphics. Sharp, high contrast bump maps will produce crisp, hard edges on the object's surface, while softer gradations of gray will produce rounded shapes.

Bump maps are often included with the ready-made textures supplied with 3D programs. They can also be imported as bitmaps from an image-editing program. Precise bump maps can be drawn in a PostScript illustration program and then converted to bitmap form for use in 3D.

Building a stone wall
Our image of stone wall owes its realism to the combination of a color texture map and a bump map, applied to a flat, planar surface. It was rendered with two wall-mounted lights to bring out the roughness of the texture (**A**). To create the surface map we started with a scan of flagstones from *Wraptures*™ from Form and Function Co. (**B**). To create a matching bump map we converted a copy of the color image to grayscale in Photoshop (**C**). To do this we converted the color image to CMYK mode and then deleted all the channels except black because the black channel had the best overall contrast and was least affected by variations in the color of the stones.

Mapping a globe
We used a stylized map design created in a PostScript program (**D**) to create both a bump map and a color map for a sphere. First we opened the PostScript (EPS) file in Photoshop to convert it to a bitmap. We inverted the image (**E**) so that the land areas were white and would be raised from the surface of the sphere (**F**). To create the matching color map we added color to a copy of the image (**G**) and added it to the surface map for the sphere (**H**).

Riveting a spacecraft

A bump map provides a realistic surface for a spacecraft composed of primitives. To create it we used Illustrator to draw a surface design, using crisp black lines to delineate the edges of the metal sheets and softer circles filled with radial gradients going from white in the center to a slightly darker gray than the background at the circumference (**A**). When converted to a bitmap the dark lines look recessed and the circles look raised and dome-shaped (**B**). The bump map image was designed to function as a tile using the techniques described in "Creating a Seamless Texture Tile" on page 113. When applied to the cylindrical spacecraft the bump map repeats and wraps around it (**C**).

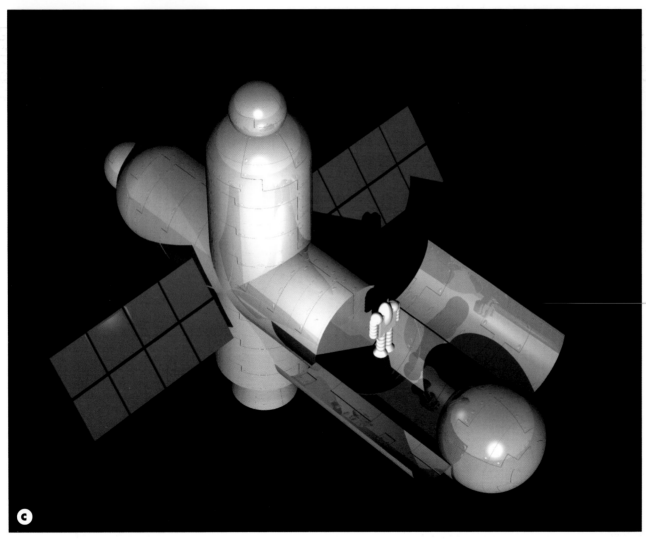

Decorating a blouse

We scanned a cut-paper design from *Authentic Chinese Cut-paper Designs* by Carol Belanger Grafton (Dover, 1988) and inverted it to function as a bump map (**D**). We applied the bump map to a woman's blouse to create a lacy texture (**E**). The model is adapted from *18 Perfect People*, a collection of 3D clip art from Acuris.

Reflecting the past
The image of a historical building reflected in the towering glass walls of a new high-rise is a common sight in urban areas throughout the world. We applied a bump map to the glass windows of our office building so that it would distort the reflection of an old mission tower placed offstage.

Offstage reflection
A 2D shape of an old mission tower was placed directly behind the camera so it would be visible only as a reflection.

USING A BUMP MAP TO DISTORT REFLECTIONS

A bump map applied to a reflective surface distorts the reflections. We took advantage of that fact to create a model in which the image of an old mission tower is broken up and reflected in the glass of a modern office building.

We started by constructing an office building model by using wall modules comprised of grids of extruded squares. We created a glass texture, which included a bump map designed to make the glass ripple. This was applied to each of the wall panels as a group, so that the ripple in each separate "window" was slightly different. We then imported a bitmapped image of the silhouette of an old California mission tower and positioned it behind the camera so that its shape would be reflected in the office building. To exaggerate the distortion we also rotated some of the glass tiles one or two degrees around the vertical axis.

MAKING THE GLASS RIPPLE

To create a bump map that could add a ripple to window glass we used Photoshop to create some ellipses and filled them with gradations from gray to white (**A**). Next we blurred the image (**B**) and converted it into a tile that could be repeated seamlessly (**C**), using the techniques described in "Creating a Seamless Texture Tile" on page 113. We then imported the image into the bump channel of the glass texture.

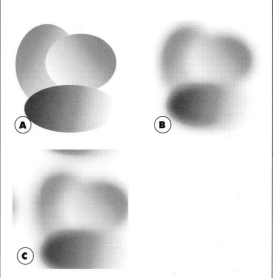

A typical wall tile with a surface warped by the bump map.

Defining Surface Properties

Adding polish
We applied three levels of "shininess" to the simple objects in this model: matte (**A**), semi-gloss (**B**), glossy (maximum reflectance) (**C**) and in the last example, the walls and floor have also been made glossy (**D**).

REFLECTANCE

The way an object reflects light back to our eyes is an important factor in determining its appearance. For example, though silver and chrome look similar at first, a teapot made of silver reflects light differently than one made of chrome, which helps us to distinguish between the two materials. Reflectivity is often subtle, producing just a highlight and a slight reflection of the surrounding environment. But reflectivity can also create dramatic effects, as when high-gloss or mirror-like objects reflect each other. Curved surfaces—such as spheres, cylinders and cones—can be especially interesting when given highly reflective surfaces because their curves cause the light to reflect at many different angles, producing a wide variety of tonal gradations and highlights.

When many objects in a model are shiny, the inter-action of light with the objects and of the objects with each other can produce an interplay of reflection that's so complex and interesting it can become the subject of the image. Picture, for example, a still life of colored Christmas tree ornaments on a mirrored tray. But as with bright color, high reflectance is not always compat-ible with realism. In general, objects with semi-matte reflectance will look more "real."

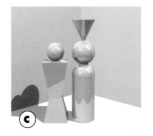

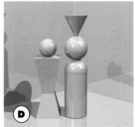

Low reflectance adds realism
These planes might have looked like miniatures if we had made them very shiny.

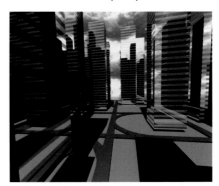

Where mirrors converge
A reflectance map of horizontal stripes was applied to the surfaces of these buildings, allowing some parts of the model to reflect and others to remain dull. Recursive reflections occur when reflective objects mirror each other. (For more on reflectance mapping, see page 123.)

Matte textures
In this architec-tural model all the surfaces are matte to add realism.

Shiny toys
A highly reflective surface suggests a small object viewed at close quarters.

REFLECTANCE, SHININESS, HIGHLIGHT, SPECULARITY: WHAT DO THEY ALL MEAN?

The terms that describe the attributes of reflective surfaces can be confusing. Here are some useful definitions:

REFLECTANCE OR REFLECTIVITY

Re... ...xtent to which an object bounces
... objects or environments in the
...ective surface acts like a mirror).

...AR HIGHLIGHTS

...ntensity and the color of the highlight
...ty is separate from that of reflec-
...umber of highlights on an object is
...n of the light sources in the model.
...e metallic when the color of the
...or of the object.

...y the size of the highlight. Shinier
...e highlights, whereas duller objects
...ighlights.

SETTING UP AND EDITIN...

Reflectance is one of sev...
times called *channels*) tha...
how glossy a surface will...
used in setting up a gloss...
ing, reflectance and spe...
include channels for shin...
sidebar). Usually, just in...
surface definition will no...

HOT TIP

Applying various environment maps will change the appearance of reflective objects radically. A room environment map with its multiple highlights (below, top) gives an indoor feeling to our scene, while a chrome environment suggests serenity (below, bottom).

rendered using ray tracing (see Chapter 8, "Lighting, Viewing and Rendering" starting on page 127).

ENVIRONMENT MAPS

If there are other objects surrounding a reflective object they may be reflected in its surface if they are in the right position, but if there is nothing for the object to reflect, the rendering will be uninteresting and unrealistic. This problem can be solved by using an environment map, which is a virtual dome surrounding the model and bearing an image or color blend that simulates indoor or outdoor environments. Most programs include a library of environment maps. (See "Environment Maps" on page 147.)

Adding reflectance
An nonreflective object, (**A**), placed on a 100% reflective, rippled surface takes on a shiny appearance when its reflectance level is set to 50%.

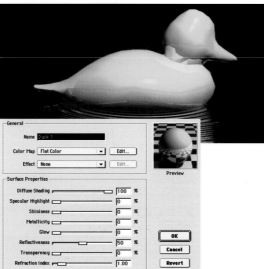

Adding an environment and changing attributes
The duck in this scene starts out with the same matte surface as in example (**A**), below left, but we've added an environment map to the scene (see screen dump above). Because the duck is matte at this point, its appearance is not affected by the environment, but the water is greatly changed (**B**).

The duck's appearance is changed by specifying the following attributes: 50% reflectance (**C**); 50% reflectance, 50% specular highlight (**D**); 50% reflectance, 50% specular highlight and 50% shininess (**E**); 50% reflectance, 50% specular highlight.

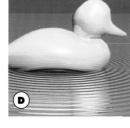

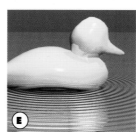

Changing specular color
Highlight color also changes the appearance of reflective objects. At top the specular color is blue, at bottom it's red.

I…chose my wife, as she did her wedding gown, not for a fine flossy surface, but such qualities as would wear well.
—Oliver Goldsmith, *The Vicar of Wakefield*, 1766

GETTING
STARTED
WITH 3D

122

Analyzing the properties of glowing objects
At 80% strength, ambient light illuminates a cylinder and a light fixture with no surface textures applied (**A**). A glow factor of 0.5 applied to the bulb shape (**B**) causes it to appear lighter, but the neighboring cylinder is not affected since a glowing object is not a light source itself. When the ambient light is reduced from 80% to 20% (**C**), the glow of the bulb is reduced accordingly. Thus, a glowing object raises the baseline level of the amount of light it receives. If all light sources are deleted, (**D**) the glowing object becomes a dark featureless shape. But placing a light source inside the bulb shape (**E**) and giving it a glow factor of 0.5 with 10% opacity makes the glowing object appear to give off light.

MAKING OBJECTS GLOW

Glow is the attribute of a surface map that determines the luminance of an object. An object with a high glow value will look like it has a light inside it. Glow can be used to create the effect of neon light, for example, or LED numbers on a digital clock. However, a 3D object with a glow attribute does not function as a light source within the model. It will not cast light on other objects or add to the amount of ambient light in the scene.

However, if a point or radial light source is placed inside a semitransparent light-bulb shape whose surface map has glow applied to it, the two elements combined will make the object look like an illuminated light bulb. The point light source will shine through the bulb on the surrounding area and creates shadows. Without its inner light source, the glowing bulb may look a little brighter than other objects, but it won't look like a light bulb that's turned on.

COMBINING REFLECTANCE AND GLOW
REFLECTANCE

Just as areas of a surface can be raised and lowered using a bump map (see pages 117–119), different areas can be made dull or shiny by importing a light and dark image into the reflectance channel of a surface map. We used this technique to create alternating horizontal stripes of shiny "glass" and nonreflecting "metal" to make a pair of buildings look as though they were constructed with horizontal bands of windows. This made it possible to create each building using a single cuboid, rather than by creating a stack of alternating shiny and dull slabs (see next page).

GLOW

In the same way as a reflectance map, the light and dark areas of a bitmap image placed in the glow channel of a surface map will affect how much glowing light appears. We used this technique to create a building sign in which the light glows through the shape of a logo (see next page).

Making a candle glow
Working in StudioPro we created a candle flame from an elongated sphere. Using the mesh editor we pulled up the top vertex of the spheroid to create a flame-like shape. Then we made a smaller duplicate and placed it within the larger one. We gave the outer flame the following surface parameters: Glow 0.7, Reflectivity 0.64, Transparency 0.56 and made the color a light orange. Then we gave the inner flame texture these values: Glow 0, Reflectivity 0, Transparency 0.56 and colored it medium gray. To make the candle illuminate the surroundings, a point light source was positioned near the tip of the flame.

Striping the towers

To make two cuboids look like buildings constructed of alternating bands of green-colored glass and dark metal we created a simple bitmap image of white and black bands (**A**) and used it as a reflectance map to modify the glossy green glass surface applied to the cubes (**B**). For added realism we imported a sky background from a photograph and set the environment to reflect this background. To create reflecting pools in the foreground we modified the building reflectance map (**C**) and added it to a shiny terra cotta surface that was applied to an infinite plane beneath the buildings (**D**).

The exterior lights are point light sources within translucent spheres. The spheres have been given a glow attribute.

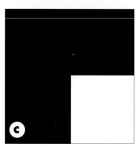

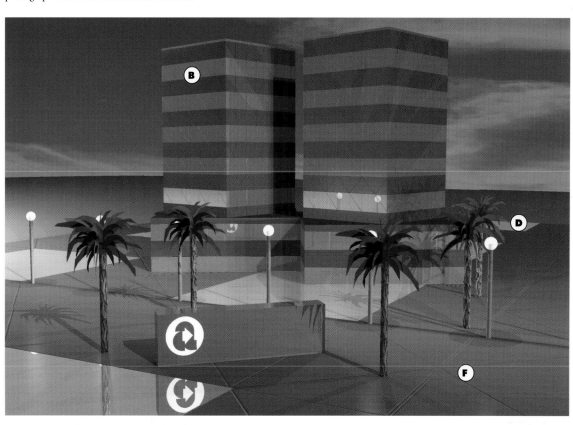

HOW REFLECTANCE MAPPING WORKS

The light areas of the map image reflect to make alternating shiny and dull stripes.

The light areas of the map image reflect the sky to resemble water.

DESIGNING SURFACES

123

Bump and glow

Carrying through the geometrical theme, we modified the reflectance bitmap again, this time adding some diagonal lines (**E**). We used this as a bump map to make the ground plane more interesting (**F**).

Then, to create a glowing sign we created a logo panel in a PostScript program (**G**), converted it to a bitmap and used it as a map in the glow channel of a texture applied to a rectangular sign shape. The white areas of the logo amplify the ambient light and make the sign appear to be illuminated from within.

Analyzing the properties of transparent objects
Working in StudioPro with a vase of flowers adapted from Jim Lennon's *Architectural Shapes 1* we set up a simple model to test various settings of transparency. The glass texture at full reflectance has a very pale green color. (StudioPro uses "opacity" rather than transparency as an attribute.)

Creating a transparency map
To demonstrate the use of a bitmap in the transparency channel of a surface, we started with a pitcher model from Ray Dream Designer's Dream Models collection (**A**) and imported a transparency map into the transparency channel of a metallic red surface map (**B**). The line art used to create the transparency map (**C**) was taken from Dynamic Graphics Designer's Club, *Ideas and Images, 1991.*

TRANSPARENCY

Transparency is one of the most amazing aspects of computer 3D. The virtual "light" in a model can pass through an object that has a transparent surface, making it possible to create objects that mimic glass and liquids, creating a lovely interplay of light, shadow and reflections. Technically speaking, transparency is the attribute of a surface map that determines the transmissive properties of a surface; that is, how much light will shine through the object. In the realm of computer 3D, transparency is specified using a transparency coefficient, which is a fractional value. However, different programs provide different interfaces and values for specifying transparency, sometimes simply ranging from 0 (for complete opacity) to 100 (for complete transparency).

In addition to setting a transparency value, most programs also make it possible to import a bitmapped image into the transparency channel, where it functions much like a bump map (see page 117) or a reflectance map (see page 122). The light areas of the bitmap will be transparent and the dark areas will be opaque, with gray areas having a semi-transparent value. So a transparency map can be a handy way to create doors and windows in an object.

A decorative transparency map can also be applied to an object like a glass or a vase, to make it look like a glass object that has been painted.

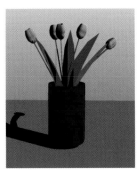
100% opacity

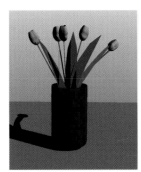
75% opacity

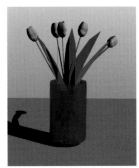
50% opacity

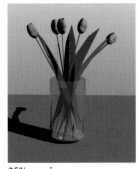
25% opacity

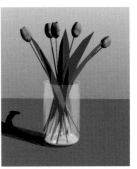
10% opacity

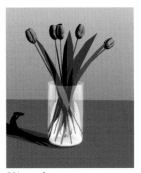
0% opacity

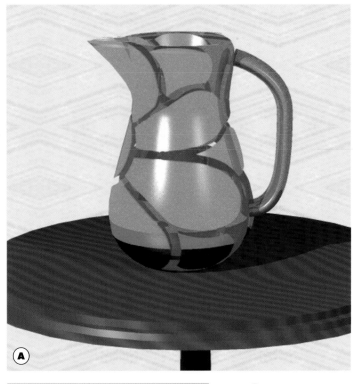
(A)

(B)

C

Creating openings in objects with stencil mapping
The crew of a spacefleet approaching Mars are able to see where they are going because of a *stencil map*. Similar to a transparency map, a stencil map makes parts of the surface of an object disappear in rendering. But unlike a transparency map a stencil map affects all texture channels, so it effectively removes parts of the surface. The clear areas of the rockets' noses are caused by an image of a pair of black circles (**A**), imported into the stencil channel.

Bending rays with refraction
Refracted light can be made to behave in much the same way in 3D modeling as it does in the real world. If a lens shape is given a transparent texture with an appropriate refractive value, it will bend the light coming from objects behind it.

REFRACTION

Refraction occurs when light passing through a transparent object or medium is "bent" by it. For example, objects seen through water (such as the tip of your finger in a glass of water, or a submerged fish at the end of your line) look larger than they do through air, and their position may be offset.

Refraction is specified using a *refraction index*. The refraction index of air is defined as 1 because air does not refract or distort objects seen through it. Index values of higher than 1 mean that light will be refracted somewhat. For example, the refractive index of water is 1.333, while the index of diamond is 2.4175. The index indicates how much that medium diverts light from its normal straight path. Different 3D programs use different conventions for specifying refraction, however, and not all use a refraction index value.

The effects of refraction in a model are calculated by ray tracing and when combined with values for transparency produce very realistic effects.

HOT TIP
Transparent objects look more convincing with refraction applied.

Creating cut-out objects
Another way to use transparency mapping is to place a color image in a color channel and make sure it's in register with a silhouette of the same image placed in a transparency channel. When these are mapped onto a flat, rectangular surface the color image (**B**) and the silhouette (**C**) create a precise cut-out to create the illusion of an object, such as a person or animal, placed into the scene.

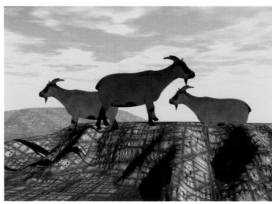

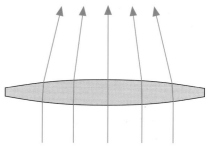

Creating the tumbler

To create a glass tumbler we made a simple lathed shape in Vision 3D. It is shown here with an opaque surface and a light source directly overhead (**A**). We then set the transparency channel of the surface map to 99%, which made the tumbler almost disappear against the black background. The light source creates a strong highlight at the bottom of the tumbler (**B**). We inserted another lathed shape to represent the liquid in the tumbler, colored it brown to represent a soft drink and set its transparency at 95% (**C**).

REFINING TRANSPARENCY AND REFRACTION

Transparency is sometimes one of the more challenging surface attributes to manage in 3D because absolutely transparent objects are invisible! If the background is white they will disappear. Objects that are very transparent can often only be seen by way of their highlights and reflections. These are determined by the lighting setup and the environment, so rendering a transparent object is very much an exercise in lighting and environmental techniques.

However, it's rare that a 3D object should be completely transparent. Take a look in your kitchen cabinet. Are those glasses absolutely transparent? For a more realistic appearance, avoid making objects completely transparent. A setting of 99% transparency (or 1% opacity) will make an object very transparent but still barely visible.

When refraction is combined with objects that are very transparent very realistic effects can be created. A transparent object acts as a lens. When light rays pass through it they are bent, distorting the appearance of objects that lie within or beyond it.

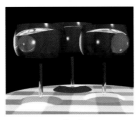

An exaggerated refraction setting, created in Infini-D.

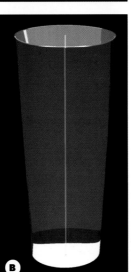

Finishing touches

To complete the tumbler image we added an ice cube, an opaque straw and a cherry. We set the index of refraction of the tumbler to a value close to that of glass and the index of the liquid to a value close to that of water. We also added three white cylinders off stage, out of range of the camera, to create more highlights in the tumbler surface. The final image reveals a convincingly bent straw and a very pleasing interplay of light and reflection (**D**).

FREE WITH EVERY KID'S MEAL

Shirley Temple

8 | Lighting, Viewing and Rendering

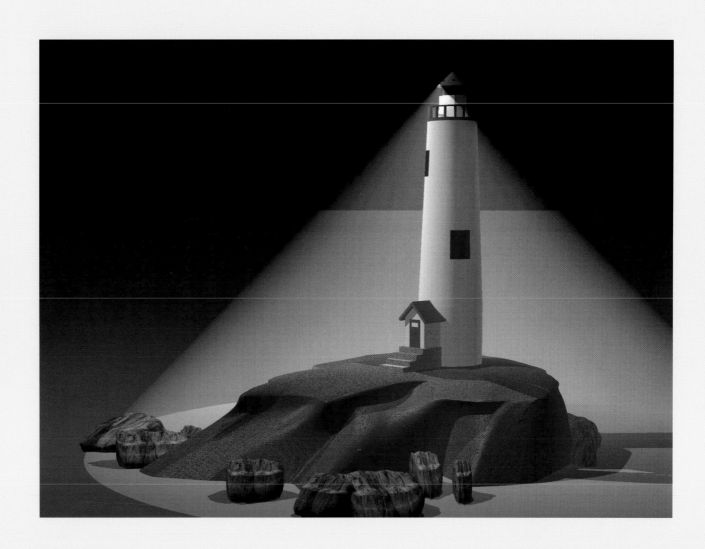

Working with Lights

LIGHTING THE SCENE

Light reveals the world to us—whether the real world or the computer 3D world. Light is what illuminates objects so that they are pulled out of the darkness of their surroundings. Light creates the depth shading that delineates forms. Light casts shadows, sometimes in a complex interplay of tones and shapes. Light interacts with surface materials to create characteristic reflections and highlights.

The lighting elements in a computer 3D model are designed to behave just like their namesakes in the real world (spot light, ambient light and so on), and the light they shine on the elements of the model is designed to behave like real light—it illuminates objects, bounces off hard surfaces, is absorbed by dark colors and so on.

Lighting can be used in a straightforward way simply to make a model visible with the most detail and least distortion. It can also be used to create special effects (such as a beam coming out from a lighthouse at dusk) or create a mood (such as the feeling conveyed by the slanting, yellow light of late afternoon sun).

The process and terminology of computer 3D lighting follows the conventions already established in photography, theater and motion picture filming. Lights in the desktop 3D world have similar names and properties and they can be arranged to illuminate a scene much as a photographer would set up lights in a studio.

TYPES OF LIGHTS

There are four main types of lights available in computer 3D, which are generally called *ambient*, *point*, *spot* and *distant*. All of these can be adjusted as to a number of parameters, such as intensity, color and direction.

AMBIENT LIGHT

Ambient light is indirect background light that seems to softly illuminate everything in a scene, but without casting shadows. It is uniform and nondirectional, quite similar to sunlight outdoors on an overcast day. Although ambient light casts no shadows, it affects the depth and color of shadows cast by other light sources. If ambient light in a scene is set to zero, for example, the shadows cast by other light sources will be black. (See "Changing the Ambient Light Color" on page 137.)

POINT, BULB OR RADIAL LIGHTS

A *point light* is similar to a bare light bulb. It sheds light uniformly in all directions, can be adjusted in intensity (like a light bulb on a dimmer switch) and can have different colors. Point lights can be inserted and positioned anywhere in the model. A point light is, perhaps, the simplest type of light source to implement.

SPOT LIGHTS

A *spot light* is one that sheds light in a particular direction. Its light spreads out in a cone shape, with the point of the cone at the origin of the light and the base at the area being illuminated. The spread of the cone and the distance covered by the light from origin to destination can be specified. The edges of the area of illumination can also be edited to appear either hard and focused or soft and fuzzy. As with point lights, spot lights can be placed and maneuvered anywhere within a model, but they can be aimed at specific areas.

DISTANT, DIRECTIONAL, GLOBAL OR PARALLEL LIGHTS

A *distant light* emits light in only one direction and is located, in theory, at an infinite distance from the model so that its light beams enter the model in parallel (rather than radiating at all angles, as with a point light, or radiating out in a cone shape, as with a spot light). As with ambient light, a distant light does not appear as an object in modeling windows and is often specified in an environment or scene setting menu. A distant light is also sometimes called a *global light* or a *directional light* and is similar to the light cast by the sun on a clear day.

THE FOUR BASIC LIGHT TYPES

AMBIENT LIGHT

Nondirectional, diffuse light

Does not cast shadows, but determines the depth and color of shadows cast by other light sources

Fills scene uniformly

SPOT LIGHT

Focused rays can be aimed

Fall-off can be specified

Can cast shadows

Shape and edges of light area can be specified

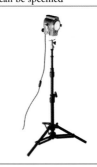

POINT, BULB OR RADIAL LIGHT

Rays diverge in all directions

Can cast shadows

Fall-off can be specified

DISTANT, DIRECTIONAL, GLOBAL OR PARALLEL LIGHT

Rays parallel

Covers entire scene

Can cast shadows

No fall-off

How far that little candle throws his beams!
So shines a good deed in a naughty world.
—William Shakespeare, *The Merchant of Venice*

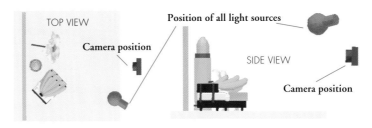

TOP VIEW

Position of all light sources

Camera position

SIDE VIEW

Camera position

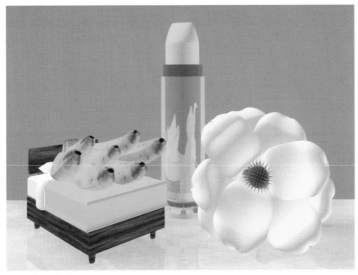

A Ambient light

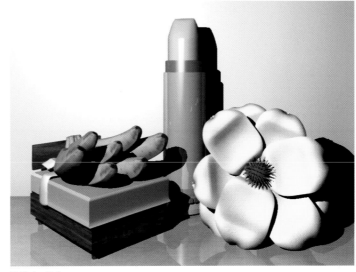

B Point light

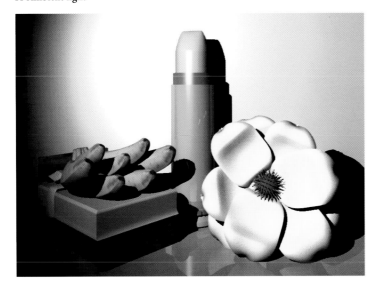

C Spot light

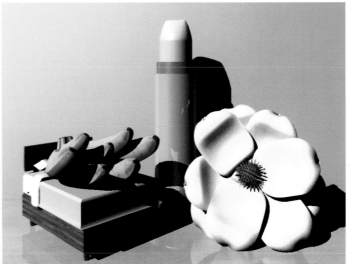

D Directional light

LIGHTING,
VIEWING AND
RENDERING

129

Using basic light sources
These figures show the same stage-like scene lit by the four types of light commonly available in desktop 3D: ambient, point, spot and distant. In most programs ambient light is always present in a model, although its color and intensity can be specified. Ambient light is usually combined with positioned lights and serves the purpose of filling in dark areas of shadow cast by other lights. (However, for comparison, only one light source at a time is used in each of our figures. Figures **B**, **C** and **D** do not also include ambient light.)

Our ambient light was set to white at full strength and spread its light throughout the model without casting shadows (**A**).

All the other lights in our figures were located in the same position in front of the model, to the left and slightly above the center, and all were set to white light. The top and side views shown above show the positioning we used. (The Ray Dream Designer interface shows a bulb light. It was later changed to a spot light and to a distant light.)

Our point light radiated light in all directions from its center (**B**). Our spot light was aimed at the center of the model and its light cone was specified to have a blurry edge (**C**). Though it came from the same direction as the point and spot lights, the distant light in our figure (**D**) shed light rays that are parallel, as opposed to the radiating light shed by the point light and the cone-shaped light of the spot.

Illustrating the six basic functions of lighting
Each of the models below is lit by only one light source, with its direction and intensity varied to emphasize the different functions of lighting. To create just enough light for rendering, we used a clip art lamp containing a point light source and did not place any other lights in the scene (**A**). To enhance the perception of depth, we positioned our light so that it cast shadows leading the eye to a focal point in the middle distance. The light drops off rapidly to black, giving a feeling of infinite depth (**B**). To highlight the car, we made it sparkle in a spot light while the surrounding area remains dimly lit. The strong cast shadow also focuses attention on the subject (**C**). To create a mood, we contrasted a sombre, backlit seascape with the playfulness of dolphins. The reflections in the foreground echo the moody sky (**D**). Light falling almost straight down casts shadows on our house that indicate the time of day and season—noon in midsummer (**E**). A rhythmic pattern of repeating curves and verticals is crisscrossed by a slanting shadows to create a pleasing composition in this monochromatic urban landscape (**F**).

THEORIES OF LIGHTING

Theories and techniques already used in photography, theater, filmmaking and television can be used in the realm of computer 3D. The purposes of a lighting set-up in computer graphics and any photographic media are:

A TO CREATE ENOUGH LIGHT FOR RENDERING

In order to render an image from a 3D model there must be at least one light source, at sufficient brightness to interact with the surfaces of the model.

B TO ENHANCE THE PERCEPTION OF DEPTH

Careful placement of lights, and adjustment of intensity and color, helps lend reality to a scene by bringing out details such as the modeling across surfaces, reflections and cast shadows.

C TO HIGHLIGHT IMPORTANT PARTS OF THE SCENE

Lighting can direct the attention of the viewer by making the important parts of a scene brighter and more detailed than the peripheral or background elements.

D TO CREATE A MOOD OR EMOTIONAL TONE

Bright scenes usually look cheerful and dark scenes usually look scary. Between these two poles lie a range of subtle nuances of emotion that can be developed by a sensitive use of lighting.

E TO INDICATE THE TIME OF DAY

A model of an outdoor scene can be rendered in morning, afternoon and evening by changing the position and direction of the directional light that imitates the light coming from the sun. In addition, light coming into interiors through windows can be slanted and colored to imitate daylight at different times of day.

F TO CREATE A PLEASING COMPOSITION

The shapes of the shadows cast by light and the shapes of the reflections created in shiny surfaces become graphic elements in the rendered image and must be taken into account as positive or negative spaces, along with the shapes of objects themselves.

A

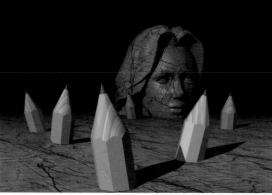

B

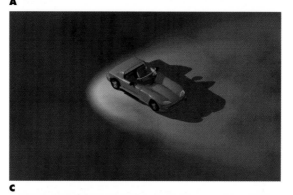

C

D

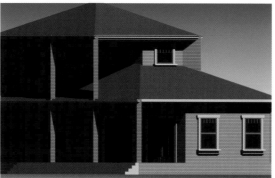

E

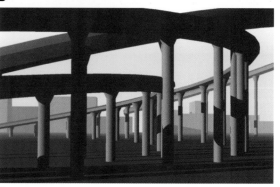

F

3-POINT LIGHTING SYSTEMS

In the lighting of any sort of "stage" or scene, there are usually three types of lights—*key*, *fill* and *back*—that arranged in a *3-point lighting* scheme. (Note that these terms refer to the function of the light, not its lamp type; that is, a key light can be either a point light or a spot light.)

KEY LIGHT

The *key light* is the main light illuminating the front of a scene. It is used primarily to light the subject and create the modeling that reveals its depth and surface texture. A key light may be placed to the right or left of center and is often placed high and aimed slightly downward at the subject. The key light may be the sun (in computer 3D the sun is imitated with a directional light) or a spot light and may be fairly bright. The shadows cast by the key light are strong and can be distracting.

FILL LIGHT

The *fill light* is used to soften the shadows or dark areas caused by the key light by filling them in with soft light. Like the key light, the fill light is placed in front of the scene, often high. But it is placed opposite the key light, often so that the line from fill light to subject and from key light to subject form a right angle. The fill light is usually less intense than the key light and may be a point light that spreads in all directions, rather than a spot light that is focused on a particular area. In 3D models the role of the fill light is often played by the ambient light.

BACK LIGHT

The *back light* is placed behind the scene and serves to separate the objects in the scene from the background by creating a faint halo of light along their outlines.

USING LIGHTS EFFECTIVELY

Effective, efficient lighting is crucial to 3D modeling, for without it the model cannot be rendered. But to keep

Backlight versus key light
The model at right has two identical point light sources, one in front of the model and one behind. Giving different weight to the each light reveals and obscures different parts of the model, as shown below. Shining a light directly at an object can make it look flat and lifeless like a deer frozen in the headlights. Often it's better to light your subject indirectly. In this example the backlighting draws us into the mystery of the maze and beckons beyond.

Placing the lights
In a traditional 3-point lighting set-up, the key light is usually placed at an angle of 30 to 45 degrees away from the line of sight (the line between the camera and the subject), either to the left or right and elevated about 30 to 45 degrees from the ground plane.

The fill light is usually placed on the other side of the camera from the key light, also at a 30 to 45 degree angle from the line of sight, usually at a level with the camera. It is less intense and more diffuse than the key light. The back light is located behind the scene and above the level of the camera.

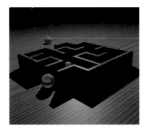

Bright back light, no key light

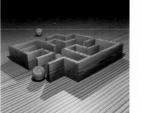

Equal back light and key light

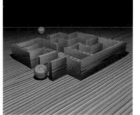

No back light, bright key light

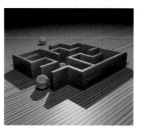

Bright back light, soft key light

rendering times shorter, it's important to use as few lights in a scene as possible. Most scenes can be well lit with three lights arranged in a 3-point lighting set-up (one of which may be the ambient light source). However, computer 3D is very flexible and lighting can be set up to meet a variety of needs.

There is light in shadow and shadow in light,
And black in the blue of the sky.
—Lucy Larcom (1826–1893)

ATTRIBUTES OF LIGHTING

Lights can be specified with a number of variables, including position, intensity, direction, spread, fall-off, color, and shadows. We'll define these terms here and explain them in more detail in the sections that follow.

POSITION

Spot and point lights require a physical location and can be placed anywhere in a 3D model. Their position can be specified by x, y, z coordinates. Ambient light, by contrast, has no point of origin but is an overall specification. The location of a directional light is hypothetically at an infinite distance from the model, so it has no physical position among the other objects in a model, but its direction can usually be specified in a palette by moving a spot on a sphere, as though it were the sun in the sky.

INTENSITY

All four types of light can be specified as to intensity, either soft or bright. Intensity is usually measured in percentages from 0 to 100.

DIRECTION

Both ambient light and point lights cast light uniformly in all directions. However spot lights shine light in a particular direction and can be aimed. Distant lights also shine light in a particular direction.

SPREAD

Spread refers to the size of the cone of light that is cast by a spot light. The area of light that falls on the subject can be large or small and focused or unfocused, with either a hard edge or a soft, blurry edge.

FALL-OFF

Fall-off refers to the range of the light. A light's range can be set to any specific distance (including infinity) and the fall-off may be linear or exponential.

COLOR

Lights in a 3D model can be any color chosen from the millions of colors available on the RGB palette. Sunlight is white and indoor lights tend to be yellowish, so these colors are often used to create realism in 3D rendering. However, other colors (for example, red and blue) can be used to create special moods.

SHADOWS

Unlike light in the real world, the shadow-making function of point, spot and directional lights can be turned on or off.

POSITIONING LIGHTS IN A MODEL

Point and spot lights can be placed in a 3D model just as though they were physical objects. In most programs they appear in the model on-screen and can be moved and rotated in the same way as other 3D objects. (However, while lighting objects appear on-screen during the process of creating a model, they do not appear as objects in the final rendering. Only the effects of the light they shed are visible.)

Point lights do not need to be aimed, since they shed light uniformly in all directions. But spot lights do require aiming and they can be rotated using the same rotation tools used for other 3D objects. In some programs spot lights can be set to point at a particular object in a model and also to track it, so that if the object is moved, the light rotates to follow it.

Most programs make it possible to choose lights from a menu, or drag them into a scene from a tool bar. They can be positioned relative to the model using orthographic views (see page 27). Some of the effects of lighting are visible in a rudimentary way in Gouraud and Phong shading methods, so you can check your lighting set-up in these draft modes. But the full effect of lighting in a model, complete with cast shadows, reflections and so on, is visible only when the model is rendered by ray tracing (see "Rendering" on page 34).

Adding light sources

To make it easy to understand the effect of adding light sources we set up a simple temple model and placed a camera in front of it.

We made the building and ground matte white so as not to introduce other variables such as reflectance, color or texture. The background is black with black fog to blur the horizon.

A ray traced rendering with one global light source (**1**) with shadows turned off reveals a dull, flat-looking scene (**A**). Simply enabling the shadows brings the model to life (**B**).

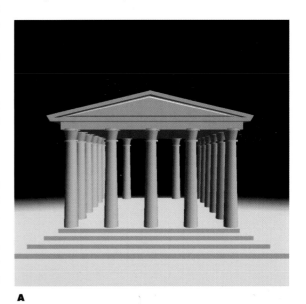

A

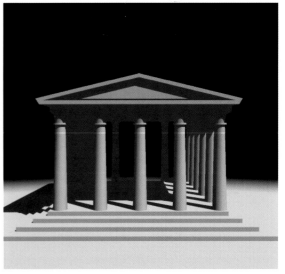

B

Next we placed one blue-colored spot light (**2**), above and to the left of the roof. It was given a fall-off distance to about the center of the building and a narrow angle with soft edges to the light cone. It created a dramatic interest on the gable and added a sense of depth to the model (**C**). Another spot light, colored yellow (**3**), was added at close range near the temple steps at the right of the building. We gave it a short fall-off distance. It warms up the foreground and adds tonal range to the row of columns. Unlike the blue light, the yellow spot has a hard edged-cone which is visible at the right edge of the gable (**D**).

Adding a warm-colored point source light (**4**) reveals the temple's interior, which had been obscured by shadows from other lights. To avoid a confusing pattern of shadows on the ground surrounding the building we specified that this interior light would cast no shadows (**E**). Two more radial lights (**5**, **6**) of lesser intensity in green and blue provide the finishing touch to the interior (**F**). (The numbered lights we refer to are shown in position in the diagrams on the right.)

Model and lighting key
The direction and position of all the lights used in the model is:
1 Directional light source
2, **3** Spot lights
4, **5**, **6** Point lights

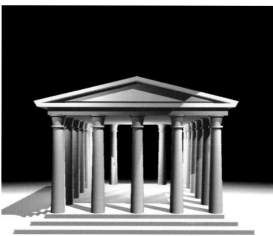

Isometric view

Front view

Right side view

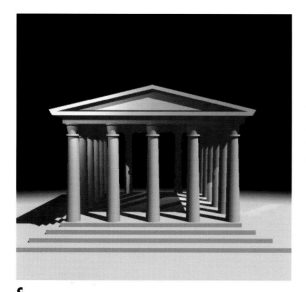

C

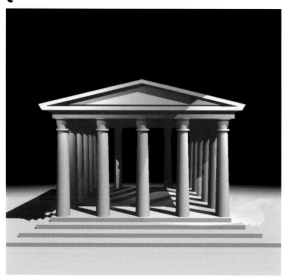

D

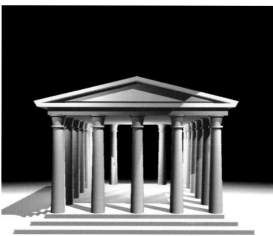

E

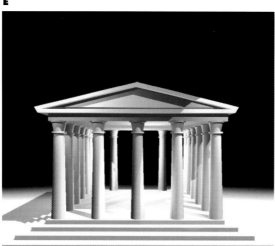

F

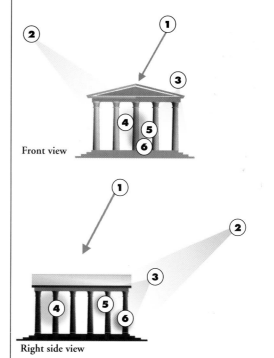

THE INTENSITY OF LIGHT

Another variable in lighting is the relative strength of a light source. In studio photography lights are rarely all the same intensity. Generally the key light is the brightest light, with the fill light set at about half the intensity of the key.

In 3D models you have complete control over the light sources. Lights can be turned on or off or dimmed to any degree you like. It's easy to experiment with different light strengths, although it may take some time to render all the possible variations. We show here a useful index of various intensity mixes.

Interior versus exterior light
In this model we have one interior and visible light source and one external, distant light source coming through an open window.
Models from Dream Models

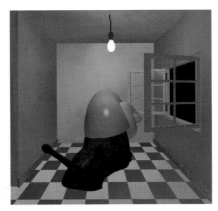

Dim interior light
No exterior light

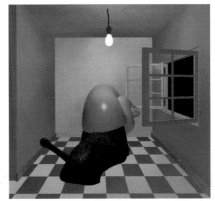

Low-intensity interior light
No exterior light

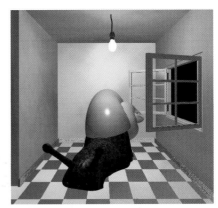

Mid-intensity interior light
No exterior light

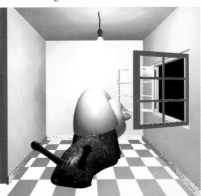

High-intensity interior light
No exterior light

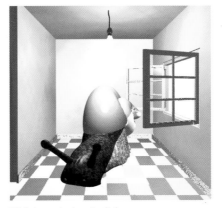

High-intensity interior light
High-intensity exterior light

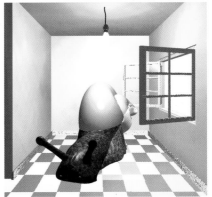

High-intensity interior light
Mid-intensity exterior light

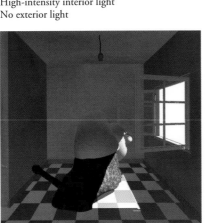

No interior light
Mid-intensity exterior light

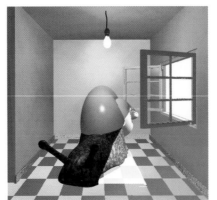

Mid-intensity interior light
Mid-intensity exterior light

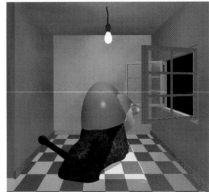

Low-intensity interior light
Low-intensity exterior light

Projecting a cone of light
Spot lights give off a cone of light. Usually, the angle or spread of the cone is adjustable.

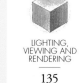

DIRECTION, SPREAD AND FALL-OFF

Spot lights are especially powerful lighting sources in computer 3D because they can be aimed to point in a particular direction and the area of light that they cast (spread) can be adjusted in size. In addition to basic light intensity, the range of a spot light can be specified in terms of a fall-off value, so that the light cast will extend into the model by a specified distance.

Changing spot light direction
We placed a spot light in front of the chair, about eight chair widths away and about two chair heights above the model and pointed it straight at the chair (**A**). Then we moved it to the right to point across the chair (**B**), and placed it behind, pointing forward (**C**).
Model from Cyberprops

Adjusting the edge of the light cone
We adjusted the angle of the cone, first to 10 degrees (**D**), then to 30 degrees (**E**). We made the edge of the light soft (**F**) by adjusting the half-angle or penumbra.
Model from Cyberprops

Adjusting the fall-off
As the light cone from the spot light spreads away from the source, the intensity of the light is attenuated (**G**). By setting the fall-off distance we limited the range of the light, causing it to diminish more rapidly (**H**).
Models from Strata Clip

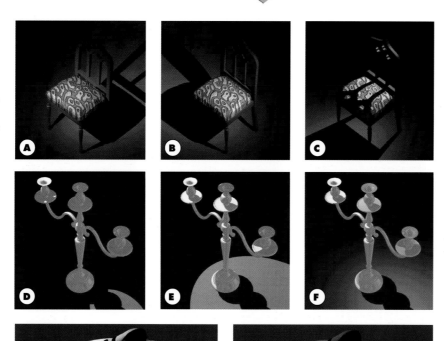

THE POWER OF LIGHT

Modeling and surface properties give spacial information but lighting provides the emotional dimension. It is the lighting in a Hollywood film or comic book that tells you whether it's the hero or the villain. The shadow on the steps tells you that something awful is about to happen, or the moist glint in the heroine's eye tells you it's time to take out the handkerchief. The same factors apply in 3D graphics; how you handle the lighting brings out the character of the model, focuses your eye dramatically on specific parts of the model and throws other parts into relative obscurity.

There's a certain slant of light,
On winter afternoons,
That oppresses, like the weight
Of cathedral tunes.

Heavenly hurt it gives us;
We can find no scar,
But internal difference
Where the meanings are.

None may teach it anything
'Tis the seal, despair,—
An imperial affliction
Sent us of the air.

When it comes, the landscape listens,
Shadows hold their breath;
When it goes, 'tis like the distance
On the look of death.
—Emily Dickinson

VARIATIONS IN LIGHT COLOR

The design for a college textbook cover illustration started with the creation of a cube with head-shaped cutouts, which was placed on some steps. All the elements of the model were white and only the light sources were colored. During the course of developing design ideas, the model went through several experimental variations in light color, each one greatly affecting the mood of the illustration. The lighting setup consisted of one directional light, one spot light and two point lights.

Lighting key
The direction and position of the lights in the model is as follows:
1 Directional light, shining from the left
2 Spot light aimed away from the camera
3, **4** Point source lights, one outside and one inside the cube
 Only the global light is set to cast shadows.

Starting point
Spot light magenta (**2**); point lights green (**3**), orange (**4**).

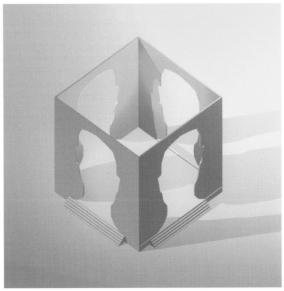

Variation 1
Spot light yellow (**2**); point lights green (**3**), blue (**4**).

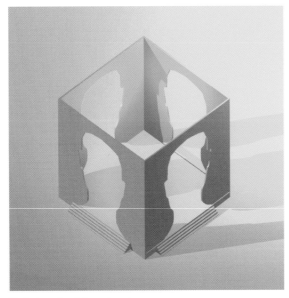

Variations 3 and 4, getting closer
Spot light orange (**2**); Point lights, orange (**3**), red (**4**). Toning down the saturation of the spot light (see right) gives a more pleasing, elegant result.

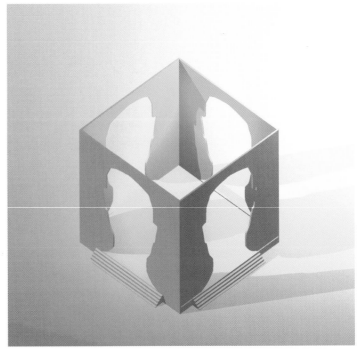

Cover story
The final image approved by the publisher used a neutral spot light color with yellow and green point lights to produce a fairly subtle color scheme for a college textbook cover. For human interest, a small figure was added the foreground.

CHANGING THE AMBIENT LIGHT COLOR

Another way to change the color of the rendered image is to vary the ambient light color. An ambient light can almost be thought of as the opposite of a light source because it determines the depth and color of the shadows.

Ambient light determines the amount and color of light that is scattered into a model by the "environment". For example, imagine a photography studio in which all the walls are painted black. If lights are shined on objects in this black room the shadows cast would be dark, whereas in a white-walled studio the shadows would be gray.

In this example we varied the ambient light color from deep purple, to dark green, to black. The color and position of the other light sources are the same as in *Variation 1* on the facing page.

Deep purple ambient light

Dark green ambient light

Black ambient light

PSYCHOLOGY

CAROLE WADE & CAROL TAVRIS Fifth Edition

LIGHTING AN OUTDOOR SCENE

Lighting an outdoor scene is easy in some ways because there is usually only one light source—the sun (or sometimes the moon). By varying the angle of the sun, different times of day can be represented. The French Impressionist painter, Monet, became fascinated with the quality of light at different times of the day and painted the same scene many times throughout the day capturing all the nuances of color as the light changed.

By varying the strength of the shadows the day can be sunny or overcast.

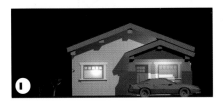

Sun cycle
We rendered the same scene with a sequence of different positions for the directional (global) light source. In the key below the approximate position of the sun at each "time of day" is noted.

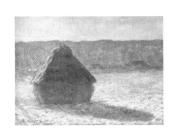

Haystack in winter
Impressionist Claude Monet painted several versions of this haystack to capture the effect of natural light at different times of the day.

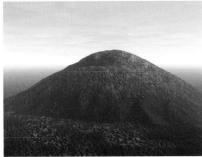 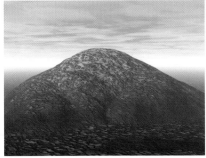 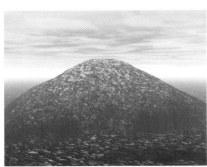

A Sunrise **B** Morning **C** Noon

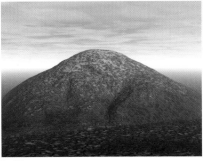 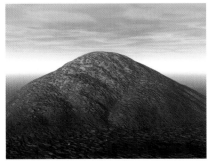 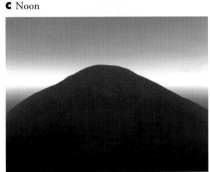

D Afternoon **E** Sunset **F** Dusk

Shadows and lighting in outdoor scenes
Strong shadows convey sunlight (**G**), while making the ambient light a pale color and reducing the intensity of the directional light produces weak shadows, for the effect of an overcast day (**H**). At night the shadows are strong again. Auxiliary lights in the windows add atmosphere (**I**).

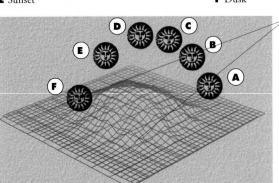

Position of camera

...variable as the shade by the light quivering aspen made.
—Sir Walter Scott, 1808

USING GELS

A *gel* is an image that modifies the light coming from a light source. The term comes from the world of theater lighting, in which plates filled with a thin film of colored gelatin are slotted in front of lights to change their color. However, in desktop 3D gels go beyond the function of providing colored light, since color can already be specified as an attribute of a light source (along with intensity and so on) without use of a gel. More typically, gels are used in order to project multicolored images onto a scene. For example, an image of a stained-glass window might be used as a gel to simulate the effect of light falling through such a window into a room. In effect, a colored gel functions like a transparency, as though a photographic slide were being projected onto a scene.

COLOR VERSUS PATTERN

Theater and film lighting directors also make use of stencils to partially block the light coming from a light source. This is done in order to give the effect of objects offstage, such as a leafy tree or Venetian blinds. So in some 3D programs a differentiation is made between gels used to add color to a light and gels used to partially block the light coming from a light source. For example, in Infini-D a gel is defined as a color image, whereas a black-and-white image used as a gel is called a *mask*. In Ray Dream Designer

gels and masks are combined in one function, but if a gel is a 1-bit (black-and-white) image it automatically functions as a mask, partially blocking light. In Bryce a mask is called a *gel cookie*, based on the use of that term in filmmaking. Regardless of terminology, the black areas of a black-and-white gel will block light and the white areas will allow it to pass through.

In addition to bitmapped images, Ray Dream Designer makes it possible to create gels based on mathematical formulas, which create patterns similar to those produced in procedural textures. Also, movies can be used as gels. The effects of this would be seen when a scene is rendered as an animation sequence. For example, a movie of a tree waving in the wind could create an effect of moving shadows in a scene.

Gels are usually applied to spot lights, but in some programs they may also be applied to point (bulb) lights and direction or global light sources (see "The Four Basic Light Types" on page 128).

OTHER EFFECTS

Other special lighting effects include lens flare and visible light (sometimes called volumetric light). These are *post-process effects*, meaning that they are computed after the image rendering process is complete. For more information see page 148.

Using ready-made gels
Any bitmapped image or texture can be used as a gel. Most programs include ready-made gels and also make it possible to import bitmapped images for use as gels. Ready-made gels usually include editable horizontal and vertical slats for simulating blinds, gels in the shapes of window frames and also gradients between two colors for simulating special lighting conditions, such as sunset and sunrise.

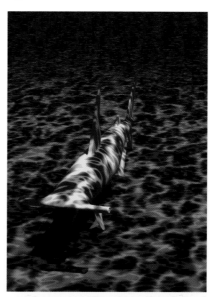

Casting shadows
Gels provide a more efficient way to create the effect of an offstage object than to model an actual object and place it outside the camera's view. For example, it's much easier to cast shadows on a scene by creating a bitmapped image of leaves and using it as a gel than to model a tree with leaves and place it offstage to block a light source.

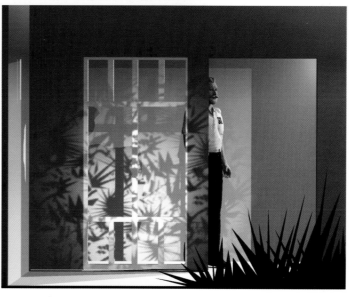

Working with Cameras

Focal length and viewing angle
The focal length—or the distance between the lens and the focal plane—determines the spread of the view seen by the camera. A camera lens with a long focal length has a narrow view angle and functions as a telephoto lens, while a lens with a short focal length has a wide view angle and functions as a wide-angle lens.

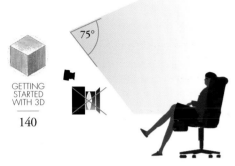

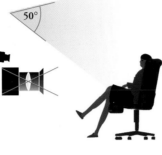

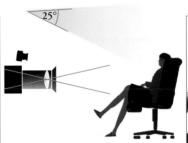

VIEWING THE SCENE

In desktop 3D, a scene is viewed through a "camera," which serves as the *viewpoint* for generating a perspective view of the model (see "Linear Perspective" on page 10). Every 3D scene includes a default camera, which makes it possible to "see" the model as it is being constructed. It usually can be switched between a perspective view and orthographic views such as front or side (see "Viewing the 3D World" on page 26). But in addition to the default camera, any number of other cameras can be added to a scene and the model can be viewed through any of them. Cameras are regarded as "objects" and can be positioned and rotated in the same way as other 3D objects, so that they can capture a view from any point in the model.

TYPES OF CAMERA LENSES

Cameras in desktop 3D are designed to simulate the effects of real-world cameras and 3D programs often make it possible to specify different lens types, such as wide-angle and telephoto. The default camera in many computer programs is similar to a 50 mm normal lens. But once a camera has been introduced into a scene, its lens type and focal length can be edited at any time. There are usually two main lens types: conical and spherical. *Conical lenses* (also called *normal lenses*) are used for capturing views similar to those seen through real-world cameras. Spherical lenses are used for capturing spherical or 360-degree images that can be used in virtual reality presentations.

CONICAL LENSES

There are three main types of conical lens: normal, wide-angle and telephoto. Some programs include each type of lens separately, with default settings for each. In other programs, the properties of wide-angle or telephoto lenses are created by using a slider or numeric values to change either the viewing angle or focal length of a normal lens.

Focal length is the distance between the center of a lens and the *focal plane*, or the plane in which the image seen by the camera is projected in sharp focus (when the camera is focused on infinity). In a real-world camera, the film is positioned in the focal plane. In computer 3D the focal plane is the "picture plane" (see page 11).

NORMAL

A *normal lens* typically has a focal length of 50 mm and a viewing angle of about 46 degrees. A normal lens is so-called because it creates an image similar to that seen by the human eye.

WIDE-ANGLE

A *wide-angle lens* captures a wider view of a scene than a normal lens. It typically has a focal length of 24 to 18 mm, which provides a viewing angle of 84 to 100 degrees. A wide-angle view tends to exaggerate the perspective in a scene. An extremely wide-angle lens, sometimes called a *fish-eye lens*, creates a very distorted perspective.

TELEPHOTO

A *telephoto lens* focuses on a smaller area of a scene than does a normal lens. In photography, a telephoto lens is often used to make a distant object or scene look larger in the viewfinder, without having to move the camera closer to the object. A telephoto lens typically has a focal length of 200 mm, which produces a viewing angle of 12 degrees. A telephoto lens tends to flatten the perspective in a scene.

ZOOM

A *zoom lens* is one that can be adapted to function as a wide-angle, normal and telephoto lens by varying the focal length of the lens.

ISOMETRIC LENS

Most 3D programs also include a camera lens type that produces an isometric view, or one in which receding lines do not converge on a distant vanishing point. For more information on isometric views see "Isometric Perspective" on page 28.

Camera view area

Image area

Defining image area
The image area of a scene, which determines what part of the scene will be rendered, is usually just a portion of the total view seen by a camera. Its boundaries can be set to any appropriate size and proportions. In some programs the camera window itself can be resized, determining the size and proportion of the rendered image.

SETTING THE IMAGE AREA

The view seen through a camera determines both the view you see on-screen and the view that will be rendered. However, these two views are not always identical, and different programs have different ways of handling this aspect of camera view. For example, in Ray Dream Designer, the current camera determines the view seen in the modeling window. You may see a large or small area of the model, depending upon the current size of the window (it can be resized by dragging its corner) and the current level of magnification. But regardless of what appears in the modeling window, the only part of the camera's view that will be rendered is that defined by a "production frame" which can be toggled to appear on-screen with handles to adjust its size and position in the viewing area.

By contrast, in StudioPro, Vision 3D, Infini-D and Bryce 3D, there are modeling windows which are not associated with cameras and additional camera windows. Renderings can be made from either a modeling window or a camera window. In StudioPro and Vision 3D, the camera window can be dragged to be resized and its boundaries determine the boundaries of the rendered image. No matter how this feature is implemented, most 3D programs make it possible to determine exactly what portion of a camera's view will be rendered into a final image.

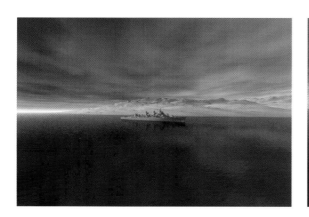

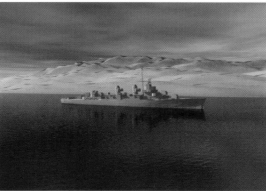

Adjusting the viewing angle
The normal lens provided in most programs as a camera default has an average focal length of 50 mm and an associated viewing angle of about 46 degrees. But most programs make it possible to change focal length to create custom lenses with viewing angles ranging from extremely wide-angle to tightly telephoto. Perspective is exaggerated with a wide-angle lens, while a telephoto lens tends to flatten the perspective in a scene.
Model from Acuris

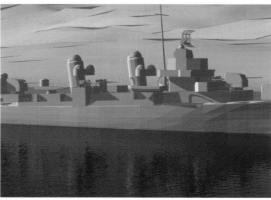

POSITIONING AND AIMING CAMERAS

Cameras can be placed anywhere in a scene and pointed at any angle using the same tools used for positioning and rotating other 3D objects. As with other objects, cameras can be moved or rotated by dragging with the mouse or by entering numeric values in a palette or dialog box. And as with other functions, many camera moves can be controlled using modifier keys. Programs often include features designed to make camera handling easier.

POINTING AT AN OBJECT

Since aiming a camera can be tricky, most programs provide a "point at" function that automatically points a camera at a particular selected object. The camera generally points at the centerpoint of an object (see "Setting the Center of Rotation" on page 71). A "point at" command can be quickly used to get the camera pointing in the right direction and then the camera view can be fine-tuned using other controls.

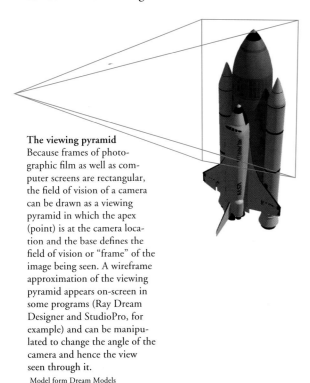

The viewing pyramid
Because frames of photographic film as well as computer screens are rectangular, the field of vision of a camera can be drawn as a viewing pyramid in which the apex (point) is at the camera location and the base defines the field of vision or "frame" of the image being seen. A wireframe approximation of the viewing pyramid appears on-screen in some programs (Ray Dream Designer and StudioPro, for example) and can be manipulated to change the angle of the camera and hence the view seen through it.

Model form Dream Models

FOLLOWING AN OBJECT

Many programs also make it possible to point a camera at an object so that when the object is moved, the camera automatically reorients itself to continue pointing at the object in its new location. Sometimes this is done by selecting camera and object and linking them with a command. Sometimes a special type of camera is used.

PAN, TRACK AND DOLLY

Some 3D programs, notably Ray Dream Designer and StudioPro, provide tools for moving cameras in the same way that motion picture film cameras are moved, using the conventions of *pan*, *track* and *dolly*.

PAN

To *pan* means to rotate a stationary camera around its own vertical axis. With panning, your view of a scene changes in the same way as when you stand in one place and turn your head from side to side. In Ray Dream Designer the pan control also allows up and down movement, while in StudioPro, up and down panning is controlled with a "boom" tool.

TRACK

To *track* means to move the camera up or down, or left or right within a plane that is parallel to the view frame. In filmmaking, for example, a camera fastened to a car and fixed to point perpendicularly, might by driven along a road to track past all the houses on that road.

DOLLY

To *dolly* means to rotate a camera around an object, while keeping the camera pointed at the object. For example, you might dolly around a sculpture by walking completely around it, while keeping yours eyes trained on it. Dollying in computer 3D can be done at any angle —circling the camera around an object either vertically (as with a Ferris wheel), horizontally (as with a merry-go-round), or at any other angle.

HOT TIP

If you want to aim a camera at a specific part of a model using a "point at" command, but there is no object there to select, create a temporary object, point the camera at it and then delete the object.

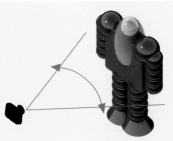

Panning rotates the camera on its own axis from side to side.

Tracking moves the camera within a plane parallel to the picture plane.

Dollying rotates the camera around the object.

MULTIPLE VIEWS AND IMAGES

The "perspective predicament" is a concept in epistemology (the study of the foundations of knowledge). The problem is that each person can see the world from only one viewpoint, which is real but limited. This gives rise to "the plight of being confined to the experience of only part of actuality" (D. D. Runes, *Dictionary of Philosophy*, 1942). But in the realm of desktop 3D, the actuality of the "world" or 3D scene *can* be viewed from an infinite number of viewpoints simply by changing the position of the camera. And a scene can be rendered into a final image any number of times, using any number of different cameras in different positions.

CREATING MULTIPLE CAMERAS

If you plan to render your model from several different viewpoints, it would be possible to add a single camera (in addition to the default camera) and to reposition it in order to capture different views of a scene. But since positioning and aiming cameras can be a time-consuming process, it's often better to introduce several different cameras (one for each view) and leave each camera in place. As new cameras are added to a scene, each one is given a default name (Camera 1, Camera 2 and so on), and a pull-down menu or dialog box will make it possible to switch between camera views. However, in many programs you can give cameras specific names to help you remember their locations or purpose, such as "above, left," "down, right," "bird's-eye view" and so on.

VIEWING THROUGH MULTIPLE WINDOWS

When working with cameras it's often helpful to open two or more viewing windows at once, which can be done in most programs. For example, when trying to position a particular camera you could open one view for the default camera and another for the camera you're positioning. In the default camera's view window you'll be able to see the second camera as an object so you can keep track of its position as you move it by dragging. In the second camera's view window you'll be able to see the results of any changes you make to the camera's position. Remember that while cameras are visible in view windows, they are not visible as objects in the final rendering—only their effects are visible.

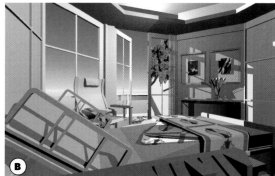

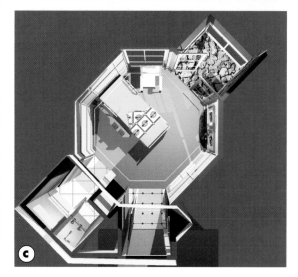

Rendering from multiple cameras.
This model of a hospital room is viewed from the point of view of a patient, Camera 1 (**A**), a visitor, Camera 2 (**B**) and an administrator, Camera 3 (**C**). Before rendering from Camera 3 we removed or "hid" the roof and ceiling.

The position of the three cameras is shown in the diagram below.
Model by Jim Lennon

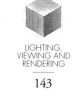

THE EMOTIONAL IMPACT OF CAMERA VIEW

Children's book illustrators know that it is possible to provoke strong emotional reactions in their readers by changing the viewpoint of a scene. For example, viewing the loathsome giant from a low point at his feet (Jack's-eye-view) can make the giant look much larger and more frightening. Likewise, looking down at a small child from a high vantage point can make the child look smaller and more vulnerable. The emotional impact of viewpoint can be exploited easily in desktop 3D simply by changing camera location.

This topic is one of many aspects of *visual literacy* discussed in The On-Line Visual Literacy Project, an Internet site maintained by Pomona College in Claremont, California, (www.pomona.edu/visual-lit/intro/intro.html), which provides this introduction:

"Objects located dramatically above eye level are said to be seen from worm's eye view, while those positioned extremely below eye level are seen from bird's eye view. The decision of which point of view to take within the frame involves more than just aesthetic considerations; it has psychological implications as well. A slender upright object seen from worm's eye view tends to look more massive and stable because it is appears wider at the base and grows narrower from the bottom like a mountain. The same object seen from bird's eye view often looks more minuscule and unstable because it appears narrower at the base and grows wider from the bottom like a top."

Rendering Images

FROM 3D MODEL TO 2D IMAGE

The goal of all the processes described in this book thus far—creating 3D objects, arranging them into models, applying color and texture, setting up lights, positioning cameras—is to create a final two-dimensional image. This is done through a process called *rendering*. A 3D model can be rendered any number of times, with different camera viewpoints as well as with changes in lighting or surface treatment, so that with a few modifications, a single model can be used to generate an unlimited number of images.

The word *render* comes from the Latin verb *reddere*, "to give back," and means not only to recite something you've learned or to return something taken or lost, but also to represent or depict something through artistic means. So a rendering is an artistic reproduction, as in "the artist has shown himself extremely skilful in his rendering of curious effects of light" (1893). It is this last sense of the word which is used in computer graphics.

In computer 3D, a *renderer* is a program used for rendering an image from a model. The renderer must take into consideration three main components of the model—its geometry (the shapes of the 3D objects it contains and their placement), its surface attributes (any colors or textures that have been applied to objects) and its illumination (the effects of any lights placed in the model). Over the years, many renderers have been developed to provide a solid-looking, *shaded* image of a model (as opposed to a see-through type of wireframe image). Most 3D programs include simple renderers that can be used to quickly get a rough idea of what a model looks like. These include rendering methods such as flat shading, Gouraud shading and Phong shading (see our introductory section on "Rendering" on page 34). However the most realistic effects to date are achieved with a rendering method called "ray tracing."

WHAT IS RAY TRACING?

The process of ray tracing follows the course of every ray of light that is emitted from the model to the 2D image (the *picture plane*) to determine whether it came directly from a light, bounced off of a surface, or passed through a translucent material. The process of ray tracing makes it possible to realistically render not only the geometry and surface attributes of the model, but also light effects such as shadows, reflections and refraction. For most 3D images, ray tracing is the highest quality method of rendering currently available, though some programs, for example StudioPro, also include a *radiosity* renderer which is especially good at calculating the effects of diffuse light traveling back and forth between multiple reflective surfaces.

PREPARING FOR RENDERING

Since ray tracing can take a long time—from 20 minutes to 20 hours, depending upon the complexity of the model—it's best to plan ahead. There are at least five factors that can affect rendering time: the size of the image, the number of polygons generated for object surfaces (surface fidelity), the complexity of the model, the type of rendering you choose and the memory capacity and speed of your computer system.

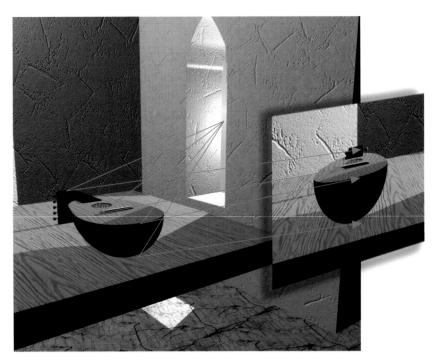

Tracing the rays
Ray tracing works by starting with each pixel in the final image bitmap and tracing the path of the light ray that hits it, backwards through the model, to find its origin. By evaluating the course of the ray as it travels from light sources or is bounced off of objects, the ray tracer can determine what color or value the pixel should be.

Rendering at different qualities

The model shown below has a fairly simple physical geometry, but does contain some elements that can increase rendering time, such as reflective surfaces, transparent surfaces, tiled texture maps and shadows. Sometimes Phong shading provides enough detail for a pleasing image. But the Phong method, unlike ray tracing, does not accurately render transparency or calculate reflections.

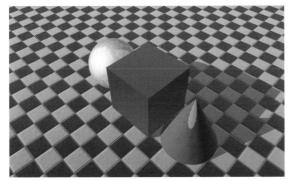

Phong shading (7 seconds)

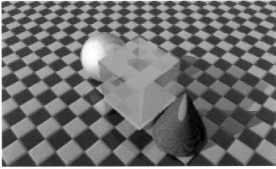

Ray tracing at 72 dpi at actual size (2 minutes)

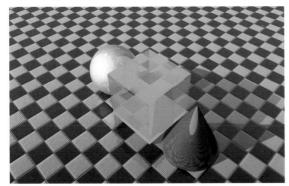

Ray tracing at 300 dpi at actual size (24 minutes)

We will draw the curtain and show you the picture.
—Shakespeare, *Twelfth-Night* (1598–1600)

IMAGE SIZE AND RESOLUTION

Ray tracing is done on a pixel by pixel basis; that is, the color and intensity of each pixel in the final bitmapped image is determined by the quality of the light ray that hits the center of the pixel from the model. So for a 3 × 5 inch image at a resolution of 250 dots per inch (750 by 1250 pixels), for example, the pathways of 937,500 light rays would be calculated. It's easy to see why ray tracing is often a time-consuming process and why increases in the size or resolution of an image add to the time needed for rendering. If your final image will be used on-screen (as a web site graphic, for example) then a resolution of 72 dpi will be sufficient. If your image will be printed, then higher resolutions are necessary. In general it's best to render your image at actual size, at the lowest resolution that will produce the quality you want.

ADJUSTING SURFACE FIDELITY

Before final rendering, 3D programs break objects down into hundreds (sometimes thousands) of tiny polygons (see "Defining the Mesh" on page 59). Programs calculate the optimum number of polygons needed to make objects appear smooth, taking into consideration the size of the objects, the desired resolution and the object's distance from the camera. Some programs provide *surface fidelity* controls that allow the user to increase or decrease the number of polygons created. Increasing fidelity increases smoothness but adds to rendering time. Since surface fidelity controls can often be applied on an object-by-object basis, one way to reduce rendering time is to reduce the surface fidelity of selected objects that are in the background.

SIMPLIFYING A MODEL

There are various ways to simplify a model so that the rendering time is reduced. Keep in mind that you're

trying to reduce the number of calculations needed to describe each individual ray as it bounces through the 3D scene and also to reduce the amount of memory required to handle elements such as imported texture maps. To reduce rendering time you can:

• Reduce the number of image-based texture maps used to define surfaces (see "Image-Based Texture Maps" on page 108).

• Limit the size of image-based texture maps.

• Reduce image-based texture maps to 8-bit color depth (see "Hot Tip" in the section on "Creating Your Own Textures" on page 109).

• Replace image-based texture maps with procedural textures when possible (see "Procedural Texture Maps" on page 102).

• Simplify the geometry and texturing of objects that are in the background.

• Reduce the surface fidelity of objects in the background.

• Use the minimum number of lights (see "Theories of Lighting" on page 130).

• Disable the rendering options for reflection, transparency and refraction if these are not used in your model.

In addition, some programs make it possible to apply rendering preferences to individual objects in a model, including the attributes of reflection and refraction. So objects that are in the background, for example, could be rendered with less detail than those in the foreground.

CHECKING A SCENE WITH DRAFT RENDERING

While creating a model, you can frequently check its appearance using the Gouraud and Phong renderers that are built into most programs. Many programs also include a rendering "preview" tool that makes it possible to ray trace a selected small area in the view window.

If the model looks satisfactory with these methods,

the next step is to render a ray traced image using a low resolution (such as 72 dpi, for example) and a small image size. The resulting image will be relatively "bitty," but it will include the optical effects (such as shadows and reflection) that other rendering methods may not include. In addition, some programs also make it possible to enable or disable certain aspects of the ray tracing process. So if you are concerned only with checking the appearance of cast shadows, for example, you could create a draft rendering by turning off the rendering of reflective surfaces.

If the draft ray tracing is satisfactory, you can plan to run the final rendering during a break or on another computer, so that your work flow is not interrupted. Some programs make it possible to render "in the background" so you can continue working on other computer tasks, although this can slow the rendering process. It's also possible to queue a batch of renderings and run them one after the other during a long block of available computer time, such as overnight.

MAXIMIZING YOUR SYSTEM

To work with 3D programs, it's best to have a computer system that's fast and has a lot of available memory, both as RAM (random access memory) and hard disk storage space. As with image-editing, the more memory the better. You should have a minimum of 20 MB of RAM and at least 40MB free on your hard drive for the application itself and some working room. However, there are various ways to maximize your use of your system, whatever its capacity.

• Assign more system RAM to the 3D application.
• Quit all other applications while running a 3D program.
• Close all unnecessary on-screen windows.

Anti-aliasing by super-sampling

One method that is used to produce a sharper image is *super-sampling* or adaptive oversampling. Super-sampling generates extra pixels which are interpolated when the rendering is completed. A super-sampling factor of three, for example, generates nine pixels centered around each pixel in the final image (**A**). When the rendering is done, these nine pixels are merged to form the one pixel that will be used in the final image (**B**). The final image looks smooth because of the oversampling during the rendering process.

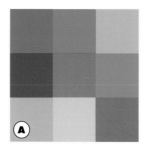
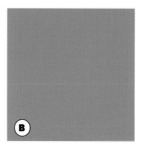

Anti-aliasing by pixel-averaging

Pixel-averaging or area-sampling is another method used to smooth the "stair-stepped" or jagged edges that occur along diagonal shapes in an image (**C**). Pixel-averaging smooths these diagonal lines by making the intensity of each pixel proportional to the amount covered by the object (**D**). Both super-sampling and pixel-averaging may be used in combination and can be set to affect edges only or apply to an entire scene.

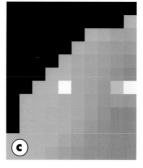

OTHER RENDERING OPTIONS
ANTI-ALIASING

This process smooths the edges of diagonal lines in an image so that the stair-stepping of the pixels in the image bitmap is less apparent (see "How Computers Draw" on page 36). Anti-aliasing makes the surface edges in the final image look smoother.

COLOR DEPTH AND FILE FORMAT

Desktop 3D programs make it possible to specify whether the image should be output in 8-bit, 16-bit or 24-bit color to produce an image with 256 colors, thousands of colors, or millions of colors respectively. You can also specify whether the final image should be saved in a PICT, TIFF or EPS file format or in a format appropriate for animation, such as PICS or QuickTime or AVI.

RENDERING EFFECTS

Many programs include special effects that are specified at the time of rendering and are visible only in the final ray traced image. These functions are intended to simulate natural effects seen in the real world and in photography which add to the realism of the rendered image, such as the *atmospheric effects* that make distant objects

look hazy and create a sense of depth in an image as well as global *environmental effects* in which a texture map is applied to the background of an image.

ATMOSPHERE

Outdoor objects that are far away look blue and hazy compared with objects that are close to us. This phenomenon—an effect of the transmission of light through the atmosphere—is often called "aerial perspective" and has been studied extensively by both artists and scientists since the Renaissance (see "Atmospheric perspective" on page 19). Most 3D programs provide atmospheric effects (often called *fog*) that can be used to create this look of haziness around distant objects. Fog provides an important *depth cue*, in addition to that provided by linear perspective. Usually programs allow the user to set the starting and stopping position of the fog, its density, "clumpiness" and color. Realistic atmospheric light effects can only be approximated in 3D graphics however, since in nature they are dependent upon many variables that are difficult to simulate, including the time of day, the light angle, the amount of pollution in the air and the exact wavelength of the light.

Behold him setting in his western skies,
The shadows lengthening as the vapours rise.
—John Dryden, 1680

Using depth of field
We used Ray Dream's Depth of Field filter to add a postrendering effect that simulates the shallow focal plane of an ultra close-up camera lens. In the unfiltered rendering all the details are sharp (**C**). But in the filtered version parts of the leaf in the foreground and the insect's antennae are blurred (**D**).

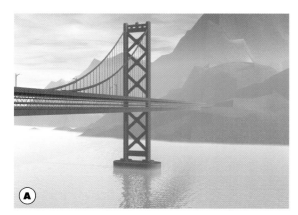

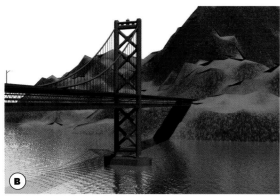

Using special atmospheric effects
One of our favorite atmospheric effects is fog. It can be used to advantage in many different situations: to blur a horizon, for example, or to simulate the effect of light drop-off. In combination with haze, mist and other atmospheric effects, very sophisticated results can be achieved. We applied Bryce's "Will o' the whisp" sky/fog effect to a model of the Golden Gate Bridge to create a sense of scale and grandeur (**A**) that is lacking in the basic rendering (**B**).
Model from Bryce 2 Accessory Kit

ENVIRONMENT MAPS

Most programs include the ability to apply an image-based texture map (such as a scan of a blue sky with clouds, for example) onto the background areas of a model, in order to fill in the blank areas between objects. In effect, the image is mapped or projected onto the inside surface of a hypothetical sphere that surrounds the model. Any reflective surfaces in the model will reflect this background. *Environment maps* make it possible to create background effects without adding actual background objects to the model. The maps can be imported images or can be specified within your program as a solid color, a gradient between two colors, or as a procedural texture.

BACKDROPS

Ray Dream Designer also includes a backdrop option which is the same as a background environment map except that the map is not reflected by objects in the model and does not interact with the lighting.

GROUND PLANE

Some programs also make it possible to set up an infinite ground plane and apply a texture map to it.

POST-PROCESS RENDERING EFFECTS

Some special effects, often called *post-process effects*, are performed after the image has been rendered by ray tracing. These include effects such as *depth of field, lens flare* and *visible light* and are intended to simulate real world or photographic effects.

DEPTH OF FIELD

The image produced when a 3D model is rendered can sometimes look *hyper*-realistic because all the objects in the scene are sharply in focus, which is not the case with natural scenes. This effect may sometimes be desirable in

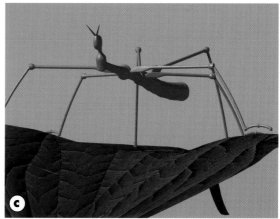

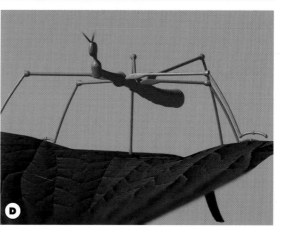

order to produce illustrations in a Super Realist style, but many programs provide a *depth of field* function designed to make some parts of the image look blurry. This filter allows you to preview the rendered image, select an area to be in focus and define the depth of the field of focus. Objects that are outside this area—either closer or further from the camera—will appear blurry.

Knowledge, in truth, is the great sun in the firmament.
Life and power are scattered with all its beams.
—Daniel Webster, 1825

Using lens flares and auras
Lens flare is a post-rendering effect in which a special filter simulates the effect of internal reflections in a camera lens (appropriate when a subject is backlit). Creating an aura around an object is also a post-rendering effect.

LENS FLARE

Another post-process effect is *lens flare*, which simulates the radiating light streaks or halos that occur when bright light is viewed through a camera lens (or even through the lens of the eye). Lens flare parameters can include color, intensity, glow, spreading, the number of streaks or rays, and glare (creating offset rings or halos near a light source). Usually a lens flare effect can only be applied to a light source which is visible within the camera view being rendered. Lens flare effects can often be applied to individually selected lights in a model.

GLOW AND AURA

Some programs include a *glow* filter that adds a hazy glow around every light source that is visible in the rendered image. In addition, many programs include an *aura* filter which applies an outside aura to objects. In StudioPro the aura can be applied to any selected object. In Ray Dream Designer the aura is applied to any objects that have a glow factor active in their surface attribute description (see "Making Objects Glow" on page 122).

VISIBLE LIGHT

Visible light is a filtering function used to create the effect of visible shafts of light in an image. Visible light is also sometimes called *volumetric light* because the light beam appears to have volume (in Ray Dream Designer it's called a *3D light cone*). The effect is intended to imitate the way light beams become visible when passing through an atmosphere full of dust or vapor. In some programs *visibility* is an attribute of a particular light and is set up when the light is created. In StudioPro, for example, a visible light beam is created by specifying an "atmosphere" as an attribute of a spot light. The atmosphere

can be composed of dusty attic air, coastal fog or haze, and the particle effects it generates will be visible as the light cone passes through it. But in other programs visible light cones are created as a post-process effect which is specified when rendering parameters are set up. However, even in post-rendering, the visible light effect can often be applied to a specific light or lights. In either case, the necessary calculations can add considerably to rendering time. Visible light beams can usually be adjusted with regard to intensity, range, gel effects, shadowing (whether or not objects in the light beam will cast shadows) and turbulence (creating the effect of swirls of dust in the "atmosphere").

Creating a visible light beam
Many programs allow the light coming from a light source to be made visible as a kind of light cone. In this rendering made in Bryce, the hovering spacecraft is casting a powerful light beam onto a barren surface made visible by specifying "Volume visible light" in the editing window of a conical light source.

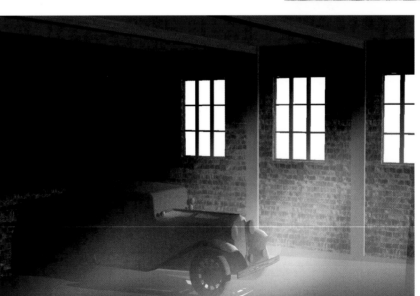

Using multiple volumetric light beams
When a fog effect is applied to a light in StudioPro, the beams of light become visible. Great care must be taken to balance the intensity of light with the density of the fog.

The real thing
Volumetric lighting effects are salient in this real photograph of Grand Central Station, New York, taken in the days of cigars and steam engines.

9 | Using 3D in Design

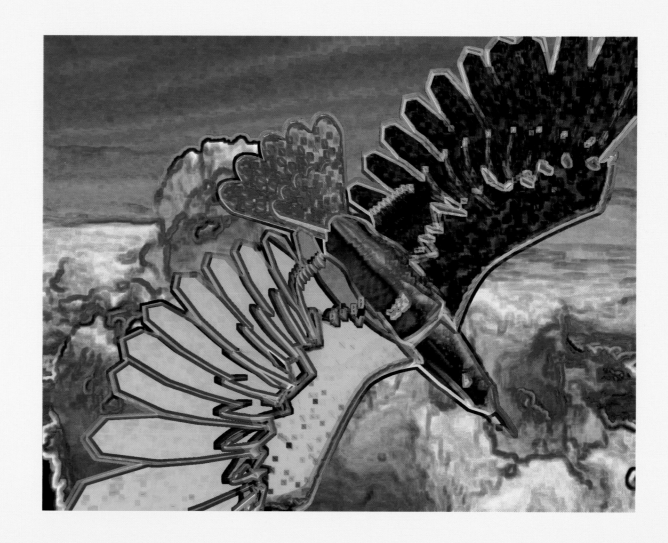

Creating and Using 3D Type

WORKING WITH TYPE IN 3D

One of the most popular uses for desktop 3D is the creation of three-dimensional type for headlines, illustrations and logos. In most cases, 3D type is extruded, with the outline of the letterform serving as the extrusion cross-section.

Type can be extruded in two basic ways; either automatically by using a program's *text tool* (which allows ready access to your system's fonts) or by importing font outlines for use as extrusion cross-sections in your program's extrusion modeling window. Font outlines for import can be created either by converting PostScript type to paths using a PostScript illustration program, or by autotracing scanned type to produce outlines. Scans can be made of type in printed clip art sources or can be made of hand-lettered characters.

Once a character or line of characters has been extruded into a solid object it can be placed into a 3D scene and manipulated in the same way as other 3D objects. It can be colored and textured; rotated, scaled and positioned; and lit with various lights.

USING A TEXT TOOL

Most desktop 3D programs include a text tool which opens a dialog box in which you can key in a single character or a string of characters and specify a font (chosen from the PostScript or Truetype fonts currently loaded in your system), choose a size in points, specify the spacing between letters and set the depth of the extrusion. After entering these values, the characters will be automatically extruded by the specified amount. These text objects can also be edited as to size, extrusion depth, spacing and so on after they've been extruded. In

HOT TIP

To determine the size a text object will be in your scene, multiply its font size in points (such as 72 points) by 0.333 to get the size of a capital letter in inches. Lowercase letters will be smaller.

addition, many programs make it possible to add a bevel to the edges of the text objects.

CREATING BEVELED TYPE

Most 3D programs provide controls for adding a beveled or slanted face to the square edges of 3D type created using a text tool. A bevel can have a straight face at a specified angle or can have a curved outline. Bevel outlines can usually be edited by adjusting control points to get the curve you want. In addition, bevels can be added to 3D type created in an extrusion modeling window (see the section on "Adding a Bevel to an Extruded Shape" on page 47).

Setting type
Most 3D programs have a text tool that provides access to the fonts loaded in your system. The font and size can be specified in a special window, but the extrusion depth is sometimes a secondary step.

Adding a bevel to type
A bevel reflects an attractive glint of light on the edges of an extruded type character. Here, a variety of fonts have been given different bevel profiles. Although selecting the right bevel profile for your lettering is mainly a matter of taste, our rule of thumb is the more complex the letterform, the simpler the bevel. (For more on beveling, see page 47.)

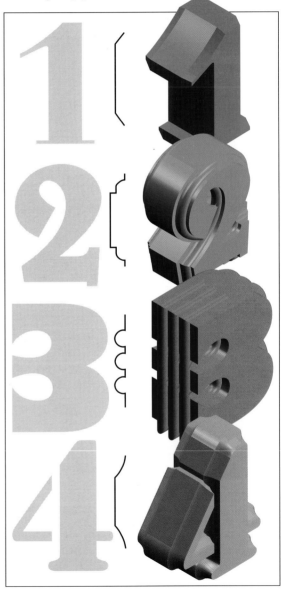

He who first shortened the labor of Copyists by device of Movable Types *was disbanding hired Armies, and cashiering most Kings and Senates, and creating a whole new Democratic world: he had invented the Art of printing.*
—Thomas Carlyle, 1834

USING IMPORTED TYPE OUTLINES

Using a text tool produces a special kind of extruded object which cannot be edited in the same way as other extruded objects. For example, it's usually not possible to convert a text object into a mesh object or to apply deformations or to combine text objects with Boolean operations. In order to edit 3D type in these ways, it's

USING SYMBOL FONTS

Some fonts consist of symbols rather than alphabet characters. These include PostScript fonts such as Zapf Dingbats (miscellaneous ornaments and symbols), Carta (map maker's symbols) and Sonata (musical notation). There are also many decorative symbol fonts available as "shareware." These icons can become the source of instant 3D illustrations. The symbols can be automatically extruded into solid shapes by keying them into a 3D program's text tool. They also can be keyed into a PostScript illustration program, autotraced or converted to font outlines and imported to serve as cross-sections for extrusion or lathing.

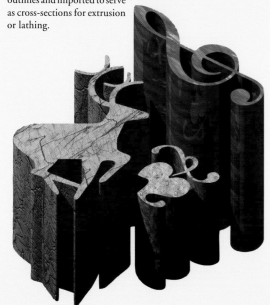

necessary to create the type not as a text object, but as an ordinary extruded object, using an imported font outline as the extrusion cross-section. Extruding type outlines in a program's extrusion modeling window means that you lose the convenience of accessing your font library from within your 3D program, but you gain in increased editing flexibility of the resulting object. In addition, imported type outlines can also be used as lathe profiles, creating another area for experimentation and special effects.

Font outlines for extrusion or lathing can be created either by drawing directly in your program's modeling windows or by importing outlines from a PostScript illustration program.

IMPORTING FONT OUTLINES

Any font that's loaded in your computer's system can be accessed through a PostScript illustration program. To create a PostScript font outline for use as an extrusion or lathing cross-section, simply key in the letter or letters you want in a program such as Illustrator or FreeHand, convert the type to font outlines and save it in an EPS format that's compatible with your 3D software.

IMPORTING SCANNED TYPE

Hand-drawn lettering or calligraphy as well as fonts printed in old books or clip art sources can be scanned and converted to PostScript outlines for use in desktop 3D. Simply scan the original art, clean up the scan in an image-editing program such as Photoshop and open the scan in an autotracing program such as Streamline to convert the bitmap to PostScript line art. The autotracer will draw around the black areas of the type to create PostScript paths which can then be imported into your 3D program and used as outlines either for extrusion or lathing.

Importing a PostScript type outline
PostScript type can be created in a PostScript drawing program and then converted to font outlines and imported into a 3D program to serve as an extrusion cross-section or lathing profile. To create this graphic we took a Poster Bodoni "H," extruded and beveled it and wrapped it snugly inside a 180-degree partially lathed Futura Ultrabold "S."

Using scanned type
If you can't find the typeface you want as an electronic font, scanning a printed letter is always an option. The script "P" was scanned from *Script and Cursive Alphabets* by Dan X. Solo (Dover Books, 1987), autotraced and imported into a 3D program where it was extruded and given a polished brass texture.

ALTERING 3D TYPE

Three-dimensional type that's been created in a model-ing window (as opposed to a text window) can be edited and altered in many ways to create truly custom and fanciful shapes and designs. Type extruded in an extru-sion modeler, for example, can be edited in many of the same ways as other extrusions, by bending the extrusion along a curved path, transforming cross-sections along the extrusion path, or creating multiple cross-sections (for more information see the section on "Creating Extruded Objects" beginning on page 40). Font out-lines can also be lathed to create special effects (see "Creating Lathed Objects" beginning on page 50). In addition, 3D type that has been created in an extrusion or lathing window can be combined with other objects in Boolean operations or altered using a 3D program's deformer functions and often can be converted to a mesh object for mesh editing (see "Working with Mesh Objects" beginning on page 57).

Performing tricks with type

There is almost no limit to the three-dimensional distortions that can be performed upon lettering: curved extrusions, morphs from one letter to another, ripples, waves and so on. Some programs make it easy to create complex and playful 3D shapes from letters. The real skill, however, comes in finding ways in which the trans-formation of the lettering conveys a message or communicates an idea in a way that the lettering alone cannot do.

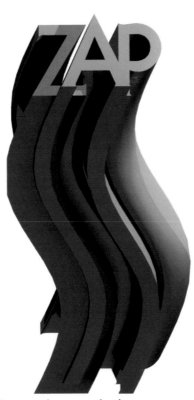

Extrusion along a curved path

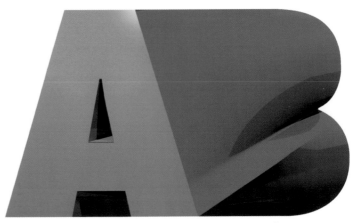

Extrusion between two different cross-sections, creating a type of "morph" or gradual change between two letterforms.

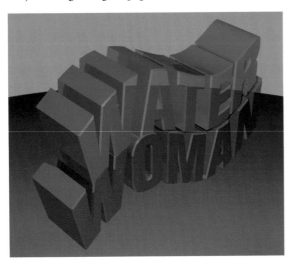

Deformed type

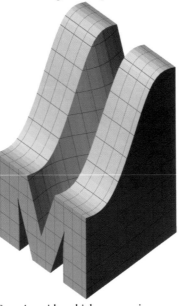

Extrusion with multiple cross-sections

Type combined with Boolean operation

APPLYING SURFACES TO 3D TYPE

Three-dimensional type, whether it is created as a text object or created in a modeling window, can be colored and textured in the same way as any other 3D object. Both procedural textures and image-based textures can be applied to 3D type, making it possible to produce many kinds of effects. In some cases, the aim is to make the type look "realistic," as though it were actually fabricated from metal, for example, or carved from a block of wood or marble. In other cases the aim is metaphorical or fanciful, to apply images to the type that make it look more interesting or that relate to the content of the text. For more information on the techniques of applying textures to 3D objects see Chapter 7, "Designing Surfaces," starting on page 101.

CREATING SHINY METALLIC TYPE

One of the most popular and effective ways of texturing 3D type is to apply a very shiny, metallic surface that mimics the look of chrome, gold or silver. When metallic type is also beveled, the possibilities for interesting light reflections increase.

CREATING AN ENVIRONMENT FOR SHINY TYPE

The surfaces surrounding metallic 3D type will be reflected in it and add to the play of color and light in the shiny surfaces. So a colorful environment can increase the complexity of reflections in any type that has a reflective surface, whether metal or glass. Most 3D programs provide image-based environment maps which create a type of spherical background which is reflected by the model. This background is set up as part of the rendering process (see "Environment Maps" on page 147). In addition, StudioPro provides a cubic environment which can greatly increase the bouncing of light rays back and forth upon metallic surfaces.

IMAGE-BASED TEXTURES FOR TYPE

Textures based on scanned images can be applied to type to make it look more attractive and also to fit the message the text conveys. Type can be covered with flowers or grass or other natural or photographic images that either

Using textures on type
Some of the standard textures available in 3D programs include wood, marble and metal. These can be applied to extruded type to add flavor to the design.

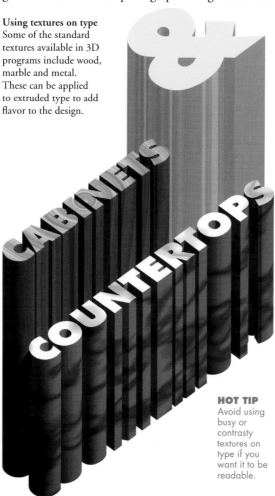

HOT TIP
Avoid using busy or contrasty textures on type if you want it to be readable.

reinforce the content of the text or play off against it. For example, a logotype design for a plastering firm might be textured with a stucco pattern. By contrast, a headline for an article on problems in marriage might include hearts and flowers in a style that conveys an unrealistic view of married life. (For more information on using textures to create metaphorical allusions in 3D (see "Creating Visual Metaphors" on page 114).

Adding an environment map
In its basic form, an extruded letter may look a little dull, even though its surface is highly reflective (**A**). Applying a chrome horizon environment map (**B**) and a room environment map (**C**) brings out the luster in the material.

USING 3D IN DESIGN

153

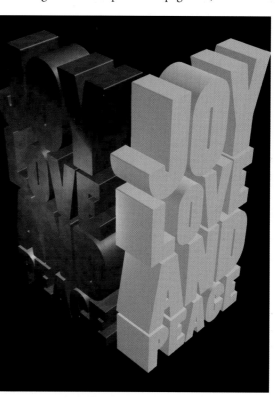

Matching texture to meaning
A well-chosen texture can amplify the message that the words convey. When the selected texture contradicts the message, the result is ironic.

Creating a package design mock-up
We typeset some sample label designs for hotel toiletries in a Post-Script illustration program and added a simple graphic element. Then we rasterized the illustration files to create bitmapped image maps. The type/graphic texture was applied to the box with cubic mapping and applied to the jar with cylindrical mapping. The tops of the box and jar are both separate objects shaded with a solid color. To map the design onto the irregular-shaped bottle we again used a cubic mapping method.

MAPPING FLAT TYPE ONTO 3D OBJECTS

Another popular use of type in 3D is the application of two-dimensional type—often combined with graphic elements—to the surfaces of a 3D object as part of a texture map. For example, a flat label design which includes type might be applied to a cylinder to create a realistic-looking mock-up of a new brand of canned food. Type can also be applied to the flat sides of rectangular boxes to create package designs and can be applied to irregularly curved surfaces such as models of shampoo bottles.

It's important to choose the right mapping method when applying flat type as a texture. Some programs require use of a decal mapping mode, while others use cubic mapping mode for flat surfaces, and cylindrical or spherical modes for curved surfaces (see "Mapping Methods" on page 116). Most programs make it possible to choose each face of a cube or rectangular box and apply an image map to each one individually.

The type and design elements to be applied as part of a surface map can be created either in a PostScript illustration program or in a bitmapped image-editing program. However, PostScript art must be *rasterized* or converted to bitmapped form before it can be imported for use as a 3D texture map in most programs. Bitmaps used for import as image maps should saved in PICT format. (Adobe Dimensions does support the import of PostScript art for mapping and the program renders final images as PostScript art rather than bitmaps. For more information see "Graphics for a Manual in 3D PostScript" on page 162.)

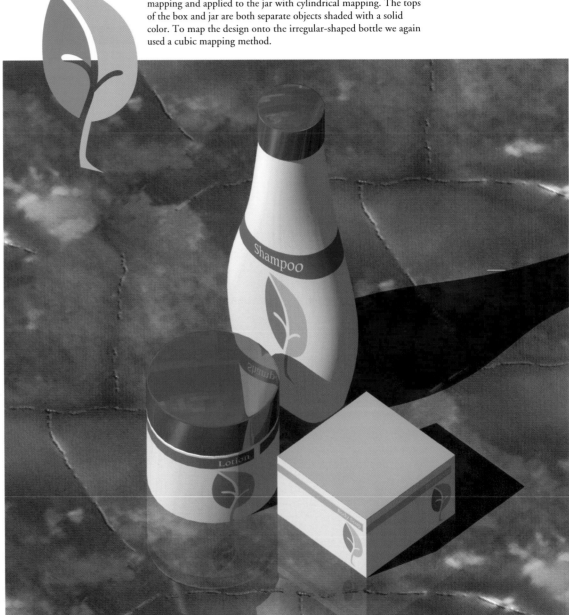

CREATING LOGO DESIGNS

Desktop 3D software is often used to design logos and logotype designs that look three-dimensional, or to take an existing two-dimensional logo and add depth to the design either for print or for a video animation. In creating logos, 3D type can be combined with simple icon shapes which are usually extruded to produce depth and sometimes lathed. Logo creation can be done in a full-featured 3D program in order to take advantage of sophisticated effects for surface textures, lighting and camera angles. However, more simple logo designs can also be created in some of the more limited 3D programs dedicated to type handling.

CREATING POSTSCRIPT 3D TYPE

Many of the programs which are devoted mainly to type effects output their images in the form of PostScript art which can be opened in a PostScript illustration program such as Illustrator or FreeHand for further coloring and editing. These PostScript 3D type programs are fairly simple and easy to learn and use, since they are restricted mainly to the extrusion of type and other simple shapes, and their other modeling, shading and rendering functions are limited. However some programs, such as Dimensions, also support lathing and make it possible to create and manipulate primitive shapes.

Making a dimensional logotype

Unlike two-dimensional graphics, three dimensional logos can change their appearance depending how they are viewed. To make this corporate symbol based on the letters "C" and "H," we took a capital "H," sliced it in half vertically and partially lathed it 270 degrees On its top surface the shape of the letter "C" is formed by the lathing process.

HOLDING
COMPANY
ANNUAL REPORT
2000

Editing and applying a 3D logo

To make this logo we set type in Adobe Dimensions and extruded it with a simple bevel. Next we enlarged the "g" to give the lettering more character. Finally, we added a rounded rectangle and two lathed hemispheres to suggest the shape of a hamburger.

We exported our Dimensions file to Illustrator and added a graduated fill to the front surface of the lettering. We also replaced the green rounded corner rectangle with a patterned fill of orange stripes.

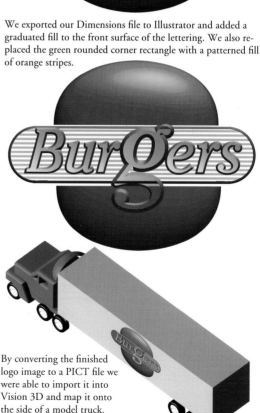

By converting the finished logo image to a PICT file we were able to import it into Vision 3D and map it onto the side of a model truck.

3D Images in Illustration

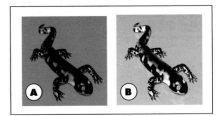

USING 3D IMAGES AS REFERENCES

Desktop 3D programs are excellent tools for producing realistic images of real world or fantasy objects and scenes. But realism may not be the look you want for a particular illustration. In that case, a 3D image can be used as a reference for an image created in another medium, just as you might use a photograph as a drawing reference. Using 3D images as references makes it possible to create exactly the scene you want, with all the correct geometry and perspective, but still produce an illustration that has the look of hand-drawn art.

To create a visual reference with clearly defined edges that will be easy to trace, adjust the lighting and applied textures in your 3D model so that the rendered image is as clear as possible. Ray tracing may provide the most clear image, but it may not always be necessary. Sometimes an image produced using Phong shading or even flat shading can produce enough edge detail for tracing. It's also possible to get adequate results using a simple screen capture of the on-screen image. An image of the 3D model can also be edited in Photoshop to improve detail by increasing the contrast, converting to grayscale, or sharpening.

HAND-TRACING

A 3D image can be traced using the tried-and-true method of placing tracing paper or acetate over a laser proof of the image. Using a light table may help in the process. A drawing made in this way, using either pencil or ink, will have the thick-and-thin line weight that's characteristic of hand work and that makes drawings look warmer and more personal than computer-generated art. However, a hand-drawing can be scanned and brought back into the computer graphics environment for coloring. A scanned drawing can be colored and embellished in a paint program such as Photoshop or

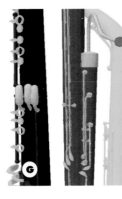

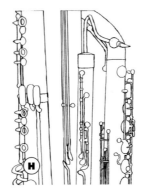

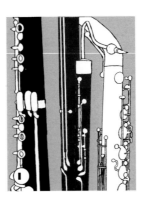

Paint or PostScript

We ray traced a Ray Dream clip art salamander (**A**), opened the image in Photoshop and converted it to grayscale (**B**). We printed the gray image and drew over the print with ink on matte acetate to create separate line drawings of the lizard outline (**C**) and the spots (**D**) To create a color bitmapped version, we scanned the outline drawing, opened it in Painter to add color with a chalk brush and then opened the Painter image in Photoshop, applied the Gallery Effects sponge filter to the lizard and added a drop shadow (**E**). As a variation in PostScript, we autotraced both drawing with Streamline, opened the EPS art in Illustrator and added gradients to the body and solid color to the spots (**F**).

Using a screen dump as a reference

We imported Ray Dream clip art models of an oboe, English horn and saxophone into a scene and made a screen dump of the on-screen view in flat shading mode (**G**). We placed matte acetate over a laser print of the screen dump, drew over the outlines with dark pencil and scanned the drawing (**H**). We opened the scan in Photoshop and dumped gray tones into some open areas of the sketch (**I**). We then converted the image to RGB color and used the Hue/Saturation controls to add monochrome brown tones (**J**).

Preparing a 3D model for tracing
We opened a copy of a model of the Alamo (from Ray Dream Designer's Dream Models collection) and replaced the stone textured surfaces with solid color to make the model easier to trace (right). We then viewed the model in the orthographic views of front, back, left, right and top and did a screen capture of each view. The front view is shown below.

Using references in PostScript Illustration
To create a set of building elevations and a top view of the Alamo, we saved orthographic views in Ray Dream, opened each view in Photoshop, saved it as a TIFF and then placed each view in Illustrator, where we traced over the important edges and curves with the pen tool and filled the shapes with solid color. Many of the shapes we drew could be used more than once in different views. We also produced a set of black-and-white line versions simply by selecting all the shapes and changing their paint specifications to a white fill and a .5-point black line.

Painter. It can also be autotraced and opened in a PostScript illustration program for further work.

COMPUTER TRACING

A 3D image can also be traced via computer by opening it in a paint program such as Photoshop or Painter and assigning it to a separate layer. You can use a variety of "natural media" brushes to draw over the image in an overlying layer, creating drawings that have the look of hand-drawn lines. Using a pressure-sensitive stylus and digitizing pad, instead of a mouse, will make the drawing process even more flexible and natural.

For more precision, a 3D image can also be imported into a PostScript illustration program and traced over using the program's Bézier drawing tools. (In Adobe Illustrator, we've found that importing an image as a placed TIFF, rather than as a template, produces a better quality on-screen image which is easier to trace.) PostScript drawings can be used to produce simple black-and-white line drawings and can also be colored with solid colors or gradations.

Starting with clip art
Ray Dream's model of the Alamo is shown above with its original surface maps. We applied Photoshop's Cutout filter to create a more graphic version (below).

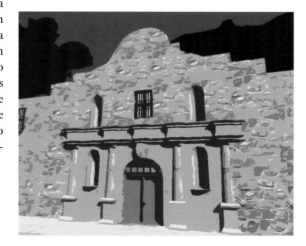

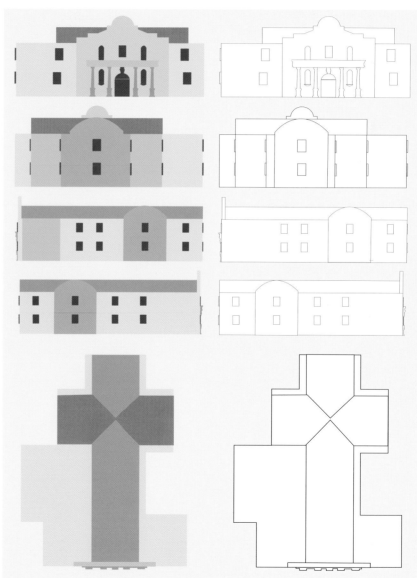

Filtered images

We used a variety of filters to alter the appearance of 3D images created using models from Ray Dream's Dream Models collection. filters can create special effects and change the photographic look of 3D renderings to a style that closer to hand-drawn art in traditional media.

APPLYING FILTER EFFECTS

Another way to alter the realist style of 3D renderings is to apply filters in an image-editing program like Photoshop. Some 3D programs include filter options that can be applied during the rendering process, but we've found that it's more flexible to render a realistic image and alter it later in Photoshop, since rendering can take a long time and filtered effects may not look right on the first try.

USING FILTERS

Photoshop includes a number of built-in filters such as Find Edges and Add Noise in addition to the collection formerly known as Gallery Effects. In addition, there are many third-party filters available for use with Photoshop, Painter and other image-editing programs. These include Kai's Power Tools (KPT) from MetaCreations, Paint Alchemy from Xaos Tools and various filter packages from Andromeda. It usually takes some trial-and-error experimentation to discover which filters work best with different types of images.

Andromeda, Prism Paint Alchemy, Crowd Photoshop, Emboss

Photoshop, Unsharp Mask, exaggerated Photoshop, Glowing Edges Paint Alchemy, Oil Canvas Wide

Paint Alchemy, Soft Pencil Dark Photoshop, Water Paper KPT, Find Edges and Invert

Filtered surrealism
To make a comment on the effects of the standard American diet, we started with a room made in Ray Dream Designer and created two surrealist images by placing into the room in turn a model of a fat man (imported from the Acuris "18 Perfect People" collection) and a double cheeseburger from the Dream Models collection. We experimented with various filters, then used Photoshop to combine filtered versions in two different ways (below).

More filter combinations
We cropped the pink teacup from the tea set scene on page 17 in Chapter 2, experimented with various filters and created a composite image from two of the filtered versions.

Original images

Photoshop, Paint Daubs

Photoshop, Find Edges

Photoshop, Find Edges, Invert

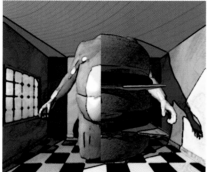

CREATING COMPOSITE IMAGES

Many interesting images and variations can be created by combining rendered and filtered images into a composite image. The illustration on the cover of this book was created by combining a wireframe rendering of the model with a ray traced rendering. On the next page we created composite images after experimenting with various filters.

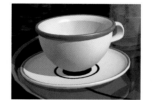

Original rendered image

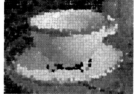

Paint Alchemy, Mosaic Medium

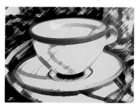

Photoshop, Colored Pencil

Photoshop, Add Noise

Photoshop, Sumi

KPT, Find Edges Charcoal

Composite image, Sumi and Mosaic Medium

Overlaying filtered effects
We ran various filters on an image of a trumpet and then combined filtered versions using layers in Photoshop.

Photoshop, Glowing Edges

Paint Alchemy, Pastel

Photoshop, Cutout

Photoshop, Fresco

Glowing Edges (75% opacity, Difference mode) over Cutout, 100%

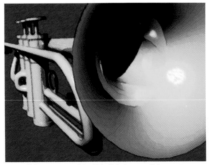

Pastel (80% opacity, Multiply mode) over Fresco, 80% opacity

COMBINING FILTERED IMAGES IN LAYERS

A single filter can make effective and pleasing changes in a rendered 3D image. But filtered images can be combined in a single image to create even more interesting results. Photoshop makes it possible to place duplicates of an image into separate layers, apply different filters to each layer and then combine the layers using various modes and levels of opacity.

POSTERIZATION, SOLARIZATION AND MORE

In addition to the special filtered effects available through Photoshop's native and third-party filters, you can create interesting and graphic effects using the standard image-editing functions of posterization, solarization and inversion, as well as by making adjustments in contrast, sharpness, hue, saturation and so on. Just as a single 3D model can be modified to capture many different images, so a single 3D rendering can be modified in an image-editing program to create images in many different styles.

Image editing
We created three versions of the original trumpet image by using various image control functions in Photoshop. The solarized version was created by using Difference mode to combine a positive image at 100% with a negative image at 50%.

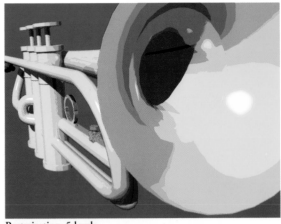

Posterization, 5 levels

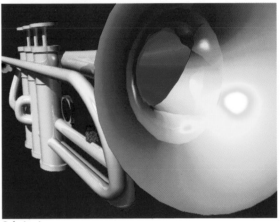

Solarization

Hues changed using Hue/Saturation controls in Photoshop

APPLYING EFFECTS IN PAINTER

Painter is a program dedicated to reproducing the appearance of natural media, such as oil paint, charcoal, chalk, water color and so on. Painter includes several "brushes" that imitate the styles of specific painters and art periods and makes it possible to apply these (and any of its brushes) to images in an automatic way through a function called AutoClone, which paints into the image using the chosen brush tool. In addition, Painter includes many paper textures which can be applied to images as overall surface textures, to imitate the look of images on canvas, textured paper, burlap and so on. These special effects can be used alone, or combined with other filtered effects in Photoshop to add textural interest to 3D renderings.

Original unfiltered rendering

Impressionist brush, applied with AutoClone

Loaded Oil brush, applied with AutoClone

Scratchy paper texture applied to original

Using AutoCloning

We rendered a clip art windmill from Ray Dream Designer's Dream Models, along with an infinite ground plane, a sky environment and directional light set to imitate bright midday sun. We opened the rendering in Painter and applied a number of different brush effects using the AutoClone function, which automatically applies the effects of any selected brush. We also created a variation with an allover paper texture and also applied Photoshop's Sumi filter to the autocloned image made with Painter's Loaded Oil brush.

Van Gogh brush, applied with AutoClone

Seurat brush, applied with AutoClone

Loaded Oil brush, AutoClone; followed by Sumi filter in Photoshop

Not all 3D graphics have to be flashy and colorful. A technical manual requires simple, black-and-white, "nuts-and-bolts" illustrations.

The right tool for the job is a program such as Dimensions, which generates clean PostScript graphics, rather than bitmapped images. The diagrams on pages of the manual below were all derived from 2D artwork created in Illustrator that were imported into Dimensions and ex-truded. (Although Dimensions comes equipped with drawing tools, they lack the sophisticated alignment and editing capabilities of the sister product, Illustrator.) The rendered images were then saved as EPS files and exported back into Illustrator for further editing.

3D graphics in PostScript format offer many advantages over bitmapped renderings. PostsScript graphics can be scaled to any size in a

Making a plug
Imported 2D shapes were extruded in Dimensions with a bevel. The screw is a lathed profile. The dotted line was added to the rendering afterwards in Illustrator (**A**).

Making weather-stripping
This model consists of unbevelled extrusions. The round rubber part is one piece and the metal channeling consists of three pieces. The Dimensions rendering has no visible lines, but all the elements of the image are shapes that can be given lines or strokes in Illustrator, FreeHand or CorelDraw to make the diagram more clear (**B**).

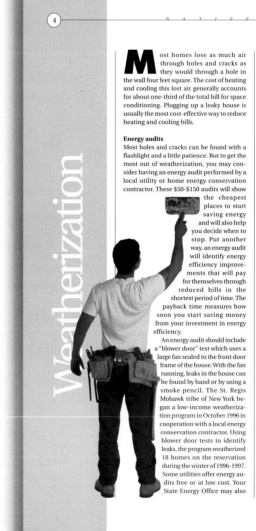

4 — N A T I V E P O W E R

Most homes lose as much air through holes and cracks as they would through a hole in the wall four feet square. The cost of heating and cooling this lost air generally accounts for about one-third of the total bill for space conditioning. Plugging up a leaky house is usually the most cost-effective way to reduce heating and cooling bills.

Energy audits
Most holes and cracks can be found with a flashlight and a little patience. But to get the most out of weatherization, you may consider having an energy audit performed by a local utility or home energy conservation contractor. These $50-$150 audits will show the cheapest places to start saving energy and will also help you decide when to stop. Put another way, an energy audit will identify energy efficiency improvements that will pay for themselves through reduced bills in the shortest period of time. The payback time measures how soon you start saving money from your investment in energy efficiency.

An energy audit should include a "blower door" test which uses a large fan sealed to the front door frame of the house. With the fan running, leaks in the house can be found by hand or by using a smoke pencil. The St. Regis Mohawk tribe of New York began a low-income weatherization program in October 1996 in cooperation with a local energy conservation contractor. Using blower door tests to identify leaks, the program weatherized 18 homes on the reservation during the winter of 1996-1997. Some utilities offer energy audits free or at low cost. Your State Energy Office may also

FOAM RUBBER GASKETS - THESE ARE USED BEHIND OUTLETS AND SWITCH PLATES LOCATED ON EXTERIOR WALLS. ILLUSTRATION: HOMEMADE MONEY, ROCKY MOUNTAIN INSTITUTE, 1995.

COMMON WEATHERSTRIPPING MATERIALS - FROM TOP: ROLLED VINYL WITH RIGID METAL BACKING, FOAM RUBBER, THIN SPRING METAL, FIN SEAL. ADAPTED FROM AN ILLUSTRATION BY NEW MEXICO STATE UNIVERSITY COOPERATIVE ENERGY EXTENSION SERVICE, SAVING ENERGY IN YOUR MOBILE HOME, 1995.

be able to refer you to contractors that perform home energy audits (see page #). The audit can help you decide if you really want to do the weatherization and insulation work yourself. Contractors can typically do an audit and all the necessary weatherization and insulation improvements for about $1000 to $3000.

layout without "pixelating" or breaking up into visible squares of tone. You can also edit the gray values, lines weights and colors of your 3D images in a PostScript drawing program. In general, PostScript graphics print faster and require less disk space than bitmaps.

We recommend keeping your outlines fairly simple. The house model below represents the upper limit of complexity. Beyond this limit

your program may become unbearably slow. Another concern is that Dimensions provides only distant or global light sources, so the interiors of boxes and other closed off-spaces can become "black holes" in your diagram.

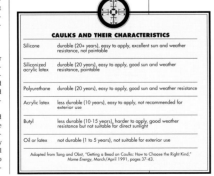

THE BLOWER DOOR TEST - THE BLOWER DOOR IS SEALED TO THE FRAME OF THE HOME'S ENTRY DOOR. WHEN WINDOWS, FIREPLACE DAMPERS, AND VENTILATION OPENINGS ARE CLOSED, THE FAN ON THE BLOWER DOOR CREATES A PARTIAL VACUUM BY SUCKING AIR OUT, AND SOURCES OF AIR LEAKAGE ATE NOTED AND SEALED. ILLUSTRATION: BUILDER'S GUIDE TO ENERGY EFFICIENT CONSTRUCTION, BONNEVILLE POWER ADMINISTRATON, 1992.

AIR LEAKAGE PATHS

BLOWER DOOR SEALED TO JAMB

AIR FLOW

HOOPA TRIBAL MEMBER WEATHERSTRIPPING THE FRONT DOOR OF A TRIBAL HOME. PHOTO CREDIT CALIFORNIA ENERGY EXTENSION SERVICE, 1992

Plugging the holes

The biggest holes are not always the easiest to find. Check to make sure your chimney has a damper. Check for holes where the chimney and plumbing stacks go through the roof, attic, and floor. Also check for gaps around plumbing and electrical wire penetrations.

Expanding foam is a good choice to fill cracks up to a couple inches wide. Really big holes can be patched with foil-faced bubble wrap (try Foil-Ray™ or Reflectix™) attached with caulk. You can also use rigid foam insulation glued into place with expanding foam. Don't worry about finding the perfect material to plug a hole. It is more important to get the hole plugged than to do so with fancy materials. Just be careful to use inflammable material near a heat sources.

Caulking the cracks

Caulk is the best way to seal cracks thinner than a pencil. While most people are impatient to get caulking, remember that preparation is the secret to making a strong and durable seal. In the long run, you'll be glad you spent some time wire brushing, cleaning and drying the surfaces to be sealed.

Caulks range in cost and character. Read labels carefully to see if the caulk is suitable for your application and for the particular materials you want to seal. Labels will clearly say whether the caulk is paintable. What they will not tell you is how well the caulk stands up to the elements. If you are applying caulk in ex-

terior areas that will receive direct sunlight, check to make sure the caulk is sun and weather resistant.

Weatherstripping

Weatherstripping comes in all shapes and sizes. Shop around for the weatherstripping that works best for your application. To seal around windows that will be opened in the spring, use rope caulk. This is a putty-like material that comes in strips or rolls. Information about reducing heat loss through windows is included in the next section.

CAULKS AND THEIR CHARACTERISTICS

Silicone	durable (20+ years), easy to apply, excellent sun and weather resistance, not paintable
Siliconized acrylic latex	durable (20 years), easy to apply, good sun and weather resistance, paintable
Polyurethane	durable (20 years), easy to apply, good sun and weather resistance
Acrylic latex	less durable (10 years), easy to apply, not recommended for exterior use
Butyl	less durable (10-15 years), harder to apply, good weather resistance but not suitable for direct sunlight
Oil or latex	not durable (1 to 5 years), not suitable for exterior use

Adapted from Tang and Obst, "Getting a Bead on Caulks: How to Choose the Right Kind," Home Energy, March/April 1991, pages 37-43.

(C)

Prefabricated housing

We drew the roof profile, foundation, walls, floors and ceiling in Illustrator and imported them into Dimensions. Because of the relative complexity of the model we used the wireframe mode (**C**) to view the model as we extruded and assembled the parts. We imported the Illustrator outlines one at a time and extruded each to the same depth as the length of the floor.

By pre-assembling the parts in a single Illustrator file we could ensure that they would fit together correctly in the 3D model. The cutouts for the windows and heating ducts were created by extruding compound shapes (see page 46) in which an overlapping shape is knocked out of another shape (**D**). The extrusion outlines for some of the smaller parts, such as the wood stove, were drawn directly in Dimensions.

(D)

CREATING MULTIUSE PROJECTS

Sometimes a project calls for several different illustrations in a similar style or with a related theme, such as images used as chapter openers in a book. With planning, you can create a single 3D model that can be used to create a series of related images, by changing the camera view, rotating the model, varying the surface textures, or taking the model apart. In our example, a model composed of extruded numerals and math symbols was rendered in a perspective view to create a cover image for a mathematics textbook. Then the camera was repositioned to capture orthographic views focussing on each separate number. It can take time to create a 3D model like this "from scratch," but the time spent is amply rewarded when the model becomes the basis of many images.

FUN WITH NUMBERS

Addition, Subtraction, Multiplication
and Division for Beginners

(A)

*The world's a scene of changes, and to be
Constant, in Nature were inconstancy.*
—Abraham Cowley, 1647

Many images from one model
We used Vision3D's text tool to create characters of four numerals and four math symbols in Helvetica Neue black, extruded them, applied color and slightly shiny surface texture and assembled the extrusions so that they formed a cross. A view looking down at the model was rendered to become a cover image for a book on mathematics (**A**). Then, to create images for chapter opening pages within the book, we rendered each separate number/symbol pair by placing a camera directly in front of each number (**B**). The highlights and reflections on the shiny surfaces add interest to the simple number and symbol shapes and the similar renderings provide unity throughout the book. As additional illustrations, we used simple 3D models of common objects, such as a veggie burger, and rendered both the assembled object and each of its parts separately (**C**).

B

Chapter 1
Addition

Seth was very hungry.
He made himself a giant veggie-burger.
How many buns did he use? How many
soy patties did he use? How many slices of
organic tomato? How many leaves of
lettuce? And how many pieces of food
is that altogether?

3+

4+

3+

(C) 2+

=12

Scanning a photo, rendering an image
We started with a photo of rowboats at a small dock (**A**) and a rendering of a sailboat from Ray Dream's Dream Models. The sailboat was modified to include a red hull and the camera was positioned to capture a view similar to the position of the rowboats in the photo. The directional lighting was set up to imitate the lighting in the photo, which was taken with the sun to the left, at about 9 o'clock in the morning (**B**). The sailboat was rendered with a solid background so that it would be easy to select and copy it by selecting the background with the wand tool and inverting the selection to select the boat.

COMBINING 3D AND 2D IMAGES

Another way to create interesting 3D images is to use an image-editing program to combine a rendered 3D image with a scan of a photograph. Architects often use this technique to create an artist's rendering to show a client how a proposed building will look. They scan a photo of the building site, render an image from their 3D model of the new building, then meld the two images together in Photoshop or a similar program. One key to a realistic result is to make sure the lighting in the model is similar to the lighting in the photograph in intensity, color and direction. That way the shadows on the model will fall in the same way as the shadows in the photo. In addition, when combining the two images it's often necessary to carefully select and remove whatever unwanted objects may be in the original photo, select and insert the image of the new object, then blend it into the photo by cloning areas of the surrounding landscape, sky or other elements. This kind of combining of images can be done not only to create realistic images that fool the eye, but to create fanciful or surrealistic images by placing images of unlikely 3D objects, perhaps at an improbable size, into a photo of a landscape or a cityscape. Applying a filter to the final, combined image will help to meld the photo and 3D elements together.

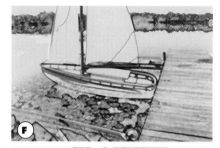

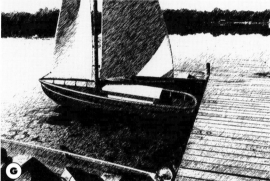

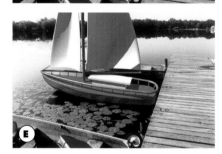

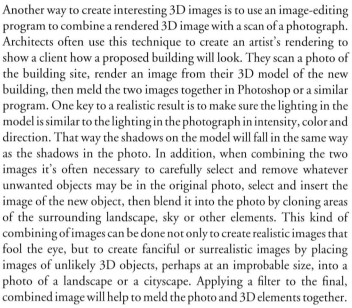

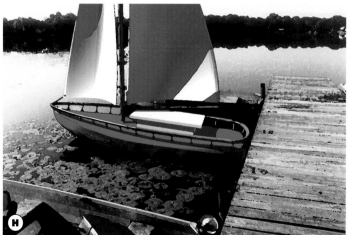

Combining two images
Using Photoshop, we selected a rowboat and deleted it (**C**). Then we selected the sailboat and pasted it into the photo in a separate layer (**D**). We deleted the rudders and used the clone tool to fill the white gaps around the sailboat with sampled textures from the photo. To create realistic highlights on the hull of the sailboat, we selected and copied the lower part of the original rowboat's hull and pasted it into the new file, stretching it to fit over the bottom half of the sailboat's hull in Darken Only mode. We also decreased the color saturation of the sailboat to make it fit better with the saturation level of its new surroundings (**E**).

Filtering the image
The finished, combined image looks fairly realistic, but to make the photo and new sailboat fit together even more seamlessly, we experimented with applying three different Photoshop filters to the image: Colored Pencil (**F**), Graphic Pen (**G**) and Watercolor (**H**).

Resources

3D CLIP ART

3Name3D
1202 West Olympic Blvd.
Suite 101
Santa Monica, CA 90404
310 314-2171
www.3name3d.com

Acuris
1098 Washington Crossing Rd.
Suite 2
Washington Crossing,
PA 18977
800 531-3227
www.acuris.com

Anti Gravity Products
456 Lincoln Blvd.
Santa Monica, CA 90402
800 747-2848
www.antigravity.com

Ketiv Technologies
6601 N.E. 78th Ct.
Suite A-8
Portland, OR 97218
800 458-0690
www.ketiv.com

Lennon Associates
Action Office
1202 Via Cortina
Del Mar, CA 92014
619 259-9244

Model Masters
420 Frontage Rd.
Northfield, IL 60093
708 446-9762
www.modelmasters.com

New World Graphics
2500 Bayard Blvd.
Wilmington, DE 19802
302 777-4905
www.nwgraphic.com

Replica Technology
4650 Langford Rd.
North Collins,
NY 14111
800 714-8184
www.reptech.com

Strata Inc.
2 West Saint George Blvd.
Saint George, UT 84770
801 628-5218
www.strata3d.com

Viewpoint Datalabs
625 S. State St.
Orem, UT 84058
801 229-3000
www.viewpoint.com

3D APPLICATIONS

Bryce
Infini-D
Ray Dream Designer/Studio
MetaCreations
6303 Carpenteria Ave.
Carpenteria, CA 93110
805 566-6200
www.metactreations.com

Dimensions
Adobe Systems
345 Park Ave.
San Jose, CA 95110
408 536-6000
www.adobe.com

Extreme 3D
Macromedia, Inc.
600 Townsend Street
San Francisco, CA 94103
415 252-2000
www.macromedia.com

Vision 3D
StudioPro
Strata Inc.
2 West Saint George Blvd.
Saint George, UT 84770
801 628-5218
www.strata3d.com

IMAGE FILTERS

Kai's Power Tools
MetaCreations
6303 Carpenteria Ave.
Carpenteria, CA 93103
805 566-6200
www.metactreations.com

Paint Alchemy
Xaos Tools, Inc.
600 Townsend St.
Suite 270 East
San Francisco, CA 94103
800 289-9267
www.xaostools.com

Various Filter packages
Andromeda Software Inc.
699 Hampshire Rd.
Suite 109
Westlake Village, CA 91361
805 379-4109

TEXTURES AND ENVIRONMENTS

Artbeats
Artbeats Software, Inc.
Box 709
Myrtle Creek, OR 94457
541 863-4429
www.artbeats.com

Direct Imagination
P.O. Box 93018
Pasadena, CA 91109
626 793-8387
www.DImagin.com

TextureScape 2
MetaCreations
P.O. Box 6659
Scotts Valley, CA 95067
408 430-4100
www.metacreations.com

Texture Farm
P.O. Box 460417
San Francisco, CA 94146
415 284-6180

SUPPORT PROGRAMS

Detailer
Painter
Poser
MetaCreations
P.O. Box 6659
Scotts Valley, CA 95067
408 430-4100
www.metacreations.com

Illustrator
PhotoShop
Streamline
Adobe Systems
45 Park Ave.
San Jose, CA 95110
408 536-6000
www.adobe.com

Index

About the Authors

GETTING
STARTED
WITH 3D

170

JANET ASHFORD is a freelance writer and designer and the co-author of four books on computer graphics: *Start with a Scan: A Guide to Transforming Scanned Photos and Objects into High Quality Art* (Peachpit, 1996), *Adobe Illustrator: A Visual Guide for the Mac* (Graphic-Sha/Addison-Wesley, 1995), *Aldus PageMaker: A Visual Guide for the Mac* (Graphic-Sha/Addison-Wesley, 1994), and *The Verbum Book of PostScript Illustration* (M & T Books, 1990).

Over the past seven years Ashford has written regular how-to articles on computer graphics for *MacUser, Step-By-Step Electronic Design, Print* and *Step-By-Step Graphics.* She has created designs for books, newsletters and brochures, and has produced original illustrations for posters, textbooks, and magazines.

Ashford has also worked as a fine artist for the past thirty years, creating drawings, paintings and posters with watercolor, pen-and-ink, oils, acrylics, and silk screen. She is also a musician, and she composed and performed the original music for the interactive Photo CD that accompanies *The Official Photo CD Handbook* (Peachpit Press, 1995). Ashford plays fiddle with two bands, Lime in the Harp (playing Celtic and American folk music) and Los Californios (playing the music of early California), and also plays with a Javanese Gamelan orchestra.

Before becoming involved with computer graphics, Ashford wrote many books and articles on childbirth and women's health, including *The Whole Birth Catalog* (Crossing Press, 1983) and *Birth Stories: The Experience Remembered* (Crossing Press, 1984). From 1979 to 1988 she edited and published *Childbirth Alternatives Quarterly*, which is archived at the National Library of Congress. Ashford's satirical short story, *Natural Love*, is included in *Cyborg Babies: From Techno-Sex to Techno-Tots* (Routledge, 1998). Her latest childbirth project is a documentary video, *The Timeless Way: A History of Birth from Ancient to Modern Times* (InJoy Videos, 1998). Ashford has a B.A. in psychology from UCLA. She and her three children live in and around Encinitas, California, north of San Diego. Information on all her work, including computer graphics, music, childbirth and psychology, can be seen at www.jashford.com.

JOHN ODAM is an award-winning graphic designer who grew up in England and received his degree from Leicester College of Art. Unlike most of his fellow art students, John wasn't particularly attracted to advertising, so decided to focus his design career on publishing. He has been living in California since 1968.

He was for many years art director of the early desktop-published *Verbum* magazine and a contributor to *Step-By-Step Electronic Design* and *Before & After*. In addition to his collaboration with Janet Ashford on *Start with Scan*, he is also co-author of *The Gray Book* (Ventana Press, 1990), a book on techniques for black-and-white computer art. He has contributed many articles and illustrations to magazines and books worldwide.

John runs a full-service design studio producing cover and page designs for college and trade books, advertising, signage, packaging, catalogs and multimedia.

John's other business revolves around Beardsley and Company, makers of a special flavored shampoo for beards. You can visit the Beardsley website at www.infonex.com/~beardsley.

In addition to playing mandocello, mandolin, mandola and guitar with Janet in Lime in the Harp, John also plays fiddle and mandolin in The Continental Drifters, a contradance string-band.